George Washington

AMERICAN SYMBOL

George Washington

AMERICAN SYMBOL

Barbara J. Mitnick, General Editor

Essays by

William Ayres

H. Nichols B. Clark

David Meschutt

Barbara J. Mitnick

William D. Moore with John D. Hamilton

Raymond H. Robinson

Barry Schwartz

and Mark Thistlethwaite

Hudson Hills Press, New York

in association with The Museums at Stony Brook
and the Museum of Our National Heritage

Published in the United States by Hudson Hills Press, Inc., 5th Floor, 122 East 25th Street, New York, NY 10010-2936.

Distributed in the United States, its territories and possessions, and Canada by National Book Network.

Distributed in the United Kingdom, Eire, and Europe by Art Books International Ltd.

EDITOR AND PUBLISHER: Paul Anbinder

COPY EDITOR: Phil Freshman

PROOFREADER: Lydia Edwards

INDEXER: Karla J. Knight

DESIGNER: Martin Lubin/David Skolkin

COMPOSITION: Angela Taormina

Manufactured in Japan by Dai Nippon Printing Company.

George Washington: American Symbol is published in conjunction with an exhibition seen at The Museums at Stony Brook, New York, February 6–May 31, 1999; at the Brandywine River Museum, Chadds Ford, Pennsylvania, June 11–September 6, 1999; and at the Museum of Our National Heritage, Lexington, Massachusetts, October 10, 1999–February 27, 2000.

LIBRARY OF CONGRESS CATALOGUING-IN-PUBLICATION DATA

George Washington : American symbol / Barbara J. Mitnick, general editor ; essays by
 William Ayres... [et al.]. — 1st ed.
 p. cm.
 "Published in conjunction with an exhibition seen at the Museums at Stony Brook, New York, February 6 – May 31, 1999; at the Brandywine River Museum, Chadds Fords, Pennsylvania, June 11 – September 6, 1999; and at the Museum of Our National Heritage, Lexington, Massachusetts, October 10, 1999 – February 27, 2000."
 Includes bibliographical references and index.
 ISBN: 1-55595-148-1 (alk. paper).
 1. Washington, George, 1732–1799—Pictorial works—Exhibitions.
2. Presidents—United States—Pictorial works—Exhibitions.
I. Mitnick, Barbara J. II. Ayres, William S. III. Museums at Stony Brook.
IV. Brandywine River Museum. V. Scottish Rite Masonic Museum of Our National Heritage.
E312.4.G46 1999
973.4'1'092—dc21 98-40429
 CIP

Contents

ABOUT THE AUTHORS

BARBARA J. MITNICK, an art historian, is general editor of *George Washington: American Symbol* and curator of the traveling exhibition. She is known for her several exhibitions and publications on American history painting. In 1993 she was curator of *Picturing History: American Painting, 1770–1930* and chief contributor to the accompanying book. Her other exhibition catalogues include *Jean Leon Gerome Ferris, 1863–1930: American Painter Historian* (1985), *The Changing Image of George Washington* (1989), and *The Portraits and History Paintings of Alonzo Chappel* (1992, with David Meschutt).

WILLIAM AYRES, Chief Curator, Director of Collections and Interpretation, Museums at Stony Brook, New York, is project director of the exhibition *George Washington: American Symbol*. A specialist in American art and material culture, he has served as director of Fraunces Tavern Museum, New York and director of development at the Henry Francis du Pont Winterthur Museum, Winterthur, Delaware. He was project director of the exhibition *Picturing History: American Painting, 1770–1930* (1993) and general editor of the book that accompanied it.

H. NICHOLS B. CLARK holds the Eleanor McDonald Storza Chair of Education, High Museum of Art, Atlanta. After holding posts at the National Gallery of Art, Washington, D.C., and the Lamont Gallery at Phillips Exeter Academy, Exeter, New Hampshire, he served as curator of American art at the Chrysler Museum, Norfolk, Virginia. His publications include *Francis W. Edmonds: American Master in the Dutch Tradition* (1988) and *Myth, Magic and Mystery: One Hundred Years of American Children's Book Illustration* (1996, with Michael Patrick Hearn and Trinkett Clark). Most recently, he authored *A Marble Quarry: The James H. Ricau Collection of Sculpture at the Chrysler Museum of Art* (1997), published by Hudson Hills Press.

JOHN D. HAMILTON, Chief Curator, Museum of Our National Heritage, Lexington, Massachusetts, has written about American military history, material culture, and Freemasonry. His books include *The Ames Sword Company, 1829–1935* (1983) and *Material Culture of the American Freemasons* (1994).

DAVID MESCHUTT, Curator of Art, West Point Museum, U.S. Military Academy, has concentrated on the study of American and British portraiture. A contributor to several periodicals, he has also authored the exhibition catalogues *John Henri Isaac Browere's Life Masks of Prominent Americans* (1988) and *The Portraits and History Paintings of Alonzo Chappel* (1992, with Barbara J. Mitnick).

WILLIAM D. MOORE, Director, Livingston Masonic Library, New York, is a specialist in Masonic architecture and material culture. He has written articles and reviews for numerous periodicals, including *American Furniture* and the *Journal of the Society of Architectural Historians*. His essay "The Masonic Lodge Room, 1870–1930: A Sacred Space of Masculine Spiritual Hierarchy" appeared in the book *Gender, Class, and Shelter* (1995).

RAYMOND H. ROBINSON, Professor of History, Northeastern University, Boston, formerly taught at Pennsylvania State University and Northwestern University. A contributor to encyclopedias and periodicals, he has also authored books dealing with nineteenth-century American history. These include *The Growing of America, 1789–1848* (1973), *America's Testing Time, 1848–1877* (1973, with Donald Jacobs), and *The Boston Economy during the Civil War* (1988).

BARRY SCHWARTZ, Professor of Sociology, University of Georgia, Athens, has published on a wide range of topics. His main area of interest, the changes and continuities in Americans' conceptions of the past, has led him to write essays such as "The Reconstruction of Abraham Lincoln," included in *Collective Remembering* (1990), and books such as *George Washington: The Making of an American Symbol* (1987); for the latter he received the 1988 Richard E. Neustadt Award. He has just completed a book dealing with changes in the image of Lincoln from 1865 to 1922.

MARK THISTLETHWAITE is professor and holder of the Kay and Velma Kimbell Chair of Art History, Texas Christian University, Fort Worth, where in 1990 he received the Chancellor's Award for Distinguished Teaching. He is a specialist in American history painting, and his numerous publications include *The Image of George Washington: Studies in Mid-Nineteenth-Century American History Painting* (1979), *Grand Illusions: History Painting in America* (1988, with William H. Gerdts), *William Ranney, East of the Mississippi* (1993), and *Painting in the Grand Manner: The Art of Peter Frederick Rothermel (1812–1895)* (1995).

Preface and
Acknowledgments

It is fair to say that George Washington was this nation's most accomplished president. Military heroes, effective administrators, and great leaders all have held the office. But none of them has embodied as fine a balance of these varied attributes as Washington. He truly was first in war, first in peace, and first in the hearts of his countrymen. He was the young colonel during the French and Indian War who matured into the role of commander in chief of the poorly equipped and often beleaguered yet ultimately successful Continental Army. He presided over the Constitutional Convention, at which the document under which we still live was framed. And as the unanimously elected first president of the United States, he was instrumental in establishing the country's basic governmental institutions. When he died in 1799, the nation entered a state of mourning that lasted several decades. One hundred years after his passing, his extraordinary life was again acknowledged in a nationwide round of commemorations. Now, in 1999, we feel drawn to reconsider and reflect upon his image—and on its abiding power to inspire Americans.

The vast array of literature on Washington is quite staggering. But there is much more to his persona than this written record reveals. His image is the one to which we have turned for sustenance during virtually every period in our history. When the nation was young and lacked inherent traditions or heroes, Washington was idolized, his face and form symbolically existing on the pedestal from which King George III had been removed. By the mid–nineteenth century, when ordinary citizens began taking their places as full participants in American life, Washington served as a hero in

visual and literary portrayals. During the Civil War, when the North and the South sought inspiration for their respective causes, Washington again filled the bill. He was the model patriot at celebrations of the nation's centennial in 1876; and he was debunked as Americans began questioning their institutions and patriotism during the 1920s and 1930s. But by the 1970s—especially in light of the bicentennial of the Declaration of Independence—Washington was once more a focus of respect and general interest. One sign of this in popular culture was that advertisers found his face and the mythology surrounding him to be valuable means of selling products. Today his visage can even be found on the World Wide Web!

In this collection of essays, published to accompany the exhibition *George Washington: American Symbol,* six art historians, a historian, and a sociologist concentrate on various aspects of that multifaceted and compelling subject. We learn, for example, that portraits done during his lifetime and a continuing array of sculptural representations provided sources for book illustrations, ceramics, textiles, and a variety of painted works of art. We are presented with evidence that, during each period of American history, biographical explorations of Washington's life paralleled visual ones and directly reflected the cultural climate of the day.

This book is also a work that represents the culmination of the efforts of a stellar group of writers whose contributions grace these pages. In the field of Washington studies, their expertise is unquestioned. By successfully cooperating to provide a clear overall view of the nature of the changing image of Washington in many media, they have produced a study that will stand the test of time.

In addition, the book and exhibition would not have been possible without the support of the Museums at Stony Brook, Stony Brook, New York, and the Museum of Our National Heritage, Lexington, Massachusetts, and their respective directors, Deborah Johnson and Thomas Leavitt. Thanks are also due to the staffs of both institutions, particularly William Ayres, who, besides serving as chief curator of the Museums at Stony Brook, project director of the exhibition, and essayist, provided me with valued editorial assistance. At the Museum of Our National Heritage, Cheryl Robertson, Director of Exhibitions and Educational Programs, and John Hamilton, Chief Curator, gave generously of their time and expertise. Thanks go, too, to Elaine Banks-Stainton for several months of general editorial help, and to Phil Freshman for his careful copyediting. Finally, we are grateful to Paul Anbinder, president of Hudson Hills Press, for his interest in and devotion to this project.

Barbara J. Mitnick
GENERAL EDITOR

COLOR PLATES

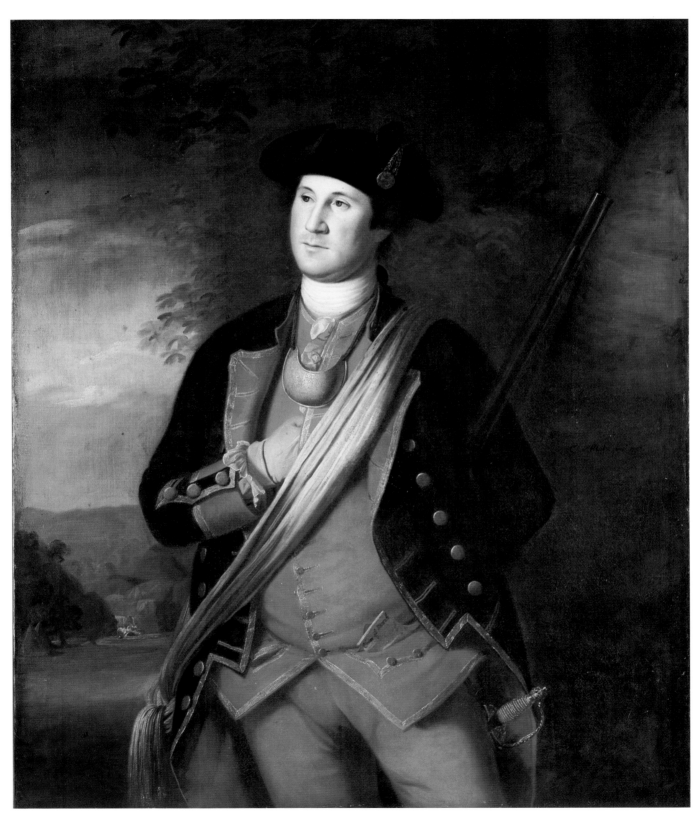

Charles Willson Peale (American, 1741–1827)
George Washington in the Uniform of a Colonel in the Virginia Militia, 1772
Oil on canvas, 50¹/₂ × 41¹/₂ in. Washington and Lee University, Lexington, Virginia.

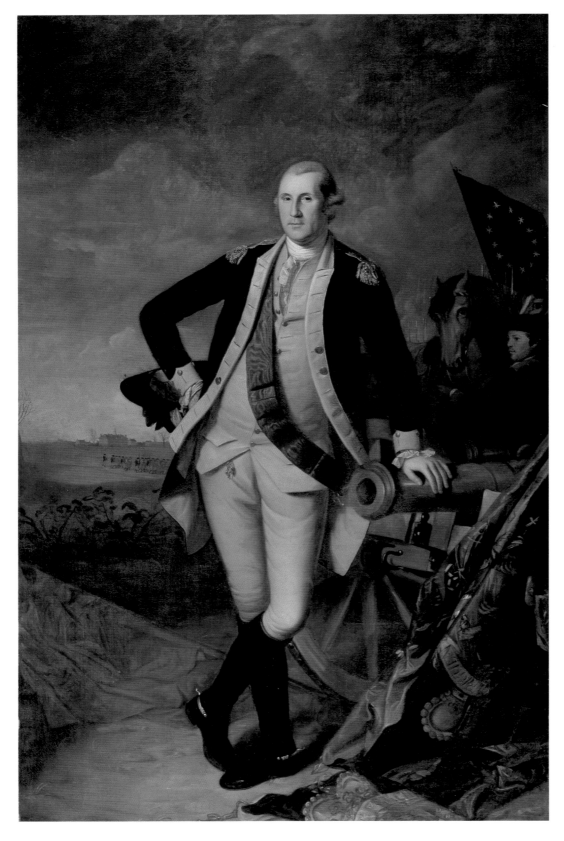

PLATE 2

Charles Willson Peale
(American, 1741–1827)
*George Washington at
Princeton,* 1779

*Oil on canvas, 93 × 58¹/₂ in.
Courtesy of the Museum of
American Art of the
Pennsylvania Academy of
the Fine Arts, Philadelphia.
Gift of Maria McKean Allen
and Phebe Warren Downes
through the bequest of their
mother, Elizabeth Wharton
McKean.*

PLATE 3
Charles Willson Peale (American, 1741–1827)
George Washington (Goldsborough portrait), ca. 1789
Oil on canvas, 22⁵/8 × 18⁵/8 in. The Hendershott Collection.

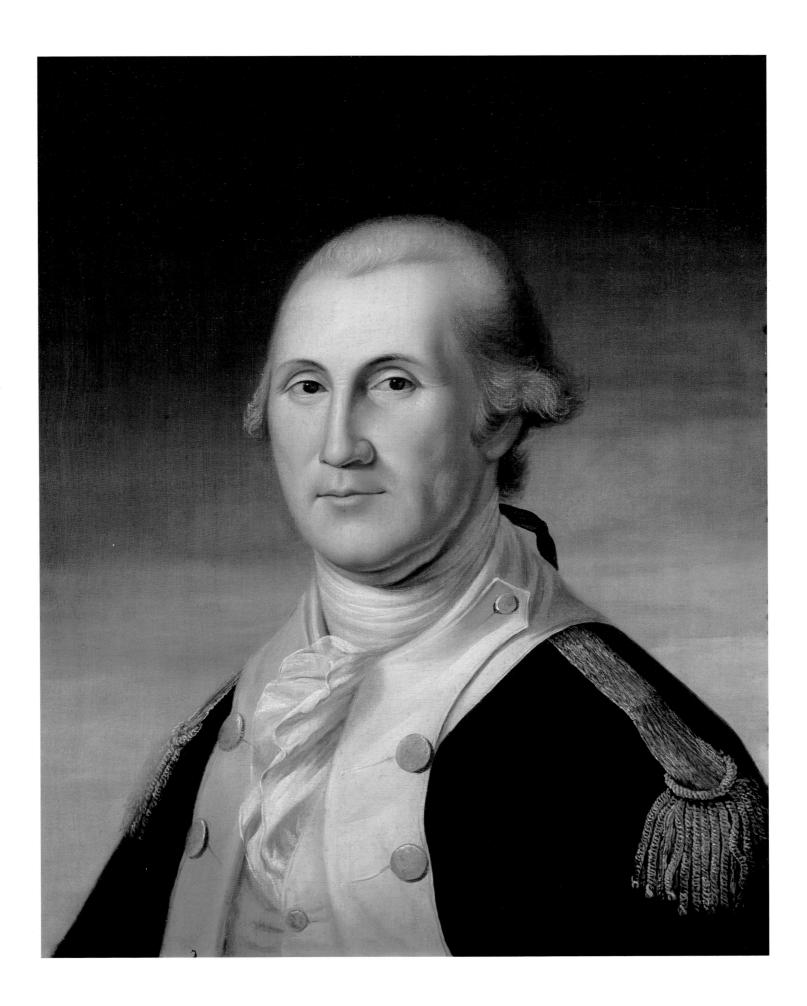

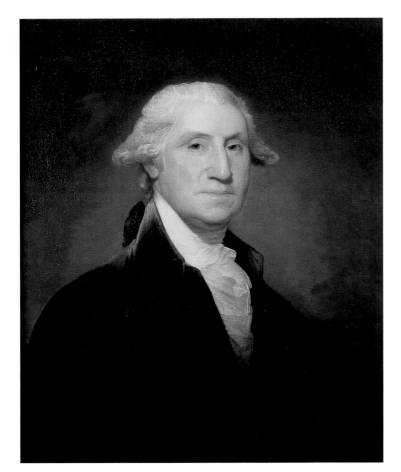

Plate 4

Gilbert Stuart (American, 1755–1828)
George Washington ("Vaughan" type, originally
painted for Robert Coleman), 1795

Oil on canvas, 29 × 24 in. Private collection.

Plate 5

Gilbert Stuart (American, 1755–1828)
George Washington ("Athenaeum" type, originally
painted for Colonel Richard Kidder Meade), 1796

Oil on canvas, 30 × 25 in. Private collection.

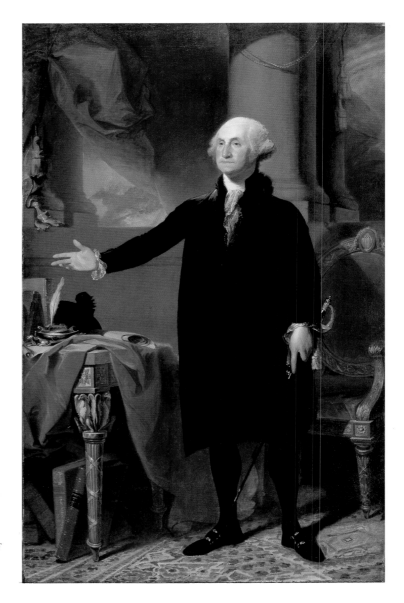

Plate 6

Gilbert Stuart (American, 1755–1828)
George Washington ("Lansdowne" portrait), 1796

*Oil on canvas, 96 × 60 in. Courtesy of the Museum of
American Art of the Pennsylvania Academy of the Fine Arts,
Philadelphia. Bequest of William Bingham.*

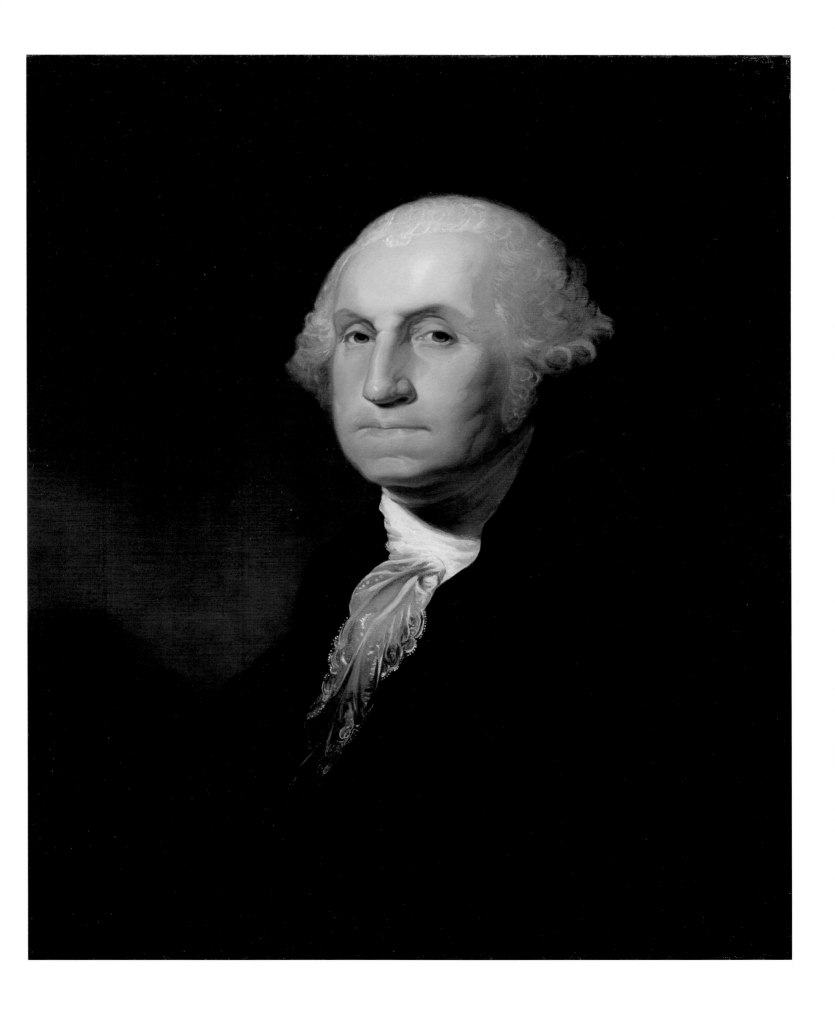

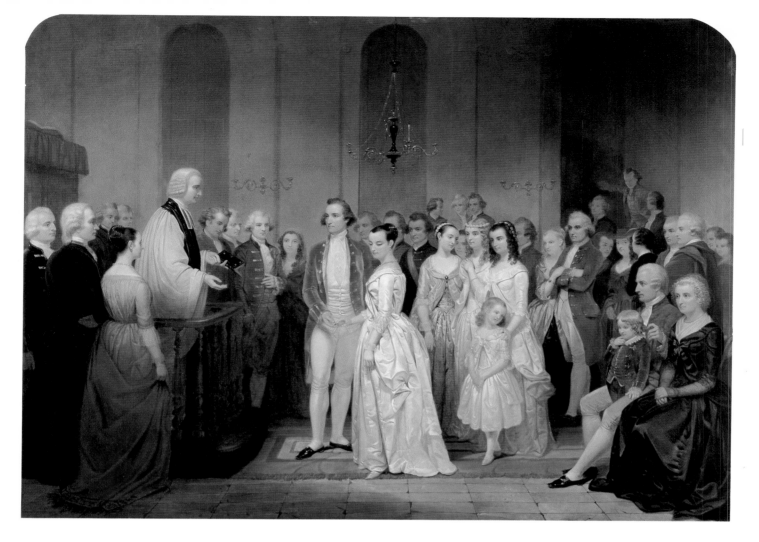

PLATE 9

Junius Brutus Stearns (American, 1810–1885)
The Marriage of Washington to Martha Custis, 1849

Oil on canvas, 40¹/₂ × 55 in. Virginia Museum of Fine Arts, Richmond.
Gift of Colonel and Mrs. Edgar Garbisch.

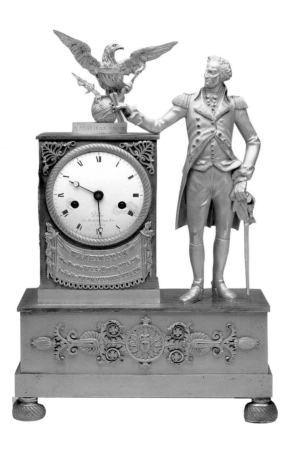

PLATE 7

Jean-Baptiste du Buc
(French, fl. 1804–17)
Mantel clock, ca. 1810

Bronze and gilt, 18 × 10⁵/₈ × 4¹/₂ in.
The Museum of Fine Arts, Houston;
The Bayou Bend Collection,
gift of Miss Ima Hogg.

PLATE 8

Dyottville Glass Works,
Philadelphia
Flask, ca. 1848

Blown-and-molded glass,
8¹/₈ × 5⁵/₈ × 3¹/₄ in. (diam.).
The Museum of Fine Arts, Houston;
The Bayou Bend Collection,
gift of Miss Ima Hogg.

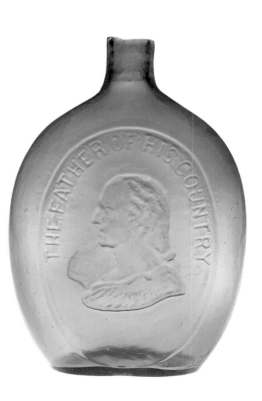

14

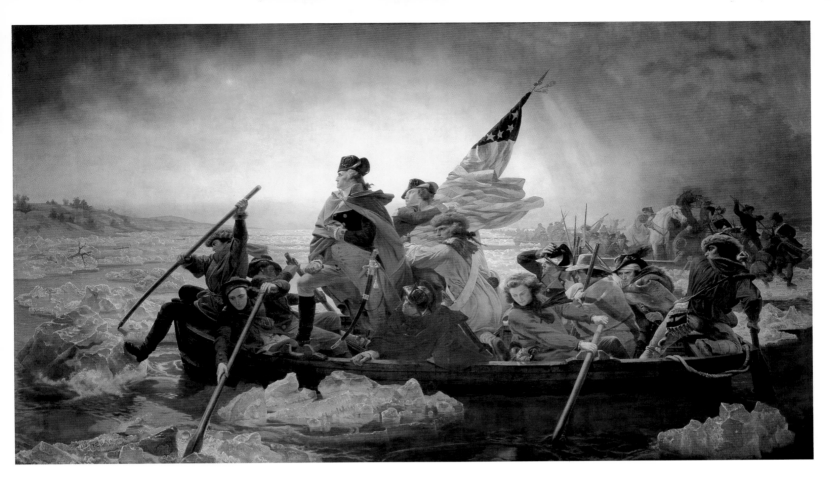

PLATE 10

Emanuel Leutze
(American, b. Germany, 1816–1868)
Washington Crossing the Delaware, 1851

Oil on canvas, 149 × 255 in.
The Metropolitan Museum of Art, New York.
Gift of John Stewart Kennedy, 1897.

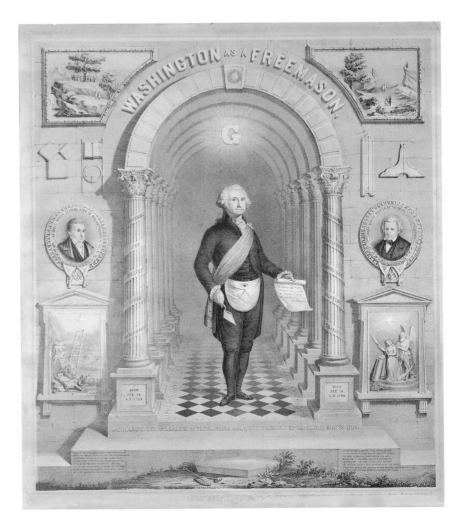

PLATE 11

Unknown

Washington as a Freemason, 1857

Lithograph, 23¹/₂ × 20¹/₈ in. Published by
Middleton, Wallace, and Company,
Cincinnati. Museum of Our National
Heritage, Lexington, Massachusetts.

Rembrandt Peale (American, 1778–1860)
George and Martha Washington: A Pair of Portraits ("Porthole" portraits), 1859

Oil on canvas laid down on panel, each: 36 × 29¼ in. The Hendershott Collection.

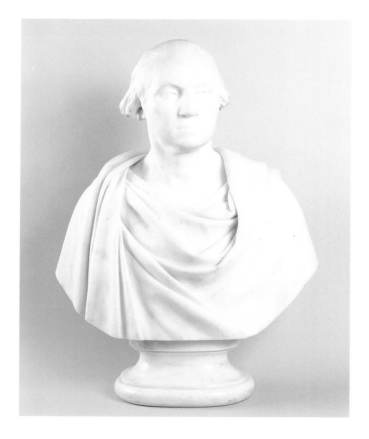

Thomas Crawford
(American, 1813–1857)
George Washington, 1848

*Marble, h: 31 in. Museum of
Our National Heritage, Lexington,
Massachusetts.*

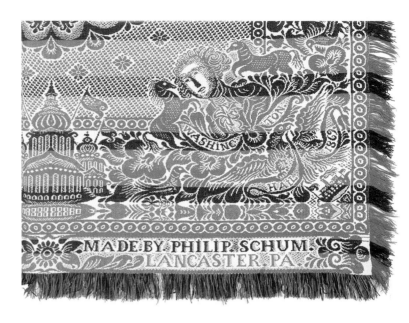

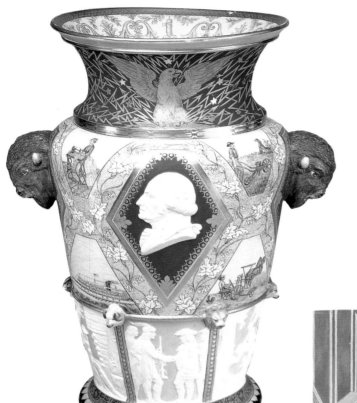

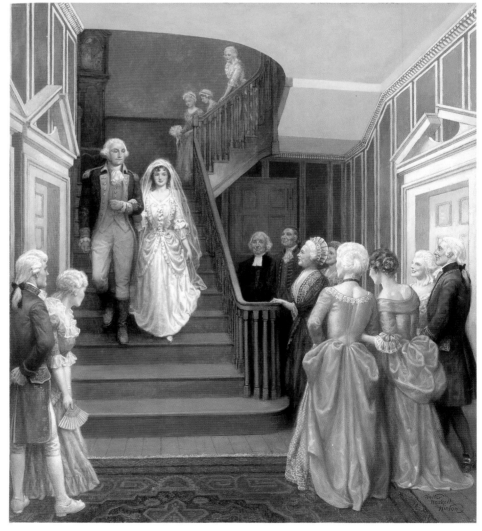

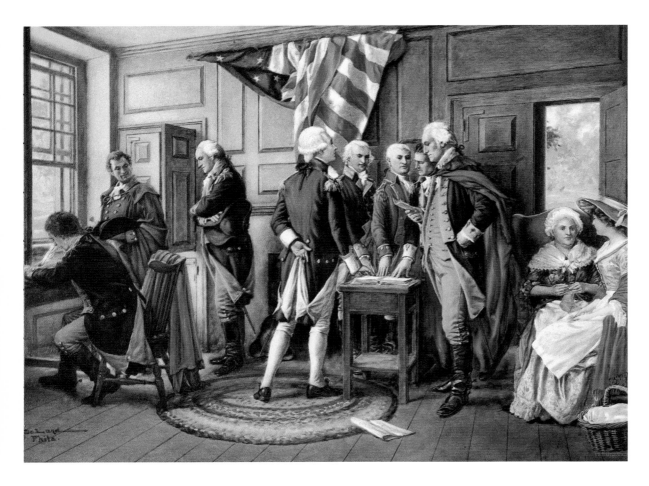

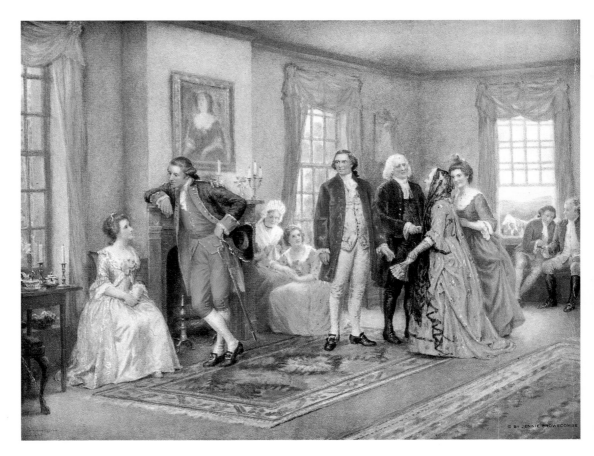

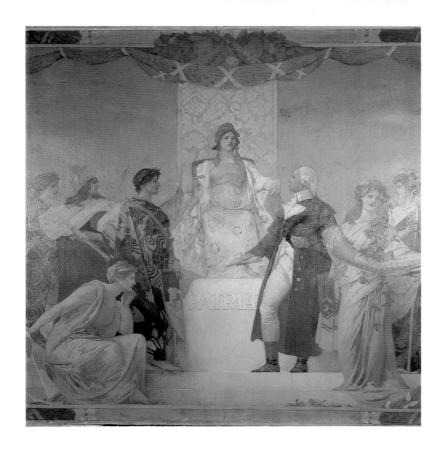

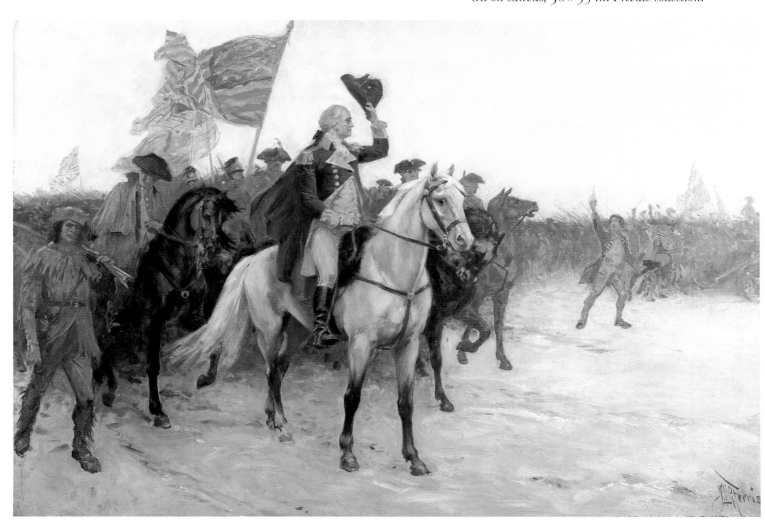

PLATE 21

Jean Leon Gerome Ferris
(American, 1863–1930)
*The Courtship of Washington,
1758,* ca. 1917

*Oil on canvas, 25 × 32 in.
Virginia Historical Society,
Richmond.*

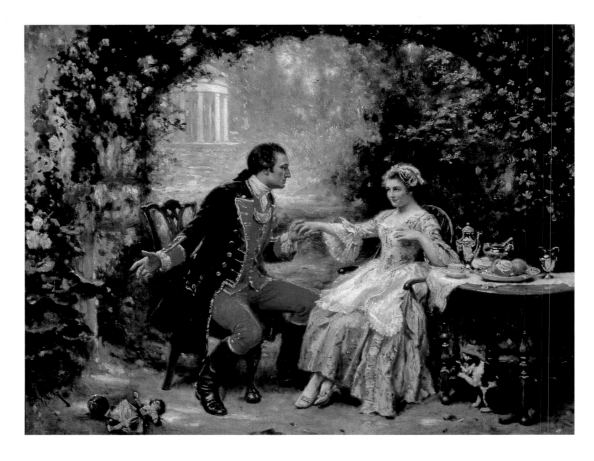

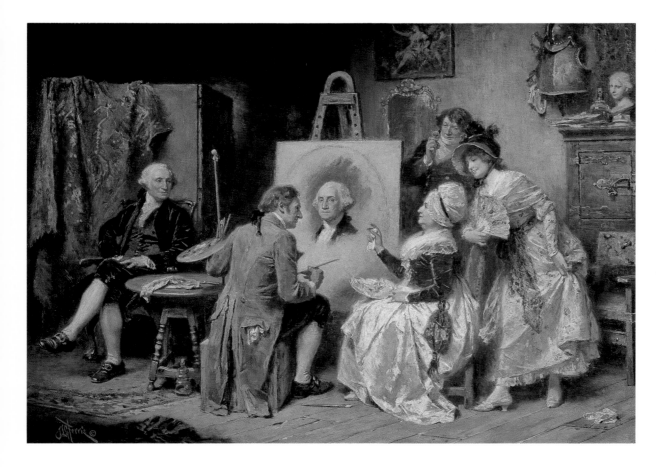

PLATE 22

**Jean Leon Gerome
Ferris** (American,
1863–1930)
*The Painter and the
President, 1795,*
ca. 1930

*Oil on canvas,
25 × 35 in. Private
collection.*

20

Donald De Lue
(American, 1897–1988)
*George Washington as
Master Mason,* ca. 1960
(smaller version of the
work displayed in the
Masonic Pavilion, 1964
World's Fair, Flushing
Meadows, New York)

*Bronze, h: 52 in. Museum
of Our National Heritage,
Lexington, Massachusetts.*

N. C. Wyeth (American, 1882–1944)
In a Dream I Meet General Washington, 1930

*Oil on canvas, 72³/8 × 79 in. Collection of the
Brandywine River Museum, Chadds Ford,
Pennsylvania. Purchased with funds given in
memory of George T. Weymouth.*

Hattie E. Burdette
(American, d. 1955)
Washington the President-Mason, 1931

*Lithograph, 46 × 32 in. Cover illustration,
The Montana Mason, May 1932.
Museum of Our National Heritage,
Lexington, Massachusetts.*

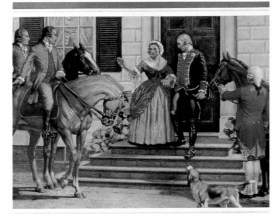

PLATE 26

Walter Beach Humphrey (American, 1892–1966)
Liberty's Delegation, 1956

Calendar illustration, Thomas D. Murphy Company, Red Oak,
Iowa. Courtesy JII Sales/Promotion Associates, Inc., Red Oak, Iowa.

PLATE 27

Robert Arneson (American, 1930–1992)
Can You Suggest a '76 Pinot Noir?, 1976

Glazed ceramic, 14¹/₂ × 14 × 6¹/₂ in.
© Estate of Robert Arneson/Licensed by VAGA,
New York.

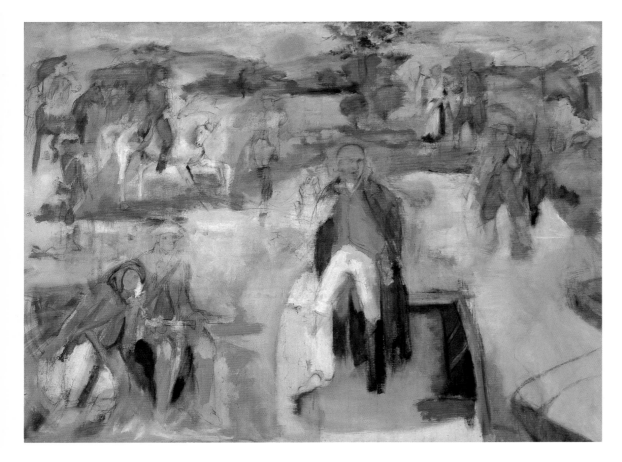

PLATE 28

Larry Rivers
(American, b. 1925)
Washington Crossing the
Delaware, 1953

Oil, graphite, and charcoal
on linen, 83⁵/₈ × 111⁵/₈ in.
The Museum of Modern Art,
New York. Given anonymously,
1963.

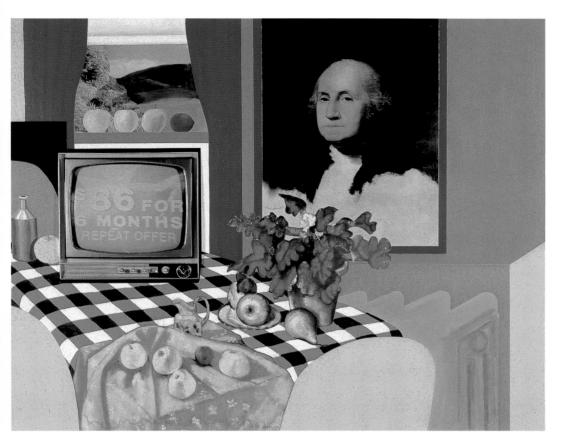

PLATE 29

Tom Wesselmann
(American, b. 1931)
Still Life #31, 1963

*Mixed-media construction with
television, 48 × 60 × 10¾ in.
Frederick R. Weisman Art
Foundation, Los Angeles.*

PLATE 30

Vitaly Komar
(American, b. Soviet Union, 1943)
and **Alexander Melamid**
(American, b. Soviet Union, 1945)
Washington Lives II, 1994

*Oil on canvas, 72 × 48 in.
Courtesy of the artists, New York.*

23

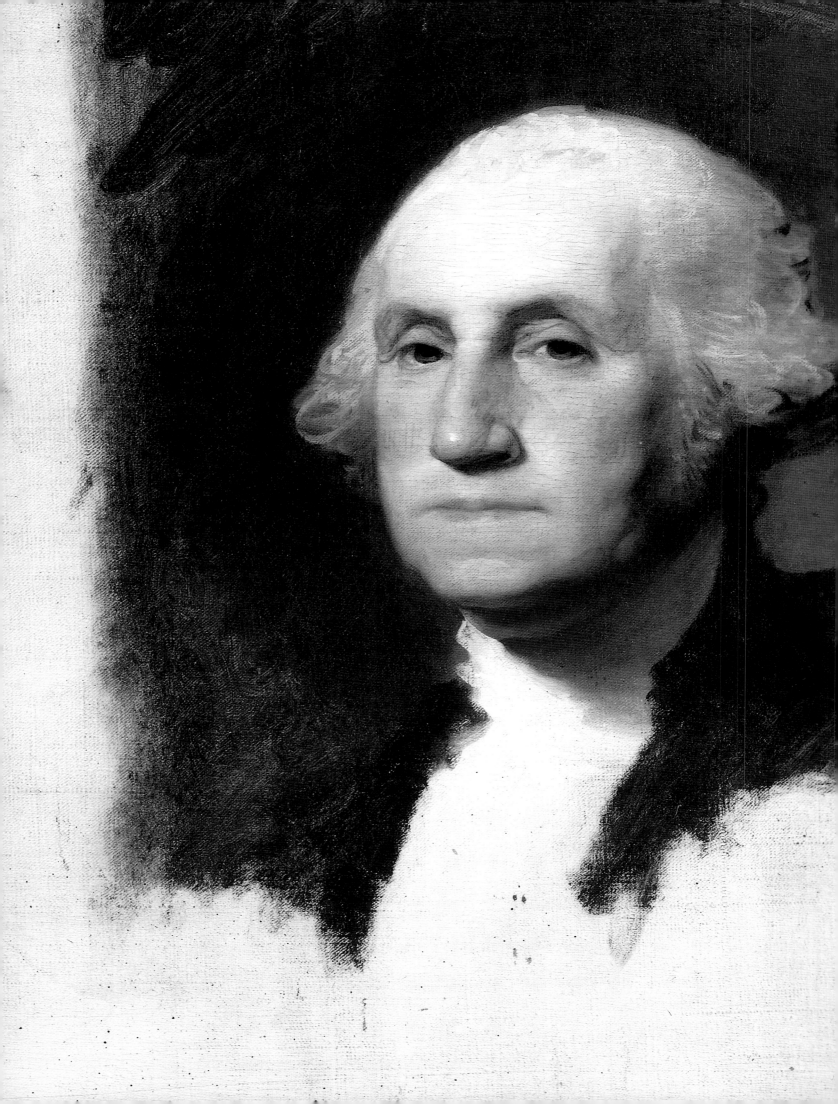

David Meschutt

Life Portraits of George Washington

*In for a penny, in for a pound, is an old adage. I am so hackneyed to the
touches of the Painters pencil, that I am now altogether at their beck, and sit
like patience on a Monument whilst they are delineating the lines of my face.*

*It is a proof among many others, of what habit & custom can effect. At first I
was as impatient at the request, and as restive under the operation, as a Colt
is of the Saddle — The next time, I submitted very reluctantly, but with less
flouncing. Now, no dray moves more readily to the Thill, than I do to the
Painters Chair.*
—George Washington to Francis Hopkinson,
May 16, 1785[1]

*T*he first time George Washington made the trip to "the Painters
Chair" was in May 1772, when he was forty years old. The painter was
Charles Willson Peale of Maryland, who had met Martha Washington a
year earlier in Williamsburg.[2] Washington's diary records Peale's arrival at
Mount Vernon on May 18, although Washington was away that day, return-
ing on the afternoon of the nineteenth. "I sat to have my Picture drawn," wrote
Washington in his diary for May 20, the day Peale began work. The next day he noted,
"I set [*sic*] again to take the drapery [clothing]," and on May 22 he wrote, "Set for Mr.
Peale to finish my Face. In the afternoon Rid with him to my Mill."[3] No further sittings
are recorded. Two days later, Washington left on a trip to Loudoun County, Virginia,
and did not return until June 4.

The result ranks among Peale's finest pre–Revolutionary War paintings (color
plate 1). Washington is depicted in the uniform of a Virginia militia colonel, the rank
he held at the end of the French and Indian War. His dress sword is at his left side.
Around his neck is a gorget, signifying his status as an officer, and a piece of paper
with the words "Order of March" sticks out of his left waistcoat pocket. The back-
ground represents the wilderness where he served during the war.

That Washington was a reluctant sitter can be seen in his letter of May 21 to his
friend the Reverend Jonathan Boucher:

Inclination having yielded to Importunity, I am now contrary to all expectation
under the hands of Mr. Peale; but in so grave—so sullen a mood—and now and
then under the influence of Morpheus, when some critical strokes are making,

that I fancy the skill of this Gentleman's Pencil, will be hard put to it, in describing to the World what manner of Man I am.[4]

Nevertheless, Martha was pleased with the painting, and it was hung in Mount Vernon's west parlor, the location of the more valuable family portraits.[5]

Four years later, in May 1776, John Hancock, then president of the Second Continental Congress, commissioned Peale to paint portraits of both the general and Mrs. Washington. By this time, Washington was commander in chief of the Continental Army. In March he had forced the British army to evacuate Boston; in recognition of this, the background of the work is a view of the city as seen from the American lines on Dorchester Heights. The artist painted Martha first and had two sittings from the general, on May 29 and 31. He continued working on both portraits through the summer without further sittings from either subject. The pictures were delivered to Hancock at the beginning of December 1776; by the following autumn they were hanging in his mansion in Boston.[6]

This second portrait (figure 19, p. 57) is not as successful as that painted in 1772. Washington was, if anything, even more reluctant to pose than he had been four years earlier, for he was preoccupied with the enormous burdens of the Revolutionary War. He looks uncomfortable, and the body, largely painted while he was absent, is awkwardly posed. The expression of calm resoluteness that is a hallmark of most Washington portraits is not present. It may have been dissatisfaction with this aspect of the work on Mrs. Washington's part that led her to commission a third portrait from Peale in 1777.

Unlike the earlier portraits, this one was a miniature. The artist set out from Philadelphia for northern New Jersey, the location of the American army at the time. At Quibbletown (now New Market), he caught up with Washington "who promised to sit for his Miniature, but at this Time he had not the Leisure," wrote Peale in his diary on June 25. In fact, Washington did not have time to pose until September 28, when he sat for the artist at Pennypacker's Mills (now Schwenksville), Pennsylvania. The result was a more characteristic likeness.[7]

Peale painted his fourth life portrait of Washington in early 1779, a full-length work commissioned by Pennsylvania's governing body, the Supreme Executive Council, for the State House in Philadelphia (color plate 2). The general posed between January 20 and February 1, and Peale continued to work on the picture for more than a month. Washington is seen standing in a casual yet dignified and graceful pose with his legs crossed, his right hand on his hip, and his left hand on a cannon. He wears his uniform of blue and buff, with the blue ribbon that until 1780 denoted his rank as commander in chief; at his left side is the green-hilted sword that he carried through much of the war. The background consists of a view of the Princeton battlefield, with Nassau Hall and other buildings of the College of New Jersey (now Princeton University) visible in the distance. A second cannon and the captured Hessian battle flags at the general's feet allude to the Battle of Trenton. The painting, which combines an excellent likeness of Washington with a symbolic depiction of the ultimately triumphant American cause, was immediately popular, and Peale produced a number of replicas. Most of these, like the original, are full-length with a Princeton background; a few are three-quarter length.[8] The artist also engraved and published a mezzotint of the life portrait in August 1780, reversing the composition and reducing it to three-quarter length.[9] His younger brother James may have helped produce some of the replicas and certainly painted at least three smaller copies.[10] In fact, the likeness was so popular that the Peales were still painting bust-length replicas into the 1790s (color plate 3).

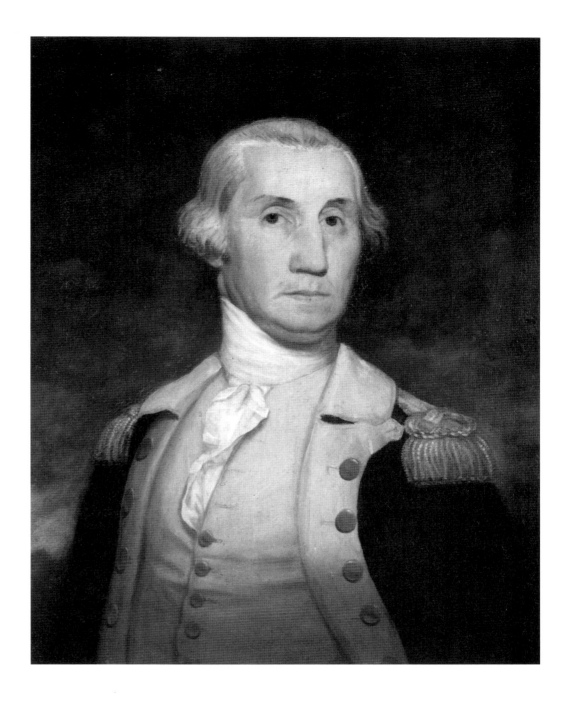

In early 1779, just after he finished posing for Peale, Washington was introduced by John Jay to the Swiss-born artist Pierre Eugène du Simitière, who drew him in profile as part of a series of portraits of American statesmen and soldiers. These drawings were subsequently sent to France for engraving. Washington thought highly of du Simitière's work, writing in 1785 that "he drew many good likenesses from the life, and got them engraved at Paris for sale."[11]

In late August 1783, shortly before the formal end of the war, Washington established his headquarters at Rocky Hill, New Jersey, five miles northeast of Princeton. Soon afterward he was visited by the young American painter and sculptor Joseph Wright, who portrayed Washington from life in both painting and sculpture. The artist first made a small painting, from which he executed three larger replicas, including an impressive three-quarter length (figure 1).[12] Wright's sculpture was Washington's first portrait from life in this medium. He began by taking a life mask, which served as the model for a bust in clay. As Washington recounted:

Wright came . . . with the singular request that I should permit him to take a model of my face, in plaster of Paris, to which I consented, with some reluctance. He oiled my features over; and placing me flat upon my back, upon a cot, proceeded to daub my face with the plaster. Whilst in this ludicrous attitude, Mrs. Washington entered the room: and, seeing my face thus overspread with the plaster, involuntarily exclaimed. Her cry excited in me a disposition to smile, which gave my mouth a slight twist, or compression of the lips that is now observable in the bust which Wright afterward made.[13]

Unfortunately, neither the life mask nor any examples of the bust have been located; but three bas-reliefs by Wright are known, one in plaster and two in wax.[14]

While Wright was painting the general, another artist appeared at Rocky Hill: the seventeen-year-old William Dunlap. He was staying at the home of Mr. and Mrs. John Van Horne, whose portraits he also painted, and it was Van Horne who asked Washington to sit for the young artist; Mrs. Washington also sat. Reported Dunlap, "I made what were thought likenesses." The portrait of Martha has disappeared, but the general's survives.[15]

Charles Willson Peale received his fifth opportunity to paint Washington from life in 1783, when the College of New Jersey commissioned a full-length portrait of the commander in chief for its main building, Nassau Hall.[16] In part because the general could spare time for only one sitting, Peale based the head on that of his 1779 portrait. The pose, however, is very different. Washington stands gracefully but theatrically, with his left hand on his hip and his right hand holding a sword. At his feet lies the dying General Hugh Mercer, a surgeon tending his wounds while a standard-bearer looks on. Washington and the other foreground figures are over-carefully composed; their actions are too obviously staged to be convincing. The scene in the background, on the other hand, is a realistic and stirring depiction of the Battle of Princeton. Whatever compositional faults it may have, the portrait is well executed and "was highly applauded when Peale brought it, in person, to the college's commencement on September 29, 1784."[17]

Peale painted a full-length portrait of Washington in 1784 for the State of Maryland that the legislature had commissioned in November 1781, in the wake of the final American victory at Yorktown. The three-year delay in completing this work was due to Peale's desire to produce a picture tailored specifically to Maryland. He copied the head of the 1783 full-length but otherwise created an entirely new composition. Washington now stands more naturally, his right hand at his hip and his left thrust into his waistcoat. Beside him are the Marquis de Lafayette and Colonel Tench Tilghman of Maryland, the aide-de-camp Washington chose to bring news of the victory to Congress.[18] Peale subsequently painted a replica for the State of Virginia—not to be hung in the capitol in Richmond but instead to be sent to the noted French sculptor Jean-Antoine Houdon, who, on the recommendation of both Thomas Jefferson and Benjamin Franklin, the American representatives to the French court, had been commissioned to execute a statue of Washington for the state.[19] However, while he was willing to utilize the Peale painting as a general guide to Washington's appearance, Houdon insisted that he could only work from life. He and three assistants sailed from Le Havre to Southampton, England, and then to Philadelphia, arriving on September 14, 1785. They spent some time there before heading to Mount Vernon, where they arrived on the evening of October 2. During his two-week stay, Houdon made a life mask, modeled a terracotta bust from life (from which he cast several plasters), and took careful measurements of Washington. He presented the clay bust to Washington, and it has remained at Mount Vernon ever since. The mask and the plas-

Figure 2

Robert Edge Pine
(British, ca. 1720s–1788)

George Washington, 1785

Oil on canvas, 35¾ × 28¼ in.
National Portrait Gallery,
Smithsonian Institution,
Washington, D.C.

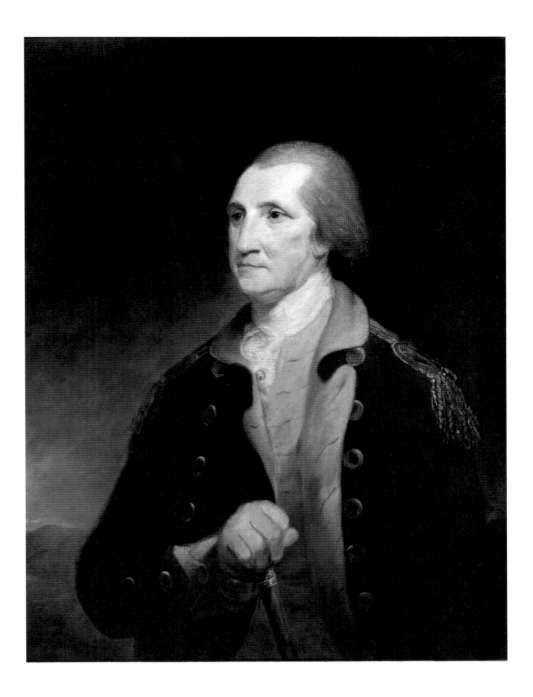

ter mold of the bust he took back to France. From the mask and the bust, together with the measurements, Houdon produced the outstanding marble statue that has stood in the rotunda of the Virginia State Capitol almost continuously since 1796 (figure 9, p. 40).

In 1785 Washington was depicted from life by the British painter Robert Edge Pine, who had been an important artist in London in the late 1750s and 1760s. A supporter of the American cause, he decided to move to the fledgling nation, settling in Philadelphia in late summer 1784. The following spring, armed with letters of introduction from various friends of Washington, he traveled to Mount Vernon, arriving on April 28. During the next twenty-two days, he painted the general (figure 2) and members of his family.[20] A better colorist than a draftsman, his portraits have charm rather than weight. A year later, after learning that the artist wanted another sitting to correct the likeness, Washington obliged and posed on the morning of July 2, 1786. Pine's portrait was not engraved and seems not to have been widely known during Washington's lifetime.[21] It is of interest, however, as the work of a painter highly esteemed in his own day in both Britain and America.

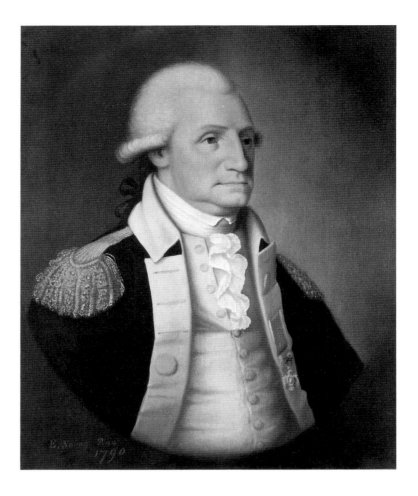

In 1787 Charles Willson Peale began a series of mezzotint engravings after the portraits of Revolutionary War figures in the Philadelphia gallery he had opened five years earlier. After completing his first subjects, Benjamin Franklin and the Marquis de Lafayette, he naturally wished to include Washington in the series. The general's arrival in Philadelphia on May 13 to preside over the Constitutional Convention provided the opportunity to do so. "With the utmost reluctance," wrote Peale on May 29, "I undertake to ask you [to] take the trouble of setting [*sic*] for another portrait . . . [in order] to make a good mezzotinto print."[22] Washington recorded the first sitting in his diary under the date June 3.[23] The painting measures twenty-three by nineteen inches, the standard dimensions Peale had fixed for portraits displayed in his museum.[24] It is the only Peale likeness depicting the general from the right rather than the left. Evidently at the same time, Charles's brother James painted a miniature in which Washington is shown in near-right profile. Better known, however, are the enlarged copies that James made of Charles's painting, which in turn served as the model for the more than fifty portraits by Charles and James's nephew, Charles Peale Polk.[25]

Washington was inaugurated as the first president of the United States on April 30, 1789. On October 3 of that year he sat for two artists; in the morning for John Ramage, an Irish-born miniaturist, and in the afternoon for the Marquise de Brehan, sister-in-law of the French minister to the new nation. As de Brehan's miniature resembles Houdon's bust in profile, she may have begun the picture using the bust as a model. Both miniatures were painted in New York City, then the seat of government.[26]

In November 1789 Joseph Willard, the president of Harvard, wrote to remind Washington that he wished to obtain the new president's portrait for the university. Willard mentioned that he had had a visit from an artist, Edward Savage, who was traveling to New York "and of his own accord, has politely and generously offered to take your Portrait . . . if you will be so kind to sit."[27] The result was a good likeness (figure 3).

Savage subsequently conceived the idea of painting a group portrait of the president and Mrs. Washington and their adopted children, Eleanor and George Washington Parke Custis, offspring of Martha's deceased son, John Parke Custis. He began the work in 1790 and completed it six years later. The portrayal of the president was initially based on the Harvard painting, but Savage subsequently altered and updated Washington's appearance, evidently without further sittings. The resulting picture is Savage's masterpiece, an interesting mix of history painting and conversation piece (figure 24, p. 64).[28]

Between February 10 and July 12, 1790, Washington recorded a number of sittings to John Trumbull, mostly for three of that Connecticut-born painter's scenes of the American Revolution: *The Capture of the Hessians at Trenton, December 26, 1776* (1786/ 1828); *The Death of General Mercer at the Battle of Princeton, January 2, 1777* (ca. 1789/ ca. 1831); and *The Surrender of Lord Cornwallis at Yorktown, October 19, 1781* (1787/ ca. 1828).[29] Washington and Trumbull had known each other since the summer of 1775, when the artist had briefly served as the general's aide-de-camp. Trumbull finished this work on July 6, and two days later the president "Sat from 9 o'clock till after 10 for Mr. Jno. Trumbull, who was drawing a Portrait of me at full length which he intended to present to Mrs. Washington."[30] This small full-length portrait (figure 4)

FIGURE 4

John Trumbull
(American, 1756–1843)

George Washington, 1790

Oil on canvas, 30 × 20¹/₈ in.
Courtesy Winterthur Museum,
Winterthur, Delaware.

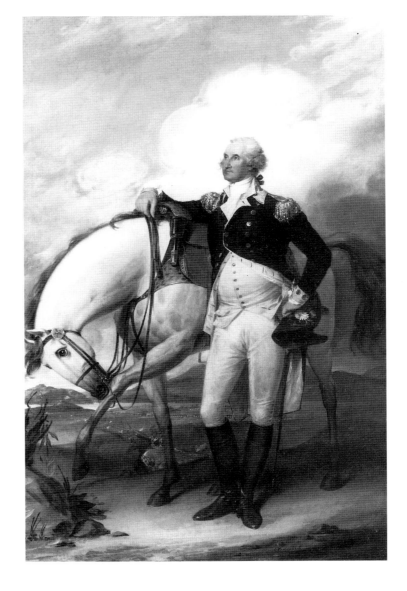

depicts Washington in uniform standing next to his white horse, while in the background can be seen "the encampment of the American Army at Verplanck's point [New York] on the North [Hudson] River in 1782—and the reception there which I saw of the French Army returning from the capture of Yorktown.... It was presented by me to Mrs. Washington in evidence of my profound and affectionate respect."[31]

Shortly after completing the picture, Trumbull was commissioned by the Common Council of the City of New York to paint a portrait of the president for the city hall. He responded with a life-size replica of the painting he had just finished, this time using as a background a view of New York at the time of the British evacuation in 1783. The success of this and a portrait of Governor George Clinton, also for the city hall, established Trumbull's reputation as the best painter then working in America. He therefore was the natural choice to depict the president for the Charleston, South Carolina, city hall in 1792. Trumbull determined to paint Washington

> in his military character, in the most sublime moment of its exertion [the period just after the Battle of Trenton]. I told the President my object; he entered into it warmly, and, as the work advanced, we talked of the scene, its dangers, its almost desperation. He *looked* the scene again, and I happily transferred to the canvass [*sic*], the lofty expression of his animated countenance.... The result was in my own opinion eminently successful, and the general was satisfied.[32]

The portrait not only recorded Washington's appearance but also commemorated an important event of the American Revolution, and as such it is as much a history painting as a portrait.[33] It did not meet with Charleston's approval, however. While acknowledging its high quality, the city's representative stated that "the city would be better satisfied with a more matter-of-fact likeness"—just the sort of portrait Trumbull had hoped *not* to do. Nonetheless, he painted a second full-length, which hangs today in Charleston's city hall. It is based on the rejected portrait, with a few superficial changes: Washington holds a walking stick instead of a spyglass in his right hand; his coat is buttoned on the right instead of the left; the horse is turned around, facing away from the general; and Charleston, rather than Trenton, is seen in the background. The result is indeed a more tranquil representation of Washington and emphasizes his role as president of the new nation.[34]

Washington sat for at least one sculptor, too, during his first term. In late 1791 or early 1792, the Italian Giuseppe Ceracchi modeled him from life in terracotta. The sculpture's neoclassical style makes it difficult for present-day observers to recognize the president's features, but his contemporaries regarded it as a successful and truthful likeness. Ceracchi carved a marble replica in 1795, for which Washington also gave sittings (figure 11, p. 43).[35]

During the 1790s the Scottish and Irish miniaturists Archibald Robertson and Walter Robertson (who were not related) painted life portraits of Washington.[36] Additionally, in 1793 Alexandria Lodge No. 22, the Masonic lodge of which he was then Master, commissioned a portrait of him from William Williams, who had recently settled in Philadelphia after working as an itinerant artist in northern Virginia. Executed in 1793–94, it is a frank, unflattering rendering in pastel that even includes Washington's mole and smallpox scars (figure 31, p. 77).[37] In 1794 Washington sat for the Swedish-born artist Adolph Ulric Wertmuller; Rembrandt Peale well summarized the result as "a highly finished laborious performance . . . with a German aspect."[38]

Gilbert Stuart moved from New York City to Philadelphia in late autumn 1794, specifically to paint Washington. The sittings evidently took place in the winter or early spring of 1795. The resulting portrait type has come to be known as the "Vaughan" because one of the surviving examples originally belonged to the London

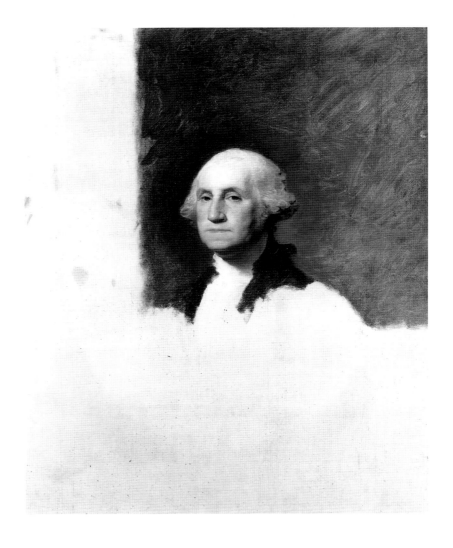

merchant Samuel Vaughan. Formerly claimed to be the original life portrait, it is now considered to be an early replica.[39] Today, more than a dozen examples attributable to Stuart are known; the one illustrated here, from 1795, belonged for many years to the Coleman family of Philadelphia (color plate 4). His "Athenaeum" portrait, probably painted in April 1796, is the best-known image of Washington (figure 5). Stuart made many replicas of it (color plate 5), and it also appears to have been the source for the head of the full-length portrait known as the "Lansdowne," although he claimed that this one, too, was done from life (color plate 6).[40]

Charles Willson Peale painted his seventh, and last, life portrait of Washington in the autumn of 1795, as a favor to his seventeen-year-old son, Rembrandt, then just beginning his career as a professional portraitist. He and his brother Raphaelle were planning to spend the winter working in Charleston, and Rembrandt felt that a picture of the president "would invite attention from its novelty and interest."[41] He asked his father to persuade Washington to sit, and the president agreed. Rembrandt later recalled that he had asked his father "to begin a portrait, alongside of me, keeping [Washington] in familiar conversation."[42] The two Peales produced fine portraits that more than hold their own with those of Gilbert Stuart. Charles's is a dignified portrayal by one who had known Washington for nearly a quarter-century, and it captures well his intelligence and calm demeanor (figure 6). Rembrandt's, although painted at the same time, presents a different Washington—older, wearier, and rather somber (figure 7).[43]

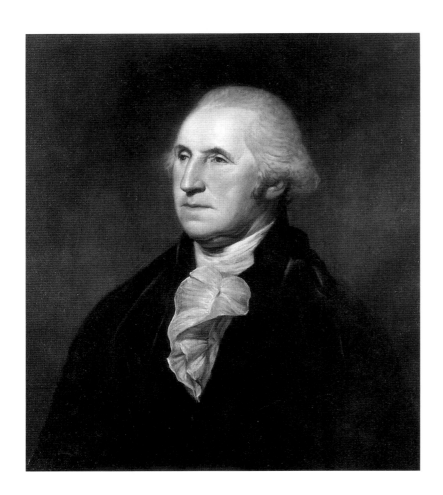

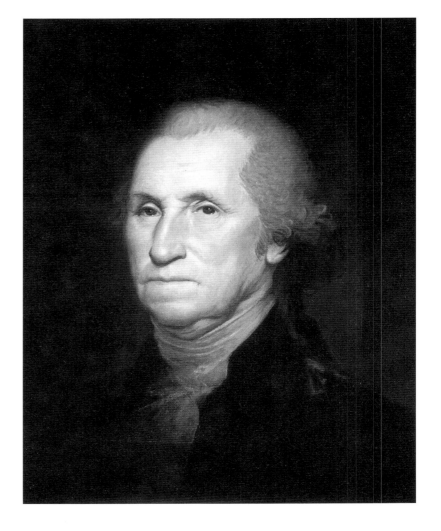

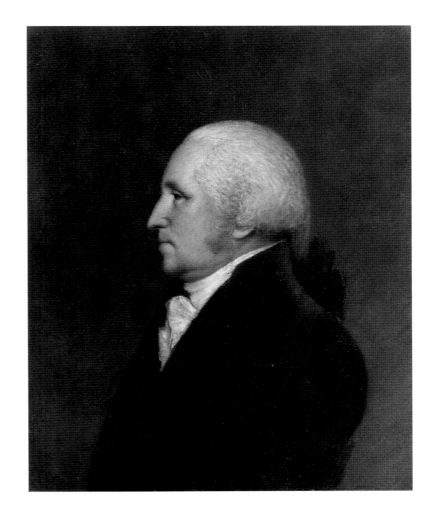

Sometime in 1796 the English pastelist James Sharples produced three portraits of Washington from life in Philadelphia: in left profile (figure 8), right profile, and three-quarter face; the profile views were highly regarded by the president's family and friends. The Sharples portraits were evidently the last for which Washington posed.[44]

Washington was painted from life many times by many artists, and the results vary widely. The "Athenaeum" portrait has greater merit as a work of art than as a correct visual record of Washington's features. Charles Willson Peale was not Stuart's equal as a painter, but his portraits are more accurate depictions of the subject's appearance. Houdon's bust and statue excel both as art and as portraiture. These great varieties of representation, for all their differences, have much in common—a sense of dignity, of seriousness, even melancholy; and all of Washington's life portraits reflect their creators' consciousness of the man as a hero.

NOTES

1. Quoted in W. W. Abbot and Dorothy Twohig, eds., *The Papers of George Washington,* Confederation Series (Charlottesville: University Press of Virginia, 1992), 2:561–62. Washington's letterbook copy is in the Washington Papers, Library of Congress, Washington, D.C.; the copy sent to Hopkinson is owned by the David Library of the American Revolution, Washington Crossing, Pa., and is on deposit at the American Philosophical Society, Philadelphia.

2. Charles Coleman Sellers, *Charles Willson Peale with Patron and Populace: A Supplement to Portraits and Miniatures by Charles Willson Peale* (Philadelphia: American Philosophical Society, 1969), 59.

3. Washington Papers, Library of Congress, Washington, D.C. Quoted in Donald Jackson, ed., *The Diaries of George Washington* (Charlottesville: University Press of Virginia, 1978), 3:108–9.

4. Washington to Boucher, May 21, 1772. Recipient's copy, Henry Ford Museum and Greenfield Village, Dearborn, Mich. Quoted in Abbot and Twohig, eds., *The Papers of George Washington,* Colonial Series (Charlottesville: University Press of Virginia, 1994), 9:49; and in Lillian B. Miller, Sidney Hart, and Toby A. Appel, eds., *The Selected Papers of Charles Willson Peale and His Family* (New Haven, Conn.: Yale University Press, 1983), 1:120. The sword in the painting is in the collection of the Mount Vernon Ladies' Association, and the gorget is in the collection of the Massachusetts Historical Society, Boston.

5. Charles C. Wall, Christine Meadows, et al., *Mount Vernon: A Handbook* (Mount Vernon, Va.: Mount Vernon Ladies' Association, 1985), 60. The portrait descended to Washington's adopted son, George Washington Parke Custis, then to Custis's daughter, Mary Anne Randolph Custis (Mrs. Robert E. Lee), and to her son, George Washington Custis Lee. He presented it to Washington and Lee University, Lexington, Va., in 1897.

6. In the summer of 1776, Peale painted a miniature of Washington for Martha Washington and one of Martha as well, copied from his paintings for Hancock; both are now in the collection of the Mount Vernon Ladies' Association. In 1778 he made a mezzotint engraving of Washington, probably from the miniature. Although he apparently struck more than one hundred impressions, only one has been located (National Portrait Gallery, Washington, D.C.).

7. See Miller, Hart, and Appel, eds., *Selected Papers of Charles Willson Peale and His Family,* 1:235. This miniature is in the collection of the Metropolitan Museum of Art, New York.

8. The replicas are discussed in Charles Coleman Sellers, *Portraits and Miniatures by Charles Willson Peale* (Philadelphia: American Philosophical Society, 1952), 228–34.

9. In the mezzotint, Peale omitted the ribbon across Washington's chest, since its use as a symbol of rank had been discontinued on June 18, 1780. Examples are owned by the National Portrait Gallery, Washington, D.C.; the Metropolitan Museum of Art, New York; and the Historical Society of Pennsylvania, Philadelphia.

10. These three copies are full-length, small (approximately thirty-six by twenty-seven inches), and contain backgrounds depicting Yorktown. They are owned, respectively, by the Metropolitan Museum of Art, New York; Historic Hudson Valley, Irvington, N.Y.; and Lafayette College, Easton, Pa. (ex. coll. the Marquis de Lafayette).

11. Washington to William Gordon, March 8, 1785. Letterbook copy, Washington Papers, Library of Congress, Washington, D.C. Quoted in Abbot and Twohig, eds., *Papers of George Washington,* Confederation Series, 2:412.

12. The life portrait and the three-quarter length, the latter painted for Samuel Powel of Philadelphia, are now owned by the Historical Society of Pennsylvania, Philadelphia. Thomas Jefferson commissioned a half-length replica, but Wright was not able to complete it before Jefferson left for France in May 1784; Jefferson eventually had John Trumbull complete the body. Francis Hopkinson commented favorably about the work in a letter to Jefferson: "Mr. Wright has made a most excellent Copy of the Generals head; he is much pleased with it himself, and I think it rather more like than the original" (Hopkinson to Jefferson, May 12, 1785; Library of Congress, Washington, D.C.). Jefferson's replica is now owned by the Massachusetts Historical Society, Boston. Another replica was painted for Friedrich Christoph, Graf zu Solms und Tecklenburg of Saxony; its location is unknown. See Monroe H. Fabian, *Joseph Wright: American Artist, 1756–1793* (Washington, D.C.: Smithsonian Institution Press, 1985), 92–113, for a full discussion of Wright's Washington portraits.

13. Elkanah Watson, *Men and Times of the Revolution* (New York: Dana and Co., 1856), 119. See also Fabian, *Joseph Wright,* 44–45, 50–51 (n. 20), 95–99, 126–27.

14. Of the three bas-reliefs, the plaster and one wax are owned by the Mount Vernon Ladies' Association; the other wax is in the collection of the Henry Francis du Pont Winterthur Museum, Winterthur, Del.

15. William Dunlap, *The History of the Rise and Progress of the Arts of Design in the United States* (New York: George P. Scott, 1834), 1:154. Dunlap's portrait is in the collection of the U.S. Capitol, Washington, D.C.

16. The college honored Washington for his willingness to relinquish military command at the cessation of hostilities. The portrait replaced one of King George II "which was torn away by a ball from the American artillery in the battle of Princeton." Sellers, *Portraits and Miniatures,* 235; and Donald Drew Egbert, *Princeton Portraits* (Princeton, N.J.: Princeton University Press, 1947), 322. The painting still hangs in Nassau Hall.

17. Sellers, *Portraits and Miniatures,* 235.

18. Tilghman was painted from life; the likeness of Lafayette was based on the portrait by Peale for his museum (Independence National Historical Park, Philadelphia), reinforced with a life sitting. The painting hangs in the Maryland State House, Annapolis.

19. Ronald E. Heaton, *The Image of Washington: The History of the Houdon Statue* (Norristown, Pa.: Privately published, 1971), 5–6.

20. These included Mrs. Washington's four grandchildren (Elizabeth Parke Custis, Martha Parke Custis, Eleanor Parke Custis, and George Washington Parke Custis) and her niece Frances Bassett, who later in the year married Washington's nephew Major George Augustine Washington. The portraits of Elizabeth Parke Custis and George Washington Parke Custis are owned by Washington and Lee University, Lexington, Va.; those of Frances Bassett, Martha Parke Custis, and Eleanor Parke Custis belong to the Mount Vernon Ladies' Association.

21. Three Pine portraits of Washington are known. The one that appears to be the life portrait is in the collection of the National Portrait Gallery, Washington, D.C. For an account of Pine's portraits of the Washington family, see Robert G. Stewart, *Robert Edge Pine: A British Portrait Painter in America, 1784–1788* (Washington, D.C.: Smithsonian Institution Press, 1979), 16, 19, 42–43, 50–55, 92–97, 107.

22. Peale to Washington, May 29, 1787. Letterbook copy, Charles Willson Peale Papers, American Philosophical Society,

Philadelphia. Quoted in Abbot and Twohig, eds., *The Papers of George Washington*, Confederation Series, 1997, 5:202.

23. Ibid., 238; Jackson, ed., *The Diaries of George Washington* (Charlottesville: University Press of Virginia, 1979), 5:173. The original diary is in the Library of Congress, Washington, D.C.

24. The portrait is in the collection of the Museum of American Art, Pennsylvania Academy of the Fine Arts, Philadelphia.

25. For an account of Polk's portraits of Washington, see Linda Crocker Simmons, *Charles Peale Polk, 1776–1822: A Limner and His Likenesses*, exh. cat. (Washington, D.C.: Corcoran Gallery of Art, 1981), 26–37. Examples of Peale's mezzotint engraving are owned by the Mount Vernon Ladies' Association; the National Portrait Gallery, Washington, D.C.; the Yale University Art Gallery, New Haven, Conn.; the Museum of American Art, Pennsylvania Academy of the Fine Arts, Philadelphia; the Henry Francis du Pont Winterthur Museum, Winterthur, Del.; the Metropolitan Museum of Art, New York; and Independence National Historical Park, Philadelphia, among other institutions. A unique example in color is in the collection of the New York Public Library.

26. Jackson, ed., *Diaries of George Washington*, 5:451. The original diary is at the Detroit Public Library. The de Brehan miniature is in the collection of the Yale University Art Gallery, New Haven, Conn. A replica, which Washington presented to Mrs. William Bingham in 1791, is owned by the Mount Vernon Ladies' Association. See *Annual Report* (Mount Vernon, Va.: Mount Vernon Ladies' Association, 1968), 20–25, 33. Ramage's miniature is in a private collection. Ramage painted a second, different miniature (Metropolitan Museum of Art, New York), presumably around this time, in which Washington is shown full-face. Although well painted, it is not as good a likeness as that painted for Mrs. Washington. Washington recorded sitting only for the miniature for Martha, so it may be that this second miniature was painted from memory, a circumstance that would help explain the lack of resemblance.

27. Willard to Washington, November 7, 1789. Recipient's copy, Washington Papers, Library of Congress, Washington, D.C. Quoted in Abbot and Twohig, eds., *The Papers of George Washington*, Presidential Series (Charlottesville: University Press of Virginia, 1993), 4:280. During this period a Danish-born artist from Boston, Christian Gullager, also painted a portrait of Washington. See Marvin Sadik, *Christian Gullager: Portrait Painter to Federal America* (Washington, D.C.: Smithsonian Institution Press, 1976), 35–44, 74–76. Gullager's portrait belongs to the Massachusetts Historical Society, Boston.

28. For a thorough discussion of Savage's Washington portraits, see Ellen G. Miles, *American Paintings of the Eighteenth Century* (Washington, D.C.: National Gallery of Art, 1995), 146–60.

29. Between 1822 and 1824, Trumbull also painted *The Resignation of General Washington, December 23, 1783* (U.S. Capitol, Washington, D.C.), and the likeness in that painting appears to be based on Trumbull's 1790 full-length. All of his American Revolution scenes are in the collection of the Yale University Art Gallery, New Haven, Conn.

30. Jackson, ed. *The Diaries of George Washington* (Charlottesville: University Press of Virginia, 1979), 6:86–87, 94.

31. John Trumbull to Elizabeth Parke Custis Law, May 1, 1829. The Winterthur Museum, Winterthur, Del., owns both the portrait and Trumbull's letter.

32. Quoted in Theodore Sizer, ed., *The Autobiography of Col. John Trumbull* (New Haven, Conn.: Yale University Press, 1953), 169–71.

33. Helen A. Cooper, *John Trumbull: The Hand and Spirit of a Painter* (New Haven, Conn.: Yale University Press, 1982), 120–21. The portrait is owned by the Yale University Art Gallery, New Haven, Conn.

34. Washington sat for Trumbull once more, in 1793, for a bust-length portrait (Yale University Art Gallery).

35. For a complete discussion of Ceracchi's busts, see Ulysse Desportes, "Giuseppe Ceracchi in America and His Busts of George Washington," *Art Quarterly* 26, no. 2 (summer 1963): 140–79. See also the essay by H. Nichols B. Clark in the present volume.

36. Archibald Robertson's miniature belongs to Colonial Williamsburg, Williamsburg, Va. He also painted a miniature of Martha Washington, which is in the same collection. Three virtually identical miniatures by Walter Robertson exist. Two are owned by the Mount Vernon Ladies' Association and one by the Tudor Place Foundation, Washington, D.C.

37. Williams's portrait remains in the collection of the Alexandria-Washington Lodge No. 22, Alexandria, Va. See the essay by William Moore in this volume.

38. Quoted in John Caldwell and Oswaldo Rodriguez, *American Paintings in the Metropolitan Museum of Art* (Princeton, N.J.: Princeton University Press, 1994), 1:152–53. A replica of 1795, in the collection of the Metropolitan Museum of Art, New York, has been reproduced more often than the life portrait in the Philadelphia Museum of Art.

39. Miles, *American Paintings of the Eighteenth Century*, 201–6. See also Dorinda Evans, "Gilbert Stuart: Two Recent Discoveries," *American Art Journal* 16, no. 3 (summer 1984), 85–88, for an argument that the life portrait lies beneath the surface paint of the "Vaughan" portrait.

40. The "Athenaeum" portrait is known by that name because for many years it belonged to the Boston Athenaeum. It and a companion portrait of Martha are now owned jointly by the Museum of Fine Arts, Boston, and the National Portrait Gallery, Washington, D.C. The "Lansdowne" portrait is so called because one version originally belonged to the Marquess of Lansdowne (private collection, on loan to the National Portrait Gallery).

41. Quoted in Carol Eaton Hevner, *Rembrandt Peale, 1778–1860: A Life in the Arts*, exh. cat. (Philadelphia: Historical Society of Pennsylvania, 1985), 32.

42. Quoted in Sellers, *Portraits and Miniatures*, 239.

43. James Peale and Raphaelle Peale are said to have made portraits of Washington during these sittings, but if so, those works have not been located.

44. The right profile is owned by the Mount Vernon Ladies' Association, as is the companion portrait of Martha in left profile. The three-quarter view is owned by the Bristol Museum and Art Gallery, Bristol, England. Which of the left profiles is from life is uncertain, but it is probably either the one in the National Portrait Gallery, Washington, D.C., originally owned by Martha Washington's granddaughter Elizabeth Parke Custis Law, or that in the Bristol Museum and Art Gallery, originally owned by Sharples himself. For Sharples's portraits of Washington, see Katharine McCook Knox, *The Sharples* (New Haven, Conn.: Yale University Press, 1930), 13–15, 67–93. A drawing by Charles-Balthazar-Julien-Févret de Saint-Mémin (location unknown) has traditionally been dated to 1798 and is said to be the last portrait for which Washington sat. But Ellen Miles makes a convincing argument for its being a posthumous portrait, executed in 1800. See Ellen G. Miles, *Saint-Mémin and the Neoclassical Profile Portrait in America* (Washington, D.C.: Smithsonian Institution Press, 1994), 101–5, 422–24.

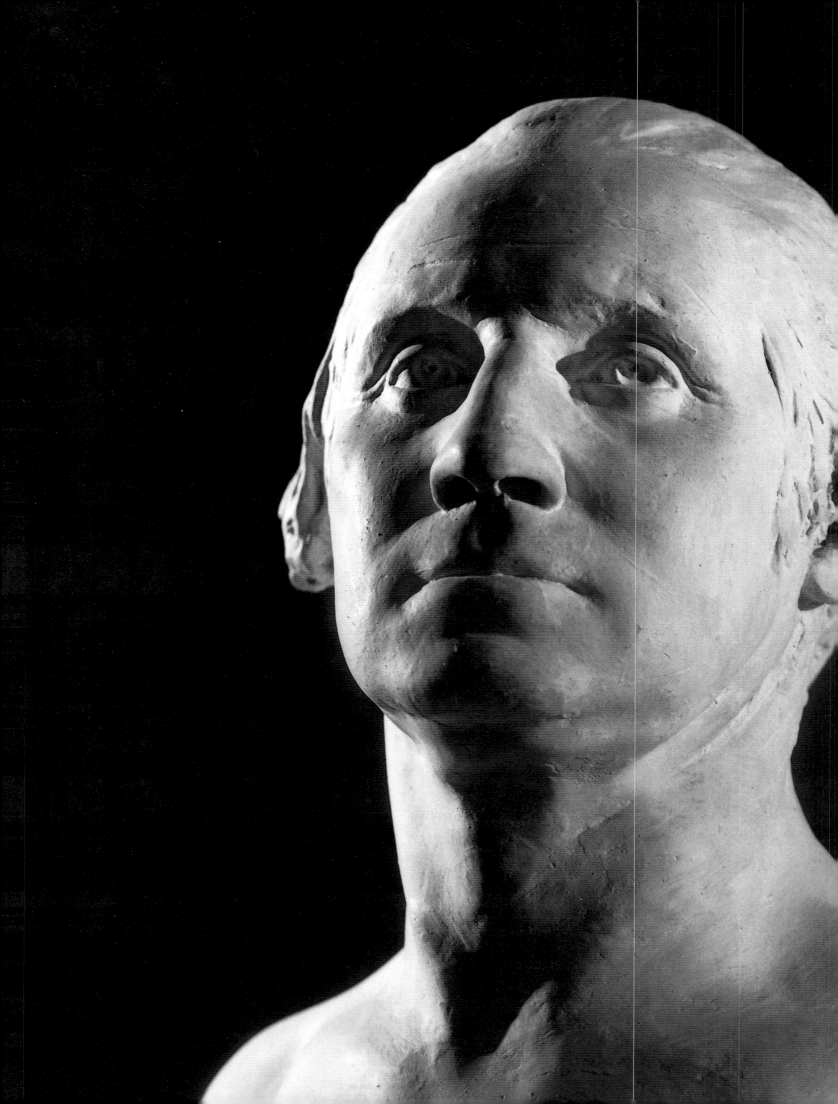

H. NICHOLS B. CLARK

AN ICON PRESERVED: CONTINUITY IN THE SCULPTURAL IMAGES OF WASHINGTON

Although sculpture is normally less physically accessible than other forms of artistic expression, statues and busts of George Washington have been created in formidable numbers during the past two hundred years. The Smithsonian Institution's Inventory of American Sculpture, for example, names more than 290 examples, and that list is by no means exhaustive. Most of these works date from the nineteenth century. During that period the range of imagery conformed, in part, to a recently delineated cycle in which Washington was first represented as a revered exemplar, then, by mid-century, as an ordinary mortal, and finally, after the nation's centennial, as a figure once again esteemed as our model citizen and patriot.[1] This same range of characterizations continued well into the twentieth century.

Even amid these cyclical swings, there was a discernible consistency in the way sculptors imagined Washington. This was mainly due to the profound impact that the statue and preparatory busts by the French sculptor Jean-Antoine Houdon had on virtually every American sculptor who made an image of America's *pater patriae* (figures 9 and 10).[2] Created in the late eighteenth century, Houdon's likeness served as a benchmark well into the twentieth century. Given the plethora of examples stretching across two hundred years, this essay will, of necessity, be selective. Nonetheless, it will attempt to articulate the significant range of sculptural interpretation that was manifest, despite the almost universal dependence on Houdon's potent and accurate portrayals.

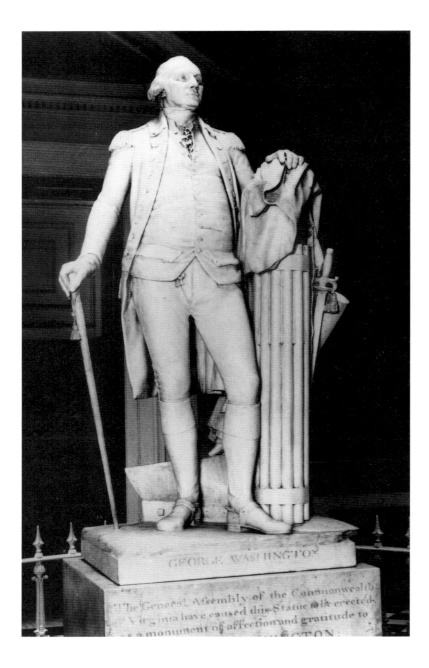

FIGURE 9

Jean-Antoine Houdon
(French, 1741–1828)

George Washington, 1786–96

*Marble, h: 74 in. State Capitol,
Richmond, Virginia.*

In late-eighteenth-century America, as George Washington's stature assumed iconic dimensions, he became a highly sought-after subject for the artist's brush and the engraver's burin.[3] By contrast, demand for sculptural representations of him in this country was modest, confined primarily at first to architectural decoration, gravestones, ships' figureheads, and trade signs. Ironically, the impetus for three-dimensional depictions came from abroad, particularly from England. During the Revolutionary War, shrewd entrepreneurs such as Josiah Wedgwood recognized the potential for marketing Washington images, especially in Europe. As early as 1777, Wedgwood created a portrait medallion, which bore little resemblance to the subject.[4] His firm also produced a basalt intaglio around 1790 and, somewhat later, a basalt bust based on Houdon's 1785 likeness.[5]

Modeling in wax was another form of portraiture that prospered in the eighteenth century. Patience Lovell Wright raised this malleable medium to a new standard, first in America and then in England, from the early 1770s until her death in 1786. She insisted on modeling from life, with one notable exception: General Washington. She based her profile image of him on a copy of the idealizing bust that her son Joseph had fashioned in the fall of 1783. Despite the secondhand source, Mrs. Wright attempted

to record Washington, attired in his military uniform, with utmost fidelity. Indeed, the resulting work is unsettlingly convincing.[6]

Joseph Wright was the first of only three sculptors—Houdon and Giuseppe Ceracchi were the other two—to model Washington from life. As suggested, Joseph sought an elevated interpretation in his several sculptures. In a surviving plaster bas-relief portrait from about 1784, the sitter's head is crowned with a laurel wreath, associating him with the virtues and political leadership of Republican Rome.[7] Although Wright's modeling of Washington provided no paradigm for subsequent sculptors, the idea of portraying him as a Roman statesman was consistent with the prevailing Neoclassical ideals of the day.

Sculpture as an artistic profession in America emerged from the folk tradition of carving ships' figureheads. The Philadelphian William Rush is recognized as the first artist to have made this transition successfully. His ambitious full-length painted-pine statue of Washington, created in 1815, reflects the same concern for conveying the subject's integrity and nobility that is evident in Houdon's statue for the Virginia State Capitol in Richmond. But Rush's commingling of contemporary everyday dress and, in his words, "flowing Grecian mantle" provides the viewer with a broader range of interpretive choices. There has been considerable speculation as to the extent of Rush's debt to Houdon. Indeed, the Frenchman's statue enjoyed such wide publicity and acclaim, almost from the moment it was unveiled in 1796, that it was hard for any aspiring sculptor of Washington to ignore.[8]

FIGURE 10

Jean-Antoine Houdon
(French, 1741–1828)

George Washington, 1785

Terracotta, h: 22 in. Courtesy of the Mount Vernon Ladies' Association.

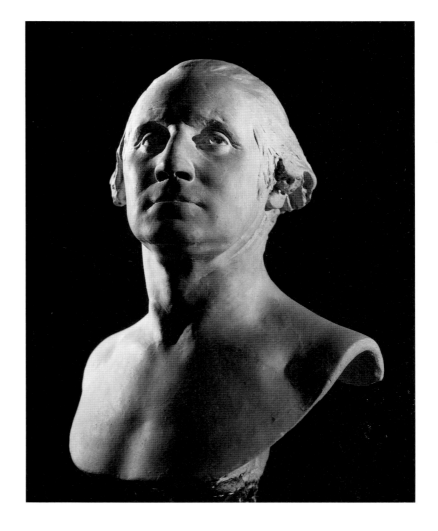

Given the absence of accomplished native sculptors in the early nineteenth century, the few monumental works ordered in America were entrusted to foreigners. Besides Houdon, these included the Italian Antonio Canova, chosen in 1816 to provide a Washington statue for the North Carolina State Capitol in Raleigh (discussed below), and the Englishman Sir Francis Chantrey, who in 1826 provided the statue that adorns a reception room in the Massachusetts State House in Boston. Many other foreigners made the pilgrimage to America in the late 1700s and early 1800s, especially after learning that the young nation's government had authorized an equestrian statue of Washington. At the outset, Houdon and the Italian Giuseppe Ceracchi were the principal rivals for this commission. But neither of them would fulfill this aspiration, as the project was repeatedly delayed and would not be realized until the mid–nineteenth century.[9]

Houdon's initial renderings derived from his 1785 visit to Mount Vernon to take his subject's likeness from life for the Virginia commission (figure 10). To augment the modest income generated from this complex undertaking, the sculptor made numerous busts of Washington and targeted them toward a wider market. With the broad dissemination of these works, it was easy for artists to gain access to an example for their own commercial endeavors. The busts circulated before the Virginia statue was completed, and the facial features in this interpretation had as powerful an influence, initially, as the statue was later to have. Busts in the spirit of Houdon's original flooded the market and were even sold door-to-door, as depicted in Francis Edmonds's *Image Pedlar*, painted in 1844. Exhibition records, too, indicate that a sizable number of busts "after Houdon" were on view in America throughout the nineteenth century.[10]

In planning the full-length statue, Houdon acceded to his clients' demands that Washington wear a military uniform rather than a classicizing toga. But in the various busts, over which he exercised complete control, the artist evoked the classical past by depicting the figure as either toga-clad or undraped.[11] He faithfully captured the facial structure and receding flesh, especially the double chin and creases where the chin and neck meet below the left ear. The swept-back coiffure also conveys an impression of immediacy.

While Houdon's images carried the most pervasive influence, the contribution of Giuseppe Ceracchi also had an impact. In late 1791 or early 1792, he succeeded in getting Washington to sit for him and fashioned a bust that provided the basis for variant versions he executed back in Italy. In 1795 he returned to Philadelphia with a marble bust and prevailed upon Washington to permit him to make some final adjustments from life. Ceracchi, conditioned to European preference, depicted the noble patriot as a Roman emperor. In addition to this idealizing approach, the sculptor also opted for a hairstyle of close-cropped locks with thick curls, in the spirit of the antique, which further ennobled the sitter (figure 11).

In 1816, when the North Carolina legislature determined that it wanted a monument of Washington for the state capitol, Thomas Jefferson's recommendation of Antonio Canova carried the day. Significantly, however, the former president also recommended that Canova use Ceracchi's idealized likeness as a model in preference to the more accurate Houdon.[12] Because of the low ceiling in the appointed chamber, Canova depicted Washington as a seated Caesar, writing on a tablet, and wearing antique garb—including sandals. Initially, the result elicited a decidedly mixed reaction, as both features and costume were, by the 1810s, too foreign and remote for many people's taste. Yet over time the statue became popular, and there was a profound sense of loss when it was destroyed in a fire in 1831.

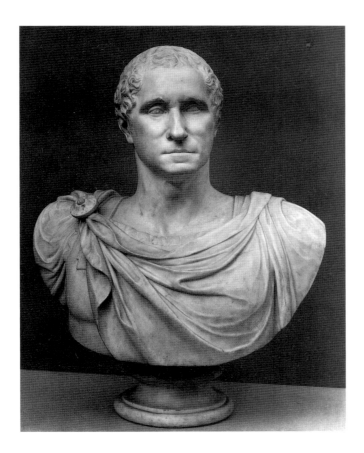

FIGURE 11

Giuseppe Ceracchi (Italian, 1751–1802)

George Washington, 1795

Marble, h: 28⅞ in. The Metropolitan Museum of Art, New York. Bequest of John L. Cadwalader, 1914.

By the second quarter of the nineteenth century, an increasing number of young American artists were deciding to pursue sculpture as a profession. Among them, Horatio Greenough was the first to go abroad—to Italy—to seek training. He also enjoyed the distinction of being the first native-born sculptor to be awarded a federal commission: Through persistent efforts on his behalf by the writer James Fenimore Cooper and the painter Washington Allston, Greenough received authorization in 1832 (the centenary of Washington's birth) to create a monument for the rotunda of the United States Capitol (figure 12). Congress specified that he take Houdon's bust likeness as his model. Yet while the head of the finished colossal marble work shares the qualities of nobility and confidence seen in that prototype, there is an Italianate flavor about it that suggests Greenough also may have consulted Ceracchi's bust.[13] In addition, there was some change from the original physiognomy to accommodate a more grandiose format. The features are broader and more generalized than in the Houdon bust, in deference to the enlarged scale; consequently, they convey a greater sense of remove.

But it was not Washington's abstracted features that instigated the intensely hostile reaction that greeted the work. Greenough, in his quest to create an imposing image worthy of the Capitol, decided to transcend Canova's conception of Washington as Caesar and cast him as the chief deity in the Greek pantheon: He based his model on Phidias's statue of Zeus at Olympia, a work known only through reconstruction from literary descriptions and antique coins. The American public reacted acerbically to the bare-chested, classically draped figure, in its exceedingly contrived pose. Greenough's unsettling mixture of idealism and naturalism failed miserably, and the statue suffered the ignominy of removal from the rotunda; it eventually found repose at the Smithsonian Institution. This episode sent a strong message to the growing cadre of sculptors aspiring to undertake interpretations of Washington: The "real" eighteenth-century man was preferable to an idealized figure redolent of a remote classical past.[14] By the time the statue was unveiled, Americans' taste for the classical was gone. But

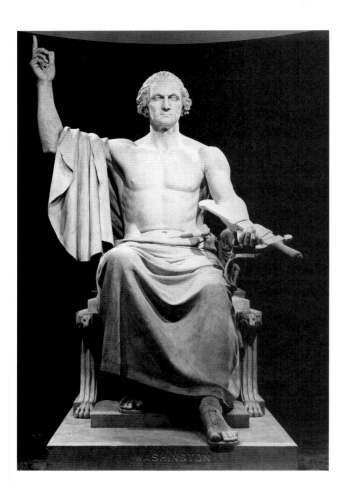

FIGURE 12

Horatio Greenough
(American, 1805–1852)

George Washington, 1832–41

*Marble, h: 126 in. National Museum
of American History, Smithsonian
Institution, Washington, D.C. Transfer
from the U.S. Capitol.*

Greenough, like Canova before him, also missed something essential that Houdon and others had captured, the ideal of the restrained and virtuous Roman citizen-leader who handled power temperately and knew when to relinquish it. Greenough had gone even further from the mark by evoking Washington as a god, and a stormy one at that.

Yet at mid-century, as interpretations of Washington in various media were becoming decidedly less heroic, the young American sculptor Thomas Crawford embarked on a project that was to reassert Washington's heroism vigorously—a monumental equestrian statue for Capitol Square in Richmond.[15] His model for both the monument, which was unveiled in 1858—the year after he died—and for an idealized bust, sculpted in 1848 (color plate 13), was Houdon.

Crawford was meticulously true to his French source. He recreated the pose of the head, slightly turned to the left, emulated the mature physiognomy, and captured the swept-back coiffure of the Houdon works. To reinforce the sense of immediacy, Crawford also chiseled the pupils of the eyes. All these elements, as well as the boldly rendered folds of the togalike garment, relate closely to the Frenchman's paradigm and amplify a characteristically American concern for balancing the ideal with the factual.

Crawford likewise borrowed from Houdon's marketing strategy, producing a series of replicas of the 1848 bust; a contemporaneous account by the noted art critic and cultural observer Henry Tuckerman indicates that there was a steady stream of orders.[16] And a newspaper article published soon after the sculptor died listed the bust as among the more popular of his works available, noting that a patron could

secure it in a plaster cast or in marble, "with the advantage of Crawford's own well-trained workmen and original models."[17]

While adhering to the Houdon prototype, Crawford also relished the challenge of putting his own mark on such a legendary image. In this he was successful; Tuckerman, for one, commented that Crawford brought to his bust interpretation a zeal and insight that resulted in an "expressive, original and finished character."[18] The artist furthered the effort to assert his own vision in the statue, creating an energetic image of Washington astride a lunging horse. Given the public nature of this monument, Crawford wanted to underscore his subject's military leadership and bravery by creating a dynamic piece. This effect is reinforced by the general's emphatic gesture; he points as though leading a charge.

Crawford's research for the statue was thorough. In his pioneering book *The Character and Portraits of Washington* (1859), Tuckerman noted that the sculptor had particularly admired Joseph Wright's 1783 oil portrait for its accurate military costume (figure 1, p. 27). Crawford recognized the prudence of this contemporary approach, given the criticisms that had been leveled at Canova and Greenough for their interpretations *à l'antique*.

Though the tradition of equestrian monuments in Europe was centuries old, it took some time before such works began being produced in America.[19] Crawford's was but the second statue of Washington on horseback to be officially dedicated. The first, created by Henry Kirke Brown for Union Square in New York City, was dedicated in 1856 (figure 13). The genesis of this work was not without complexity, however, since

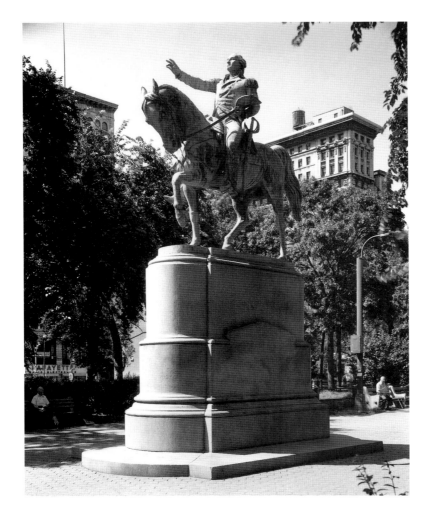

FIGURE 13
Henry Kirke Brown
(American, 1814–1886)
George Washington, 1853–58
Bronze, h: 162 in. Union Square, New York.

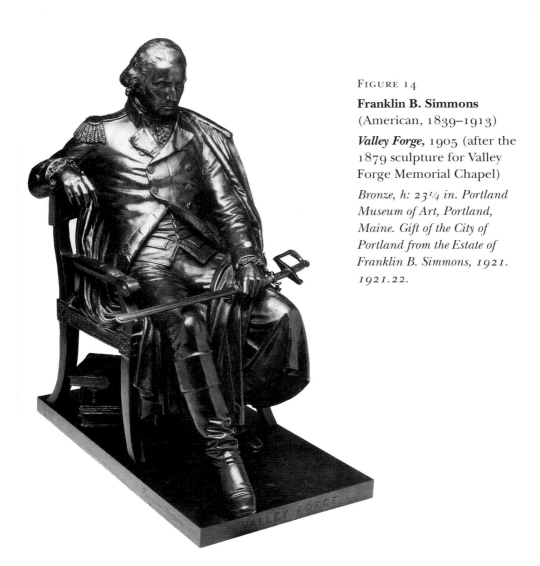

the committee in charge of the commission had approached both Brown and Horatio Greenough in 1851 regarding the proposed project. The issue resolved itself, however, when Greenough quarreled with the committee and the contract went to Brown.

Although Brown favored a direct naturalism to the classical mannerisms he observed during a several-year sojourn in Florence and Rome, he infused his statue with an aura of equilibrium and timelessness that recalls the equestrian statue of Marcus Aurelius on Capitoline Hill (the Campidoglio) in Rome, with which he was certainly acquainted. In all other aspects, however, Brown placed the utmost emphasis on accuracy. He availed himself of the version of Houdon's bust owned by the New York collector Hamilton Fish, and he studied Washington's garments, then housed in the United States Capitol. Like Crawford and others entrusted with a highly visible commission, Brown wanted to achieve the appropriate level of dignity.

Unquestionably dignified but nonetheless reflective of the prevailing taste for a less exalted Washington that continued after mid-century is Franklin Simmons's statue of a seated Washington, commissioned for the memorial chapel at Valley Forge in 1879. The winter of 1777–78, during which Washington and the Continental Army were encamped outside Philadelphia, had become legendarily memorable for its hardship and for the commander's determination. Simmons caught his subject almost slumped in his chair but still unwilling to capitulate (figure 14). This Washington is blatantly unheroic, yet he reveals a quiet, understated strength as he stoically endures the weight of his army's suffering.

The centennial of Washington's death in 1899 inspired various commemorative efforts. Among the initiatives undertaken as this milestone approached was the formation of a committee to recognize France's long-standing friendship with the United States. This resulted in a request to Daniel Chester French, who was later to sculpt the monumental seated marble figure for the Lincoln Memorial, to produce an equestrian statue of Washington as a gift to the nation of Lafayette. For this project, French worked with the sculptor Edward C. Potter, a specialist in animals; they had recently collaborated on an equestrian statue of Ulysses S. Grant for the City of Philadelphia. The two artists traveled to Paris to study the proposed site for the statue, on the Place d'Iéna near the Trocadero, and to assess comparable works. The result, which depicted the moment Washington took command of the Continental Army on July 3, 1775, was an apotheosis, with the subject seated erect, gazing skyward, and holding his sword aloft (figure 15). In this statue, he appears as a superhuman hero. French no doubt based his interpretation on a desire to have the work harmonize with the other heroic images already in that setting. As one author later noted, the sculptor portrayed Washington as "a true knight without the Medieval trappings."[20] In spite of the romantic connection, French was methodical in pursuing accurate sources for his rendering. He studied Houdon's bust, John Quincy Adams Ward's 1889 statue above the steps of Federal Hall National Memorial (formerly the Subtreasury Building) in New York City (discussed below), and appropriate Revolutionary War uniforms. French was

FIGURE 15

Daniel Chester French
(American, 1850–1931)

George Washington, ca. 1897
(1919 cast)

Bronze, h: 31 in. Chesterwood, Stockbridge, Massachusetts.

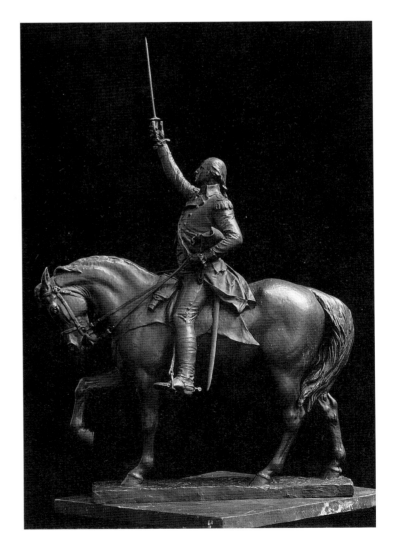

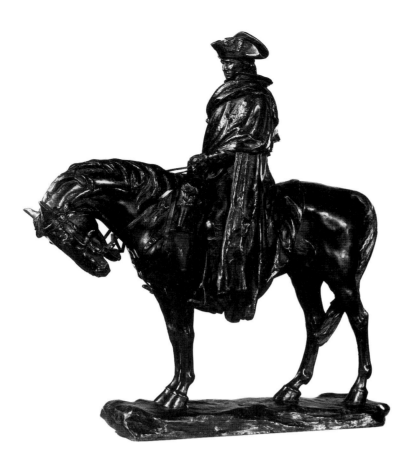

FIGURE 16

Henry Merwin Shrady
(American, 1871–1922)
George Washington, 1905–6
*Bronze, h: 25¾ in. The
Metropolitan Museum of Art,
New York. Purchase 1974,
Rogers Curatorial Fund and
Charles and Anita Blatt Funds.*

acutely aware of the magnitude of his task, since this was the first outdoor monument dedicated to an American to be placed on a European thoroughfare. In his mind, a glorification of Washington was the most appropriate manner of presentation for a foreign audience.

The specifics of a given sculptural commission always did much to shape the resulting image. While French's assignment naturally led to an elevated depiction, any portrayal of Washington at Valley Forge would necessitate a subdued approach. Like Franklin Simmons, Henry Merwin Shrady captured the hardship of that bleak winter in his design for the monument on the Brooklyn side of the Williamsburg Bridge in New York, erected in 1906 (figure 16).[21] The horse's bowed head and locked forelegs suggest a defiance of the elements, while Washington, heavily bundled against the cold, sits with left hand resting the reins on the horse's neck, right arm hanging at his side. His feet, firmly planted in the stirrups, and his penetrating gaze offset the seeming resignation conveyed by the rest of the pose. Thus Shrady, in the first decade of the new century, focused on the indomitable spirit of one of America's greatest heroes.

With the advent of new modes of transportation in this century, the equestrian statue lost some of its cachet. At least one notable late example exists, however: the monument commissioned in the early 1950s for the National Cathedral in Washington, D.C., and unveiled in 1957. Herbert Haseltine, best known for his renderings of animals, created a suitably heraldic composition. The originator of the commission, James Sheldon, suggested that Haseltine use Man o' War, the preeminent racehorse of the 1910s, as the model for Washington's steed. The sculptor enthusiastically concurred, describing the project as "the greatest American on the greatest American horse."[22] The completed work thus mingled adulation for both a historic figure and a modern-day phenomenon.

The popularity of the equestrian statue in the mid-to-late nineteenth century did not eliminate the demand for single-figure memorials. Indeed, that demand contin-

ued unabated well into our century. Although Washington had to share the limelight with other American heroes, ranging from Andrew Jackson to Abraham Lincoln to Ulysses S. Grant, he still attracted significant attention. Some of these works were commercially driven. In 1875, amid the excitement stirred by the upcoming celebration of the nation's centennial, John Rogers, who was best known for his small narrative sculptural groups, designed a plaster statuette of Washington in his military uniform for the mass market. Rogers used Houdon's bust as a model.[23] Lacking the rich narrative for which "Rogers' groups" were known, this venture did not achieve the popularity of his more characteristic works. Ironically, Rogers seems to have believed that all he had to do was translate Washington into clay, and the general public would respond enthusiastically. Apparently, his audience demanded more substance than that.

At about the time Rogers was testing the commercial waters for Washington statuettes, John Quincy Adams Ward was commencing the first of his two monuments to the leader. In the 1850s Ward had gained substantial exposure to the subject as an assistant to Henry Kirke Brown on the Union Square equestrian statue. In 1877 Ward received his own commission, to depict Washington addressing his troops, for the town of Newburyport, Massachusetts.[24] The sculptor created a stance in which the general rests his left hand on the hilt of his sword and makes an open, understated gesture with his right. As a result, the subject appears relaxed and informal, perhaps enjoying a moment off duty, and comes across as eminently approachable.

Ward's second commission was engendered by the centennial of an event of great magnitude: Washington's swearing-in as the first president of the United States in April 1789. The terms of the commission stipulated, in part:

> Said statue shall be in all respects a complete embodiment of the exalted character of Washington, together with the great event the statue commemorates, and that no expense be spared to make it in all respects worthy of the cause.[25]

The selection committee also directed that the monument be situated at the corner of Wall and Nassau Streets, where the oath had been administered. Washington's pose recalls Houdon's prototype in Richmond, and the gesture of his outstretched right hand, as it raises from the Bible, suggests the specificity of the moment (figure 17). The subject's eighteenth-century costume is treated with vigorous naturalism, its verisimilitude enhanced by the liberally depicted folds and wrinkles. Ward used Houdon's 1785 bust and Gilbert Stuart's "Athenaeum" portrait (figure 5, p. 33) to capture Washington's facial expression, and an animation informs the figure even on this solemn occasion.

The hectic advance of modernism in the twentieth century brought upheaval to the discipline of sculpture, as it did to other forms of artistic expression. But there, as in other media, certain conservative traditions continued. Public monuments remained figurative well into the century, and representational images of Washington were still earmarked for events of consequence.

James Earle Fraser, sculptor of the buffalo nickel, created a sixty-five-foot-tall plaster statue of Washington to anchor the central intersection of Constitution Mall at the 1939 New York World's Fair. In a formal sense, this gigantic effigy paid homage to Houdon's work, while also serving to celebrate America's past as dramatically as the fair's pavilions and displays spoke to the future.[26] Twenty-five years later, at the 1964 World's Fair, held on the same site in Flushing Meadows, Washington was again a presence—although not as prominent a one. Donald De Lue, whose forward-looking *Rocket Thrower* (1962) occupied the same place of honor as Fraser's Washington,

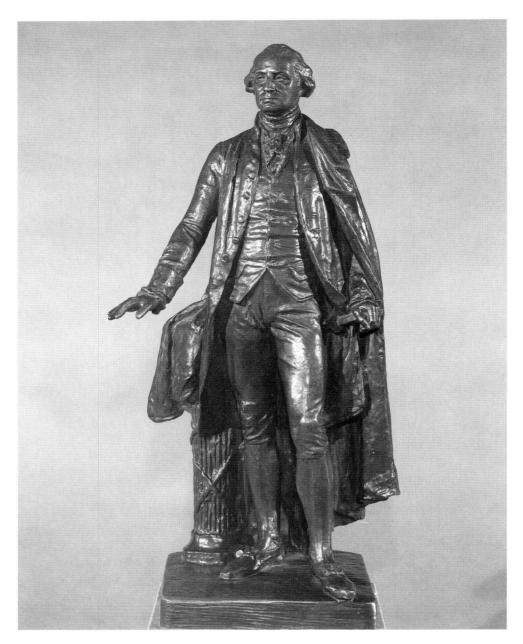

FIGURE 17

John Quincy Adams Ward
(American, 1830–1910)

Statuette of George Washington, 1889
(smaller version of the 1889 statue
at Federal Hall National Memorial,
New York)

Bronze, h: 24 in. The Metropolitan
Museum of Art, New York. Rogers Fund,
1972.

exhibited a patinated-plaster version of his *George Washington as Master Mason* in the Masonic Pavilion (color plate 25).[27]

De Lue was not the first sculptor to respond to Masonic overtures. Hiram Powers began work on a statue in 1854 at the request of the Fredericksburg, Virginia, Masonic Lodge No. 4, but it was destroyed in a fire.[28] Twenty years later, Edward V. Valentine fashioned a bust, based on Houdon's, for Statuary Hall in the United States Capitol, which shows Washington wearing his Masonic medal. In 1959 De Lue was approached by the Grand Lodge of New Orleans to create a statue for the front of the public library in the New Orleans Civic Center; this work was replicated several times.[29] Once more, the formal debt to Houdon is manifest, although the neoclassical column of bound fasces in that work has been replaced by a Gothic-inspired pedestal, perhaps alluding to the mystery of the order. Washington wears sash and medal as well as a fringed apron, which is appliquéd with Masonic symbols.

De Lue's work is compelling. The pupils of the eyes are defined, and the veins in the oversized hands bulge. Especially noticeable are the powerful thighs and legs, which evoke the sculptor's admiration of Michelangelo's energetic exaggeration. Washington

holds a mallet in his right hand, perhaps to call a meeting to order and espouse the Masonic principles, rooted in the "immutable laws of truth and justice." Thus, almost two hundred years after Houdon, sculptors still subscribed to the balance of human dignity and inspirationally powerful presence transmitted by that artist's pioneering effort.

In terms of scale, of course, all the works treated here pale in comparison to that produced by Gutzon Borglum. After commencing his grandiose project to honor Robert E. Lee on Stone Mountain in Georgia, Borglum turned his attention to an equally megalithic undertaking: carving the heads of Washington, Jefferson, Lincoln, and Theodore Roosevelt on Mount Rushmore in South Dakota. By 1927, having cleared political obstacles and the first of numerous financial hurdles, the sculptor was ready to tackle the project in earnest. He labored on it until his death in March 1941; his son Lincoln completed some of the details but left the work, unfinished, late that year.

Borglum equated his four choices with the founding, growth, preservation, and expansion of the nation.[30] Washington is the dominant figure, occupying the lead position in terms of both placement and execution. Borglum relied on traditional sources for his likeness—portraits by Gilbert Stuart, Rembrandt Peale, and, again, Houdon—but he had to apply them on a scale virtually unsurpassed in the history of sculpture. Given that dynamite and jackhammers were employed to fashion the portrait, the towering image is made up of broad, planar surfaces. Nevertheless, the beholder gets a sense of the specifics of Washington's eighteenth-century costume and hairstyle. These aspects would have been fuller had the sculptural group been completed, as a maquette on view at the Mount Rushmore visitors' center makes clear. The pupils of the eyes are chiseled, animating an expression that conveys the intensity and sense of purpose universally associated with Washington.

In the decade preceding the United States Bicentennial in 1976, the nation's sense of itself—its confidence in its values and institutions—underwent a series of seismic shocks, brought on chiefly by political assassinations, the unrest of African Americans and of the country's youth, the Vietnam War, and Watergate. In the realm of culture, pop art seized the mundane and glorified it. Andy Warhol created a new pantheon, populated by figures such as Elvis Presley and Marilyn Monroe. In academe, revisionists arose to challenge traditional interpretations of the nation's past and contest the conventional Eurocentric point of view; a more inclusive, warts-and-all historical portrait of America was evolving. In this context, many icons were subjected to iconoclastic readings; and Washington, despite his extraordinarily long period of adulation, was hardly immune. Robert Arneson epitomized this approach in his series of witty yet trenchant caricatures of the first president. By casting Washington as an oenophile in the glazed-ceramic portrait head *Can You Suggest a '76 Pinot Noir*— sculpted during the Bicentennial year—the artist probed a patrician, and to some extent superficial, dimension of his subject in a bold and humorous way (color plate 27).[31] Arneson's irreverent likeness joined a growing body of revisionist imagery by artists such as Peter Saul (figure 75, p. 147), Robert Colescott (figure 76, p. 147), and Tom Wesselmann (color plate 29).

During the twentieth century, as American society has grown ever more pluralistic, the notion of a unified cultural identity has become increasingly elusive. Today, it is difficult to envision even George Washington as an overarching heroic presence. Nonetheless, his image is anchored by small-scale and monumental sculptures alike, produced over the course of two centuries, that carry the time-honored messages of strength, benevolence, and veneration.

Notes

1. See Barbara J. Mitnick, *The Changing Image of George Washington,* exh. cat. (New York: Fraunces Tavern Museum, 1989).

2. Elizabeth Bryant Johnston, *Original Portraits of Washington, Including Statues, Monuments, and Medals* (Boston: James R. Osgood, 1882), 164ff.

3. For a study of the eighteenth-century portraits, see the essay by David Meschutt in this volume. For a discussion of the graphics aspect of this phenomenon, see Wendy C. Wick, *George Washington, An American Icon: The Eighteenth-Century Graphic Portraits,* exh. cat. (Washington, D.C.: Smithsonian Institution Traveling Exhibition Service and the National Portrait Gallery, 1982).

4. Robin Reilly, *Josiah Wedgwood, 1730–1795* (London: Macmillan, 1992), 235–36. Wedgwood's image was based on a medal designed by the *philosophe* Voltaire, further underscoring the international acclaim Washington enjoyed.

5. An example of the Wedgwood basalt is in the British Museum, London. See Aileen Dawson, *Masterpieces of Wedgwood in the British Museum* (Bloomington: Indiana University Press in association with British Museum Publications, 1984), 36.

6. Patience Wright's profile image of Washington is in the collection of the Maryland Historical Society, Baltimore. See Charles Coleman Sellers, *Patience Wright: American Artist and Spy in George III's London* (Middletown, Conn.: Wesleyan University Press, 1976), 189–93.

7. Joseph Wright's bas-relief portrait of Washington is in the collection of the Henry Francis du Pont Winterthur Museum, Winterthur, Del.

8. Rush's words are from a broadside advertising the statue, quoted in William H. Gerdts and Mark Thistlethwaite, *Grand Illusions: History Painting in America,* exh. cat. (Fort Worth: Amon Carter Museum, 1988), 145. The statue is in the Independence National Historical Park Collection, Philadelphia. For a discussion of Rush's career, see Linda Bantel et al., *William Rush, American Sculptor,* exh. cat. (Philadelphia: Pennsylvania Academy of the Fine Arts, 1982).

9. For a discussion of the original Washington commission, see H. H. Arnason, *The Sculptures of Houdon* (New York: Oxford University Press, 1975), 72–77, and John S. Hallam, "Houdon's *Washington* in Richmond: Some New Observations," *American Art Journal* 10, no. 2 (November 1978): 72–80. See also Ulysse Desportes, "Giuseppe Ceracchi in America and His Busts of George Washington," *Art Quarterly* 26, no. 2 (summer 1963): 140–79.

10. See Robert F. Perkins, Jr., and William J. Gavin III, *The Boston Athenaeum Art Exhibition Index, 1827–1874* (Boston: Library of the Boston Athenaeum, 1980), 81, and James L. Yarnall and William H. Gerdts, *The National Museum of American Art's Index to American Art Exhibition Catalogues from the Beginning through the 1876 Centennial Year* (Boston: G. K. Hall, 1986), 3:1797 and *passim.* Edmonds's *Image Pedlar* is in the collection of the New-York Historical Society, New York.

11. Arnason, *Houdon,* 77. See also Gustavus A. Eisen, *Portraits of George Washington* (New York: Robert Hamilton and Associates, 1932), 3:787–88.

12. Wayne Craven, *Sculpture in America* (New York: Thomas Y. Crowell Company, 1968), 62–63.

13. Ibid., 108.

14. For information on the humanizing of Washington's image, see Mark Edward Thistlethwaite, *The Image of George Washington: Studies in Mid-Nineteenth-Century American History Painting* (New York and London: Garland Publishing, 1979).

15. For an extensive discussion of this commission, see Lauretta Dimmick, "'An Altar Erected to Heroic Virtue Itself': Thomas Crawford and His Virginia Washington Monument," *American Art Journal* 23, no. 2 (1991): 4–73.

16. Henry T. Tuckerman, *The Character and Portraits of Washington* (New York: G. P. Putnam, 1859), 41, 81.

17. "Italian Matters—American Artists," *Boston Evening Transcript,* June 23, 1858. Crawford's specific focus on this aspect of the work was such that a visitor to his studio in 1854 recounted that the head was being modeled in a chamber completely separate from the space where the bulk of the monument was being conceived. See Florentia, "A Walk through the Studios of Rome," *Art-Journal* (June 1, 1854): 184.

18. Henry T. Tuckerman, "Crawford and Sculpture," *Atlantic Monthly* 2, no. 8 (June 1858): 75.

19. For a concise history of the equestrian statue in America, see Craven, *Sculpture in America,* 168ff. Although Washington was the intended honoree of the earliest equestrian project planned in the United States, it was not he but the populist hero Andrew Jackson whose likeness, created by Clark Mills and unveiled in Washington, D.C., in 1853, was the first to be represented on horseback. This circumstance was due to the later (February 22, 1858) unveiling of Crawford's equestrian Washington, although he had received the commission for this work in 1849. The project was interrupted by Crawford's untimely death in 1857 but was finished by Randolph Rogers one year later, under the supervision of Crawford's widow.

20. Frances Davis Whittemore, *George Washington in Sculpture* (Boston: Marshall Jones Company, 1933), 139.

21. Lewis I. Sharp, *New York City Public Sculpture by Nineteenth-Century American Artists,* exh. cat. (New York: Metropolitan Museum of Art, 1974), 19.

22. "A New Equestrian Statue of George Washington, by Herbert Haseltine," *London Illustrated News,* July 20, 1957. See also Meredith E. Ward, *William Stanley Haseltine, 1835–1900/ Herbert Haseltine, 1877–1962* (New York: Hirschl and Adler Galleries, 1992), 26.

23. David H. Wallace, *John Rogers: The People's Sculptor* (Middletown, Conn.: Wesleyan University Press, 1967), 238.

24. Lewis I. Sharp, *John Quincy Adams Ward: Dean of American Sculpture* (Newark: University of Delaware Press; and London and Toronto: Associated University Presses, 1985), 59.

25. Ibid., 210.

26. Dean Krakel, *End of the Trail: The Odyssey of a Statue* (Norman: University of Oklahoma Press, 1973), 53–54.

27. D. Roger Howlett, *The Sculpture of Donald De Lue: Gods, Prophets, and Heroes* (Boston: David R. Godine, 1990), 125. Both of De Lue's works remain in situ as part of the fair's permanent legacy. For a study of George Washington and Masonic imagery, see the essay by William D. Moore with John D. Hamilton in this volume.

28. Richard P. Wunder, *Hiram Powers: Vermont Sculptor, 1805–1873* (Newark: University of Delaware Press; and London and Toronto: Associated University Presses, 1991), 2:206–7. Although originally delivered to the Fredericksburg lodge in 1861, Powers's work was moved to Richmond, where it was

destroyed on April 3, 1865, amid the Union Army's crushing assault on that city.

29. Howlett, *Donald De Lue*, 132.

30. Judith St. George, *The Mount Rushmore Story* (New York: G. P. Putnam's Sons, 1985), 37.

31. Neal Benezra, *Robert Arneson: A Retrospective,* exh. cat. (Des Moines, Iowa: Des Moines Art Center, 1985), 50. I am grateful to Sandra Shannonhouse and the Estate of Robert Arneson for their assistance in providing the reproduction and help in arranging the loan of this work.

THE
AMERI
CAN
CONSTI
TUTION

BARBARA J. MITNICK

PARALLEL VISIONS: THE LITERARY AND VISUAL IMAGE OF GEORGE WASHINGTON

For more than two hundred years, George Washington has been a superstar. Early in his career, he acquired military, political, and diplomatic skills during the French and Indian War and in the Virginia House of Burgesses. By the time he was selected by the Second Continental Congress to command the Continental Army in the war for independence, he was on his way to stardom. His ultimate victory on the battlefield, followed by his success in presiding over the framing of the new nation's Constitution and his election as its first president, led to such extreme reverence that when he landed by boat at the foot of Wall Street on the way to his first inauguration, some people exclaimed that "they could die content, having cast their eyes at last on the savior of their country."[1]

As America evolved from a rural nation into a political and technological world power, Washington's persona was markedly altered by changing historical, cultural, and social contexts. In the first authorized Washington biography, John Marshall presented his subject as a demigod—the new nation's answer to the desire of proponents of the Enlightenment for a secular icon to replace the venerated saints of the Old World (figure 18).[2] Painted, carved, and printed images of the early years of the republic were equally reverential; the United States was a nation in need of heroes, and Washington was in the right place at the right time and with the right credentials.

Over the years, no other American has been able to compete with Washington's accomplishments in so many areas of public life. Writers and artists have continued to make him the subject of their books and pictures, and, in doing so, they have continu-

FIGURE 18

Title page, John Marshall,
The Life of George Washington, **vol. 1**
(Philadelphia, C. P. Wayne, 1804).

Private collection.

ally redefined his image. For example, at the turn of the twentieth century, the biographer Paul Leicester Ford, although himself a leading venerator, maintained that Washington should be thought of as "a man rather than a historical figure." Indeed, Ford complained that "in place of men, limited by human limits, and influenced by human passions, we have demi-gods, so stripped of human characteristics as to make us question even whether they deserve much credit for their sacrifices and deeds." Mark Twain, Ford believed, said it all when he declared that he was a greater man than Washington, for the latter "couldn't tell a lie, while he could, but wouldn't!"[3] This humanizing approach also influenced the visual arts, as Colonial Revival artists chose to depict him not only as a great patriot but also as an exemplary American citizen. Washington the ordinary man, they believed, could excite more reverence than Washington the icon.

During each period of American history, there have been significant parallels in the biographical and visual representations of George Washington. Just as early artists, writers, and printmakers presented virtually identical glorifying views of the great leader, so, too, did similarities occur at the middle and end of the nineteenth century. As his image changed in art, it also changed in literature.

THE ICON

The year was 1779. It had been four years since the American Revolution began, but there was still no assurance of ultimate success. George Washington's army was two years from victory at Yorktown and four years from the evacuation of the British from

New York City. His exemplary public career was only beginning, and there seemed to be little in his background or accomplishments to inspire a demand for biographical and visual information. Nevertheless, it was in 1779 that John Bell published his "Sketch of Mr. Washington's Life and Character" in Annapolis, the first known biography of the man produced in this country; a year later, it was reprinted in London's *Westminster Magazine*. Considering that Bell's work appeared relatively early, the author's declaration that "General Washington will be regarded by mankind as one of the greatest military ornaments of the present age, and that his name will command the veneration of the latest posterity" apparently was based on a promise of success bolstered by the general's continuing presence, fortitude, and commitment to the cause. Yet Washington did become America's quintessential leader, who "with one common voice" had been chosen to command the Continental Army and could be depended upon to meet the present challenge.[4]

The year 1779 was also significant with regard to the creation of Washington imagery. For the preceding seven years, the American portrait and history painter Charles Willson Peale had found Washington a highly suitable subject. In 1772 Peale arranged for a sitting for his portrait of Washington as a colonel in the French and Indian War (color plate 1). It became the first of some twenty-three sittings that would take place over the following two decades. Peale's second life portrait, commissioned in 1776 by John Hancock, then president of the Second Continental Congress, has been identified as the first true likeness of Washington to be used as a source for printmakers of the period, who were beginning to find growing markets at home and abroad (figure 19).[5] In 1779 the Supreme Executive Council of Pennsylvania also recognized the importance of the general's image and commissioned Peale to document an early Revolutionary War triumph in *George Washington at Princeton* (color plate 2),

FIGURE 19

Charles Willson Peale
(American, 1741–1827)

George Washington, 1776

Oil on canvas, 44¹/₈ × 38¹/₂ in. The Brooklyn Museum of Art, Brooklyn, New York. Dick S. Ramsay Fund. 34.1178.

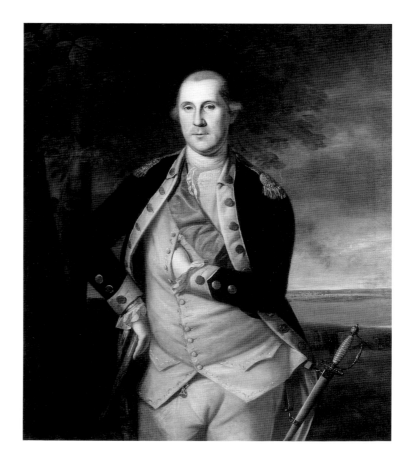

intended by the council to "excite others to tread in the same glorious and disinterested steps which lead to public happiness and private honor."[6] Indeed, Peale's fine portrait was so successful at conveying this message and dazzling his audience that numerous replicas were subsequently ordered. Therefore, 1779 can be considered a defining historic moment: Within that single year we find a major beginning of interest in Washington's image as well as of what would prove to be an enduring literary and visual mythology.

Who was this godlike figure who exacted such admiration even before his ultimate military success, to say nothing of his later achievements? To answer this question, it is important to understand that the new nation needed to establish its own traditions and generate its own heroes. As the sociologist Barry Schwartz has observed, "Great men, like other sacred symbols, are created in times of crisis and collective enthusiasm, times when people enter into intense and effervescent relationships with one another."[7] In 1779 Washington, by the example he set, was the man who could symbolically as well as literally encourage citizens to make the sacrifices required for independence. So why not shower accolades on the one willing to lead the charge? In the context of the Enlightenment, why not turn him into a virtual icon to replace the religious and sacred objects of the Old World? Why not invent a hero for a fledgling nation lacking cultural continuity?

During the next two decades, Washington enjoyed a career that remains unparalleled in American history. Despite the desperate struggles of the Revolution—namely, disease, death, desertions, and woeful shortages of supplies—Washington and his troops (with critical aid from France) finally freed the colonies from their mother country. Four years after the signing of the Treaty of Paris, which officially ended the war, Washington was called upon to serve as president of the Constitutional Convention; in 1789, and again in 1793, he was unanimously elected president of the United States—having initially declined an offer to be made king!

The election of 1789 prompted Jedidiah Morse to include his own biography of Washington in his book *American Geography*.[8] Here is the realization of Bell's prediction that Washington would be remembered as "one of the greatest military ornaments of the present age" and "will command the veneration of the latest posterity." As Washington was about to begin his first term, Morse asserted: "[W]hile true merit is esteemed, or virtue honored, mankind will never cease to revere the memory of this Hero and while gratitude remains in the human breast, the praise of WASHINGTON shall dwell on every American tongue."[9] In 1779 Bell had predicted the leader's future achievements; in 1789 Morse reveled in the fulfillment of the promise.

During this early period, sculptors, painters, printmakers, and manufacturers of household furnishings satisfied the desire for images of Washington. Statues and busts by the Frenchman Jean-Antoine Houdon and the Italian Giuseppe Ceracchi would ultimately be important sources for later efforts (figures 9–11, pp. 40, 41, 43), while citizens yearning for patriotic pictures avidly sought the more plentiful and affordable engravings made after paintings by artists such as Peale, John Trumbull, Edward Savage, and Gilbert Stuart (particularly the "Athenaeum" portrait, figure 5, p. 33). The culmination of this inspiration can be found in one of the most significant printed images produced during Washington's lifetime, Cornelius Tiebout's *Sacred to Patriotism* (1798, figure 20). Washington, in a pose reminiscent of ancient sculpture, stands on a pedestal set between a pair of obelisks identified as Liberty and Independence, obvious references to the prevailing neoclassical style. In the near background another pedestal, the one that had supported an equestrian statue of King George III in New

Cornelius Tiebout
(American, ca. 1773–1832) after
Charles Buxton (American, fl. ca. 1783–94)
after **Gilbert Stuart** (American, 1755–1828)

Sacred to Patriotism, 1798

*Engraving and etching with hand coloring,
25 × 21¹/₂ in. Fraunces Tavern Museum,
New York.*

York's Bowling Green Park before American patriots pulled it down in 1776, stands empty, a symbol of British defeat. In the distance is a scene of the November 1783 departure of the British ships from New York harbor. A more inspirational view of Washington could hardly be imagined; it remains both a tour de force of iconic imagery and a counterpart of the laudatory descriptions published in the literature of the day.[10]

Washington died on December 14, 1799. If Americans had showered him with reverence during his lifetime, there was an absolute deluge of emotion expressed after his death. According to the historian Daniel J. Boorstin, "Never was there a better example of the special potency of the Will to Believe in this New World. A deification which in European history might have required centuries, was accomplished here in decades."[11] Congress requested that suitable eulogies and orations be delivered throughout the nation; locks of Washington's hair and engravings were encapsulated in rings and other souvenirs (figure 44, p. 97); and artists created mourning images for public dissemination. Ordinary citizens and public officials alike began revering him as never before, expressing sentiments similar to those in a letter from the United States Senate to President John Adams consecrating the memory of the "heroic general, the patriotic statesman, and the virtuous sage."[12] By 1811 the continuing intensity of this worshipful attitude led Pavel Svinin, a visiting Russian diplomat, to conclude:

> The country...is glutted with bust portraits of Washington from the brush of this master [Gilbert Stuart]. It is noteworthy that every American considers it his sacred duty to have a likeness of Washington in his home, just as we have images of God's saints. He would fain keep before his eyes the simulacrum of the man to whom he owes his independence, happiness and wealth! Washington's portrait is the finest and sometimes the sole decoration of American homes.[13]

FIGURE 21

John C. McRae
(American, fl. 1850–80)
after **George G. White**
(American, ca. 1835–1898)

Father, I Cannot Tell a Lie,
I Cut the Tree, 1867

Engraving, 14¾ × 21½ in. Library
of Congress, Washington, D.C.

To many, Washington was a saint. And for some, his death created a financial opportunity. In 1800 the noted "Parson" Mason Locke Weems, who came to identify himself as the "Former Rector" of the fictitious "Mount-Vernon Parish," published the first book–length posthumous biography of Washington.[14] "You have a great deal of money lying in the bones of old George," he wrote his publisher and agent, Mathew Carey, in January 1809, "if you will but exert yourself to extract it."[15] Perhaps this reference to the financial success of the biography was at least partially related to the appearance of Weems's cherry-tree legend in the fifth edition of the book, issued three years earlier:

> 'George,' said his father, 'do you know who killed that beautiful little cherry tree yonder in the garden?' This was a tough question; and George staggered under it for a moment; but quickly recovered himself: and looking at his father, with the sweet face of youth brightened with the inexpressible charm of all conquering truth, he bravely cried out, 'I can't tell a lie, Pa, you know I can't tell a lie; I did cut it with my hatchet.'[16]

Generations of American parents have recounted this tale to their children in an effort to teach truth-telling; ironically, their admonitions are based on a Weems-invented lie. In fact, most early-nineteenth-century Americans probably understood the apocryphal nature of the story, since images from this period depicting the "event" have not appeared. Not until considerably later, when Washington began descending from his symbolic pedestal to join the ranks of ordinary Americans, did the story begin taking its place in the lore, particularly in biographies intended for children and in engravings such as *Father, I Cannot Tell a Lie, I Cut the Tree* (1867, figure 21).[17] Not surprisingly, Washington's heirs never endorsed Weems's apocryphal account.

In a quest for accuracy, Bushrod Washington, Washington's nephew and the recipient of his private papers, chose Chief Justice John Marshall, his colleague on the United States Supreme Court, to write the first authorized biography of his uncle. Completed between 1804 and 1807, Marshall's five-volume work extolls Washington as "the chosen instrument of Heaven," with fame "whiter than it is brilliant." But according to John Adams, Marshall actually produced something more closely resembling a "mausoleum, 100 feet square at the base and 200 feet high!"[18]

Marshall's worshipful stance presented problems for him as a biographer. By casting Washington in a wholly reverential light, it was difficult for him to deal with such a universal convention as marriage as it pertained to his vaunted subject. How could

"the chosen instrument of Heaven" marry? Marshall barely mentions the fact, except for referring to Washington's new wife, Martha, as "a young lady to whom he had been for some time strongly attached, and who, to a large fortune and fine person, added those amiable accomplishments which ensure domestic happiness, and fill with silent but unceasing felicity, the quiet scenes of private life."[19] This description befitting an icon was echoed by other writers of the time, including Dr. David Ramsay, who, in 1807, essentially repeated Marshall: "As a reward of his gallant and patriotic services, he shortly after obtained the hand of Mrs. Custis, who, to a fine person and a large fortune, added every accomplishment which contributes to the happiness of married life."[20] And in a passage related to the marriage in his 1807 biography, Aaron Bancroft simply paraphrased both earlier authors.[21] Even Weems followed suit, commenting that Martha "was nearest heaven of all on earth I knew; And all but adoration was her due."[22] Clearly, marriage was for mortals, and Washington was perceived as immortal. These writers sought to deemphasize the human aspects of George Washington for their readers, a position also taken by contemporary artists. Indeed, visual images of the wedding from this early period have so far eluded us.

With regard to Washington's death, the iconic view also influenced Marshall's explanation:

> [H]e has traveled on to the end of his journey, and carried with him an increasing weight of honour: he has deposited it safely where misfortune can not tarnish it; where malice can not blast it. Favoured of heaven, he departed without exhibiting the weakness of humanity; magnanimous in death, the darkness of the grave could not obscure his brightness.[23]

Instead of describing the harshness of death, Marshall portrays Washington as a supernatural force, a light entering heaven.

In the visual arts, Washington was depicted as both the nation's Moses and its Christ. J. P. Elven's etching *Washington Giving the Laws to America* (ca. 1800, figure 22), equates the leader's great successes with Moses's delivery of the Ten Commandments to his people; "America's Moses" holds a tablet titled "The American Constitution" while giving the laws to an allegorical "America." In 1851 the writer L. Carroll Judson elaborated on these parallels:

> There is a striking resemblance between the history of the Israelites bursting the chains of slavery riveted upon them by the short-sighted Pharoah and that of the American colonies throwing off the yoke of bondage imposed by the British king. Like Moses, Washington led his countrymen through the dreary wilderness of the Revolution and when the journey terminated he planted them upon the promised land of Freedom and Independence. Like Moses he placed his trust in the God of Hosts and relied upon his special aid and direction under all circumstances. Like Moses he was nobly sustained by a band of Sages and Heroes unrivalled in the history of the world.[24]

Similarly, in an attempt to associate Washington's death with Christ's ascension, John James Barralet advertised his *Commemoration of Washington* (figure 23), an engraving of Washington ascending to heaven in baroque glory, in an 1800 issue of the Philadelphia newspaper *Aurora, for the Country:*

> The Subject General WASHINGTON raised from the tomb, by the spiritual and temporal GENIUS—assisted by Immortality. At his feet AMERICA weeping over his Armour, holding the staff surmounted by the Cap of Liberty, emblematical of his mild administration, on the opposite side, an Indian, crouched in surly sorrow. In the third ground the mental Virtues, Faith, Hope and Charity.[25]

FIGURE 22

J. P. Elven
(American, fl. late 18th–early 19th century)
after **H. Singleton**
(American, fl. late 18th century)

***Washington Giving the Laws
to America,*** ca. 1800

*Etching and engraving, 10 × 6⅝ in. McAlpin
Collection, Miriam and Ira D. Wallach Division
of Art, Prints and Photographs, The New York
Public Library, Astor, Lenox, and Tilden
Foundations.*

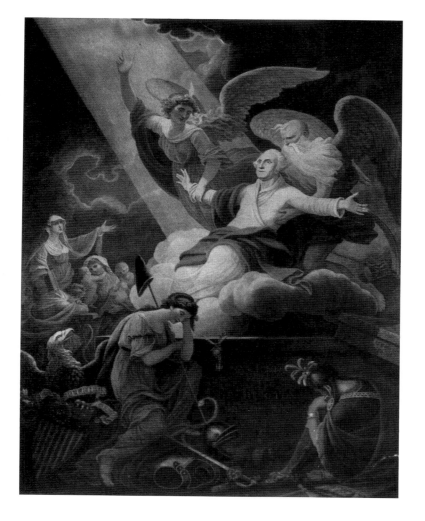

FIGURE 23

John James Barralet
(American, ca. 1747–1815)

Commemoration of Washington, 1802

*Engraving with hand coloring,
24 × 18½ in. Private collection.*

It was the period of the Enlightenment. Washington's posthumous images virtually replaced the religious icons of the Old World. America had succeeded in establishing a secular hero, idolized in both the literary and the visual arts.

THE CITIZEN

Just as Bushrod Washington had cooperated with John Marshall at the beginning of the century, in 1829 he turned over some two hundred folios of Washington manuscripts to Jared Sparks, who set about producing what Boorstin has described as a "pious, pallid, and reverential" account.[26] In addition, new editions of the Bancroft, Marshall, and Weems biographies were published in the 1830s, along with others, including the version James B. Longacre and James Herring included in their 1834 collection *The National Portrait Gallery of Distinguished Americans*.[27]

This kind of veneration would not last, however. In 1832, as the nation prepared to celebrate the centennial of Washington's birth, the original intention of the Founding Fathers to establish a democratic nation was beginning to be realized. The first six American presidents had come from elite backgrounds, but in 1828 Andrew Jackson was elected to the office. Jackson had emerged from the frontier, worked hard to elevate his status, and then, during the eight years of his presidency, led an administration focused on the popular will.[28] Not surprisingly, the myriad genre paintings of this period emphasized ordinary, everyday experiences. By the 1840s, largely because of the invention of lithography and the rise of printmaking firms such as the E. B. and E. C. Kellogg Company, N. Currier, and, starting in the late 1850s, Currier and Ives, Americans could buy inexpensive images to adorn the walls of their homes. These included scenes of Washington's life—no longer iconic but inspirational subjects that encouraged viewers to think of him as similar to themselves and therefore someone they could aspire to emulate.

History painters were now responding to calls for truthfulness.[29] Thus it became not only permissible but also desirable to depict the Washington family without such embellishments as the massive draped column and view of a mysterious ocean found in Edward Savage's *Washington Family* (ca. 1798, figure 24). Rejecting Savage's background for its otherworldly qualities, printmakers of the 1840s began to "lift" the family members out of their former lofty environment in order to place them in a contemporary American parlor—as seen in a Kellogg Company lithograph of about 1845 (figure 25). The result, of course, was anachronistic: a late-eighteenth-century family within a typical mid-nineteenth-century parlor, replete with family portrait, wallpaper, and flowers. Apparently, truthfulness at the time meant 1840s settings, even though in reality Washington's family never saw a room from that period.[30] Accuracy was also compromised in many of these later prints by the omission of any representation of Washington's slave William Lee, who had been included in Savage's late–eighteenth-century composition. Undoubtedly, this gesture was intended to satisfy abolitionists. Washington did own slaves, of course, but his admirers chose to downplay that aspect of his life as master of a plantation.

This tendency to characterize Washington and his family as ordinary people also affected painting. A case in point was a new willingness to depict Washington's marriage, which, as noted, had been a taboo subject earlier in the century. In 1849, as part of the first major series of works devoted to the life of Washington, the noted history painter Junius Brutus Stearns produced *The Marriage of Washington to Martha Custis*

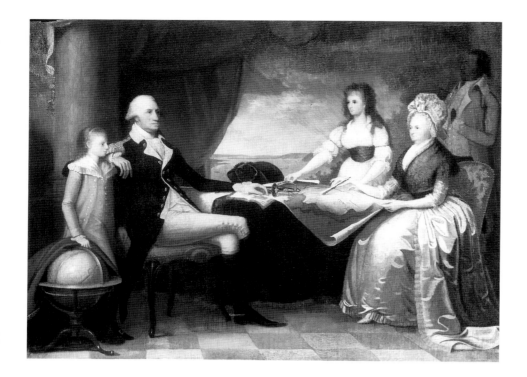

FIGURE 24

Edward Savage
(American, 1761–1817)

The Washington Family, ca. 1798
(smaller replica of the 1796 painting
in the collection of the National
Gallery of Art, Washington, D.C.)

*Oil on panel, 18 1/8 × 24 1/8 in. Courtesy
Winterthur Museum, Winterthur,
Delaware.*

FIGURE 25

Unknown after **Edward Savage**
(American, 1761–1817)

The Washington Family, ca. 1845

*Lithograph with hand coloring,
9 3/4 × 12 3/4 in. Published by E. B. and
E. C. Kellogg Company, Hartford,
Connecticut. Private collection.*

(color plate 9). Drawing upon information published that year by the Reverend G. F. Disosway, Stearns was able to give this work an accurate setting and group of participants.[31] Indeed, the mere existence of Disosway's article shows that the whole conception of Washington as marriageable had changed. While earlier authors, including Marshall and Sparks, had written of the union of two icons, by mid-century Washington was actually described and pictured taking part in this common ceremonial activity.

Biographical sources from this period also shed light on the subject. In 1848 the biographer John Frost gave the wedding a human touch by describing in detail the wedding of Washington and the widowed Martha Custis, who, he wrote, "with joyful acclamation, hailed in the prosperous and happy bridegroom her favourite hero."[32] Frost described their life together in idyllic terms, even including the difficult years when Washington was commander of the Continental Army. By the late 1840s, then,

FIGURE 26

Thomas Oldham Barlow
(American, 1824–1889) after
Thomas Pritchard Rossiter
(American, 1818–1871)
and **Louis Remy Mignot**
(American, 1831–1870)

The Home of Washington, ca. 1859

Engraving, 19 × 30 in. Private collection.

writers and artists were including Washington's marriage in their works. And significantly, when Stearns's painting was engraved by August Regnier in 1854, it was retitled *The Citizen,* to suggest succinctly Washington's ever-expanding role. By 1856, in his *Life of George Washington,* Washington Irving even asserted that Washington was "susceptible to female charms," a far cry from Marshall's "amiable accomplishments which ensure domestic happiness."[33]

Since Americans no longer felt compelled to worship an icon on a pedestal, more mundane details of Washington's life also began to interest a new generation of biographers. Just as John Frost had attempted to demystify Washington in 1848, by the 1850s writers including Benson J. Lossing, George Washington Parke Custis, Joel T. Headley, and Richard Rush, as well as Washington Irving, published accounts of Washington's domestic life that emphasized realistic description rather than iconic veneration.[34] In 1853 interest in the acquisition and restoration of Mount Vernon began growing, thanks largely to the efforts of Ann Pamela Cunningham. Money raised by the nation's schoolchildren and by the noted author and lecturer Edward Everett provided the means to purchase the estate in 1858.[35] By the late 1850s Washington was not only first in war, first in peace, and first in the hearts of his countrymen; he was also the posthumous proprietor of the nation's collective home. His domestic life as plantation owner and head of a family was intriguing to many Americans. Now, he became an American citizen living in an actual house, not a demigod astride a white horse—and certainly not on a pedestal. At the same time, the existence of the restored estate served to remind Americans of Washington's glorious career. In an 1859 essay on the subject written to accompany the exhibition of *Washington and Lafayette at Mount Vernon, 1784,* a painting he and Louis Remy Mignot had recently completed, the artist Thomas Pritchard Rossiter wrote:

> So prolific of association, sympathy, and sentiment is this home, now more emphatically the nation's; so full of suggestiveness and enthusiasm the theme, one who has visited its storied haunts knows not where to limit thought and feeling. No other sight to an American can awaken such a flood of sensibility, or so deeply stir the emotions with gratitude, devotion and patriotism.[36]

So popular was subject matter related to Washington's domestic life that numerous printed images were produced showing him in courtship, marriage, and even death. And the printmaker Thomas Oldham Barlow quickly engraved Rossiter and Mignot's painting for widespread distribution to the public (figure 26).

THE PATRIOT

Regardless of the restoration of Mount Vernon and the domestic peace it suggested, an explosion was about to occur. Soon after the completion of Irving's biography, as well as of numerous visual expressions of Washington's domestic life, the Civil War erupted. In this turbulent new context, his home could hardly remain a symbol of domestic felicity, for the nation was embarking on what would be the bloodiest conflict of its history. Surprisingly, his image remained an inspiration for the opposing views of both sides. To Northerners, Washington was a symbol of union; his critical role in establishing the nation was documented in numerous images produced during the war (figure 27). To Southerners, who saw secession from the Union as the first step in a "second American revolution," Washington symbolized the success of the first one.[37]

Only eleven years after the divisive war ended, the nation united to celebrate its one-hundredth birthday. Organized in Philadelphia, the United States International Exhibition of 1876 (popularly known as the Centennial Exposition) overflowed with patriotism and nostalgia, as America paid tribute to its institutions, its technological progress, and its heroes. Visitors were intrigued by the restaging of Revolutionary War battles in Fairmount Park, and they appeared to enjoy the replicated colonial architecture and costumed eighteenth-century characters representing Americans' early history as they wished it had been.[38] Predictably, Washington's image was a major presence, an inspiration for the newly reunited nation, just as he had been the foremost leader in the fight for American independence.

The cultural context continued to change. The spirit of nationalism and patriotism fostered by the centennial celebration gave rise to the period known today as the Colonial Revival. Composers wrote patriotic songs, architects designed replicas of colonial and federal-period homes, and biographers and artists looked back to the early history of the nation for inspiration. Once again George Washington was in the right place at the right moment. In his 1900 biography, Worthington Ford declared that

FIGURE 27

Unknown

Columbia's Noblest Sons, 1865
*Lithograph, 14¹⁄8 × 20¹⁄8 in.
Published by Kummel and Foster,
New York, and Manson Lang,
New York. Fraunces Tavern
Museum, New York.*

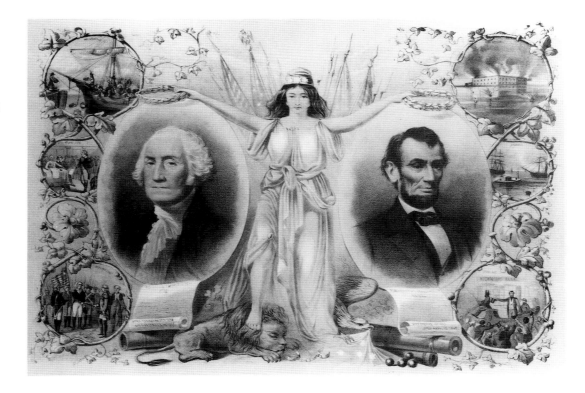

Washington "stands at this time for what is best and highest in public policy and political morality." Ford praised the *pater patriae* for his essential role in the Revolution as well as his ability as president to balance contentious, self-serving factions. He concluded his praise by declaring, "One hundred years have not materially modified these opinions."[39]

Worthington Ford's brother Paul completed the demystification of the image of George Washington that had begun in the mid–nineteeth century. Paul Ford believed that "the time had come to put the shadow-boxes of humanity round our historic portraits, not because they are ornamental in themselves, but because they will make them examples, not mere idols." Thus, at century's end, authors were including Washington's purported sentimental statements to Martha, whose persona had progressed from John Marshall's description of "a young lady to whom he had been for some time attached" to Paul Ford's "petite, over-fond, hot-tempered, obstinate . . . poor speller." Likewise, Washington's death was no longer Marshall's dignified "end of his journey" but Ford's description of the copious bleedings by doctors during his last illness as "little short of murder."[40]

As the humanizing tradition continued influencing literature after the centennial, so, too, was it evident in numerous works produced by popular history painters. Here again Washington emerged as a favorite subject. While images showing him engaged in ordinary activity had been rare during the first half of the century and then had increased by mid-century, after the centennial he was pictured in both domestic and ceremonial roles. Within a single artist's studio, a visitor could find a depiction of Washington arriving for his inauguration as well as one of him striking a grandfatherly pose at Mount Vernon, an artistic configuration unknown in the early nineteenth century.[41] In addition, while few contemporaries of Junius Brutus Stearns were interested in serializing Washington's life and career, by the end of the nineteenth century and throughout the Colonial Revival several artists, including Jennie Brownscombe, John Ward Dunsmore, Jean Leon Gerome Ferris, E. Percy Moran, and Howard Pyle, were so fascinated by the subject that they made it a large part of their life's work.[42]

Between 1900 and 1930 Ferris produced a series of seventy-eight history paintings, with almost one-third devoted to Washington subjects, mostly placed within settings informed by the nineteenth-century genre tradition.[43] But he also could portray the ceremonial side; for example, in *Washington's March through the Jerseys* (ca. 1906, color plate 20) he presented Washington's equestrian image in this major Revolutionary War episode. In *The Painter and the President, 1795* (1930, color plate 22), Ferris felt free to be more creative, inventing a scene that shows Washington posing for Gilbert Stuart in the artist's Germantown, Pennsylvania, studio.

In the eighteenth century both biographers and artists emphasized George Washington the national icon. But by Colonial Revival, the "true," and more humanized, Washington prevailed in literature as well as in the visual arts.

NOTES

1. See Barry Schwartz, *George Washington: The Making of an American Symbol* (New York: Free Press, 1987), 49. For a discussion of the development of Washington's persona up through the Colonial Revival, see Barbara J. Mitnick, *The Changing Image of George Washington*, exh. cat. (New York: Fraunces Tavern Museum, 1989).

2. John Marshall, *The Life of George Washington*, 5 vols. (Philadelphia: C. P. Wayne, 1804–7). For a discussion of the "bitter partisanship, the malicious rumor, and the unscrupulous lies which stormed about Washington during the last decade or so of his life," see Daniel J. Boorstin, "The Mythologizing of George Washington," in James Morton Smith, ed., *George Washington: A Profile* (New York: Hill and Wang, 1969), 264–65.

3. Paul Leicester Ford, *The True George Washington* (Philadelphia: J. B. Lippincott, 1905), 5–6.

4. John Bell, "A Sketch of Mr. Washington's Life and Character, Appended to a Political Epistle to His Excellency, George Washington, Esq," (Annapolis, 1779), as reprinted in *The Westminster Magazine, or the Pantheon of Taste: Containing a View of the History, Politics, Literature, Manners, Gallantry, and Fashions of the Year 1780* 8 (August 1780): 413–16. Although this is considered the first Washington biography to have been published in America, an account entitled "Particulars from the Life and Character of General Washington," extracted from a letter that appeared in the August 17, 1778, issue of Lloyd's *Evening Post*, written by "An Old Soldier," was published in London that year.

5. For a thorough discussion of the use of Washington's image by the printmakers of the period, see Wendy C. Wick, *George Washington, An American Icon: The Eighteenth-Century Graphic Portraits*, exh. cat. (Washington, D.C.: Smithsonian Institution Traveling Exhibition Service and the National Portrait Gallery, 1982). For a discussion of Peale's and other early portraitists' images of Washington, see the essay by David Meschutt in this volume.

6. Quoted in Mark Thistlethwaite, "The Artist as Interpreter of American History," *In This Academy: The Pennsylvania Academy of the Fine Arts, 1805–1976*, exh. cat. (Philadelphia: Pennsylvania Academy of the Fine Arts, 1976), 107.

7. Schwartz, *The Making of an American Symbol*, 14.

8. Jedidiah Morse, "Sketch of the Life of General Washington," *The American Geography; or, A View of the Present Situation of the United States of America* (Elizabethtown, N.J.: Printed by Shepard Kollock for the author, 1789), 127–32.

9. Ibid., 132.

10. The source for the figure in this print may have been an earlier wooden statue by William Sullivan, who supposedly received a commission to carve a likeness of Washington for installation on the empty pedestal in Bowling Green Park where the equestrian statue of King George III originally stood (see Ruthanna Hindes, "A Wooden Statue of George Washington," *The Magazine Antiques* 62, no. 1 [July 1952]; 46). However, Wick, *George Washington, An American Icon*, 131, disagrees, citing I. N. Phelps Stokes, *The Iconography of Manhattan Island* (New York: Robert H. Dodd, 1915–28), who asserts that no wooden statue of Washington was ever placed there (5:1999).

11. Boorstin, "Mythologizing," 265.

12. Quoted in John Marshall, *Life of George Washington*, 4:768.

13. Pavel Petrovich Svinin, *Picturesque United States of America: 1811, 1812, 1813, Being a Memoir on Paul Svinin, Russian Diplomatic Officer, Artist and Author, Containing Copious Excerpts from His Account of His Travels in America, with Fifty-two Reproductions of Water Colors in His Own Sketchbook, by Avrahm Yarmolinsky*. Introduction by R. T. H. Halsey (New York: William Edwin Rudge, 1930), 34. For additional discussion, see the essay by William Ayres in this volume.

14. Weems's fabricated attempt to bolster his credibility by identifying himself as the "Former Rector of Mount-Vernon Parish" first appears in the sixth edition of his Washington biography (1808). In reality, he spent most of his adulthood as an itinerant salesman of books related to salvation. Nevertheless, his Washington biography continued to be so successful that by the time of his death, in 1825, he had published twenty-nine editions. For relevant discussions, see Marcus Cunliffe, introduction to Mason Locke Weems, *The Life of George Washington* (1800; reprint, Cambridge: Harvard University Press, 1962), ix–lxii, and Boorstin, "Mythologizing," 265–72.

15. See Cunliffe, introduction to Weems, *Life of George Washington*, xviii–xix.

16. This passage first appeared in the fifth edition of Weems's biography (1806) and was included in all subsequent editions. Cunliffe, introduction to Weems, *Life of George Washington*, xvii, notes that the 1806 edition also includes a story of a cabbage–seed George's father secretly planted, that, when sprouting, spelled out "GEORGE WASHINGTON."

17. For a nineteenth-century example of a children's book containing the cherry-tree story, see [author unknown], *Child's Life of Washington* (Philadelphia and Baltimore: Fisher and Brother, 1860), 8; here the story is quoted directly from Weems. Cunliffe, introduction to Weems, *Life of George Washington*, xxi, cites the use of the incident by authors primarily writing biographies of Washington for Sunday school and public school readers. It is also clear that Weems did not restrict his apocrypha to the cherry-tree story. See Boorstin, "Mythologizing," 271, for a discussion of other material Weems undoubtedly made up. These include George's performance of feats of strength even though he hated to fight; and the dreams George's mother had when she was pregnant with him that foretold his future greatness.

18. Marshall, *Life of George Washington*, 1:iv; 5:767. See Boorstin, "Mythologizing," 268, for the quotation attributed to John Adams.

19. Marshall, *Life of George Washington*, 2:71.

20. David Ramsay, *The Life of George Washington* (New York: Hopkins and Seymour, 1807), 19.

21. Aaron Bancroft, *An Essay on the Life of George Washington, Commander in Chief of the American Army through the Revolutionary War; and the First President of the United States* (Worcester, Mass.: Thomas and Sturtevant, 1807), 38.

22. M. L. Weems, *The Life of George Washington* (Philadelphia: Printed for the author, 1808), 54.

23. Marshall, *Life of George Washington*, 5:767.

24. L. C. Judson, *The Sages and Heroes of the American Revolution* (Philadelphia: Published by the author, 1851), 368. For other discussions of comparisons of Washington and Moses, see Patricia A. Anderson, *Promoted to Glory: The Apotheosis of George Washington*, exh. cat. (Northampton, Mass.: Smith College Museum of Art, 1980), 4–6, and Robert P. Hay, "George Washington: American Moses," *American Quarterly* 21, no. 4 (winter 1969): 780–91.

25. *Aurora, for the Country* (Philadelphia, December 19, 1800), as quoted in Anderson, *Promoted to Glory*, 32, and Davida Tenenbaum Deutsch, "Washington Memorial Prints," *The*

Magazine Antiques 111, no. 2 (February 1977): 329. Barralet's engraving was reissued several times during the nineteenth century.

26. See Boorstin, "Mythologizing," 275. The full title of Sparks's volumes, completed in 1837, is *The Writings of George Washington: Being His Correspondence, Addresses, Messages, and Other Papers, Official and Private, Selected and Published from the Original Manuscripts; with a Life of the Author, Notes, and Illustrations.* Half-title: *Life of George Washington,* 12 vols. (Boston: F. Andrews, 1834–37).

27. James B. Longacre and James Herring, eds., *The National Portrait Gallery of Distinguished Americans* (New York: Monson Bancroft, 1834), 1: 1–24.

28. See Mark Edward Thistlethwaite, *The Image of George Washington: Studies in Mid-Nineteenth-Century American History Painting* (New York and London: Garland Publishing, 1979), for a study of the effect of Jacksonian democracy on the development of some humanistic images of Washington. See also Robert Remini, *Andrew Jackson and the Course of American Empire* (New York: Harper and Row, 1977).

29. During the 1840s, critics began calling for veracity rather than either idealized or lofty representations of events, both in literature and the visual arts. See "Review of New Books," *Graham's Magazine* 22 (June 1843): 367, and Thistlethwaite, *Image of George Washington,* 14–19, for a thorough discussion of calls for truthfulness in history painting during this period.

30. For information on the Kelloggs, see Kate Steinway, "The Kelloggs of Hartford: Connecticut's Currier and Ives," *Imprint: Journal of the American Historical Print Collectors Society* 13, no. 1 (spring 1988): 2–12. The firm moved often, but in 1845, around the time the Washington lithograph was produced, it was located at 136 Main Street, Hartford, Conn. The portrait of a mother and child may be a reference to the figures of Mrs. Washington and her granddaughter, Eleanor Parke Custis, who are present in the print itself.

31. Rev. G. F. Disosway, *The Ladies' Repository* 9 (January 1845): 4–5.

32. John Frost, *The Pictorial Life of General Washington* (Philadelphia: Thomas Cowperthwait, 1848), 116.

33. Washington Irving, *Life of George Washington* (New York: G. P. Putnam 1856), 1:92.

34. For examples, see Benson J. Lossing, *Mount Vernon and Its Associations* (New York: W. A. Townsend, 1859); George Washington Parke Custis, *Recollections and Private Memoirs of General Washington* (Washington, D.C.: William H. Moore, 1859); Joel T. Headley, *The Illustrated Life of Washington: Together with an Interesting Account of Mount Vernon as It Is* (New York: G. and F. Bill, 1858); and Richard Rush, *Washington in Domestic Life from Original Letters and Manuscripts* (Philadelphia: J. B. Lippincott, 1857).

35. With the purchase of Mount Vernon, Cunningham founded the Mount Vernon Ladies' Association of the Union (its full name) to raise money for the restoration of the estate, which was in a state of decay.

36. Thomas Pritchard Rossiter, *A Description of the Picture of the Home of Washington after the War* (New York: D. Appleton, 1859), 16. The painting is in the collection of the Metropolitan Museum of Art, New York.

37. Southern pictures of Washington images as inspiration behind "a second American Revolution" have not appeared, although orations making the connection were common.

38. For discussions of the Centennial, see Lillian B. Miller, "Engines, Marbles and Canvases: The Centennial Exposition of 1876," *Indiana Historical Society: Lectures, 1972–1973* (Indianapolis: Indiana Historical Society, 1973), 2–29, and James D. McCabe, *The Illustrated History of the Centennial Exhibition* (Cincinnati: Jones Brothers, 1876).

39. Worthington Ford, *George Washington* (New York: Charles Scribner's Sons, 1900), vii–viii.

40. Ford, *The True George Washington,* 6, 93, 58.

41. For example, Jean Leon Gerome Ferris repeatedly illustrated his interest in both the ceremonial as well as the domestic side of Washington. In 1913 Ferris produced *Washington's Inauguration at Independence Hall, 1793* (Virginia Historical Society, Richmond) and, at about the same time, *The Mount Vernon School House, 1786* (figure 61, p. 126).

42. For more about the works of these and other popular history painters, see the essay by Raymond H. Robinson in this volume.

43. For Ferris, see Barbara J. Mitnick, *Jean Leon Gerome Ferris, 1863–1930: American Painter Historian,* exh. cat. (Laurel, Miss.: Lauren Rogers Museum of Art, 1985).

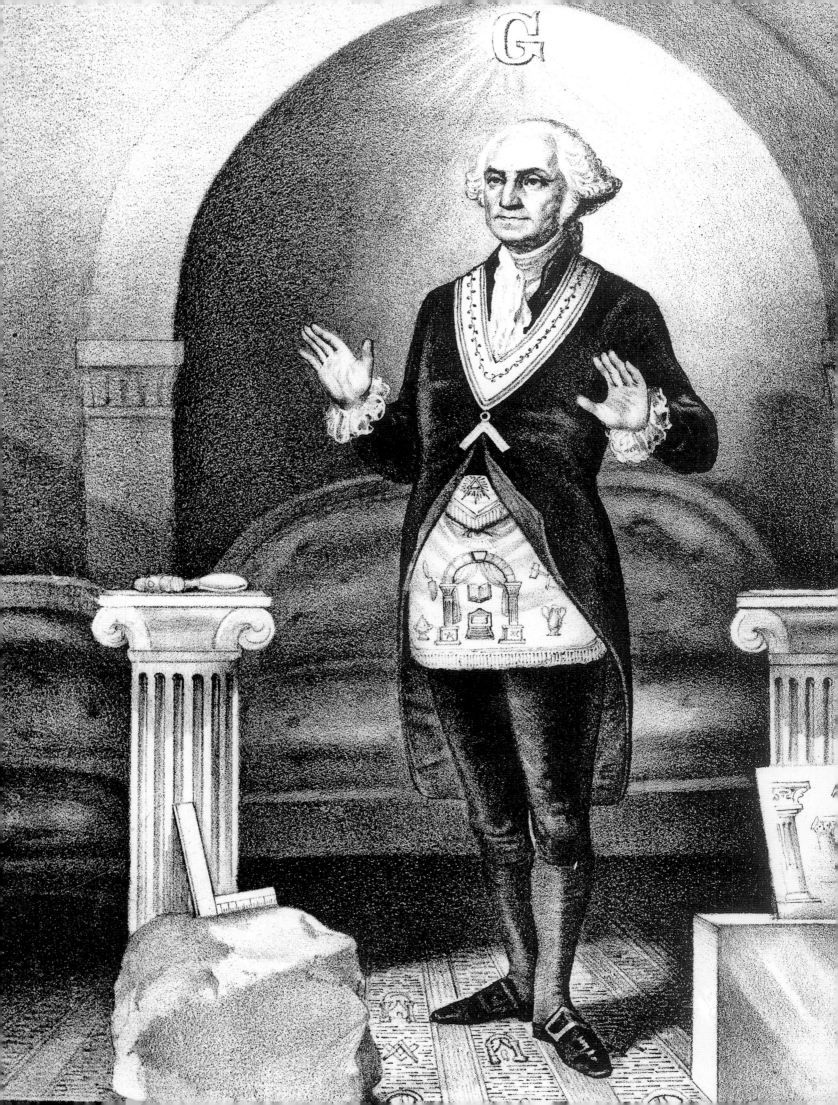

WILLIAM D. MOORE WITH JOHN D. HAMILTON

WASHINGTON AS THE MASTER OF HIS LODGE:
HISTORY AND SYMBOLISM OF A MASONIC ICON

*I*n 1868 Currier and Ives published a lithograph entitled *Washington as a Mason* (figure 28). One of 123 distinct prints of Washington published by the celebrated New York City firm, this full-length portrait exhibits the facial features of Gilbert Stuart's ubiquitous "Athenaeum" painting (figure 5, p. 33).[1] The print, however, shows the first president of the United States standing anachronistically in a mid-nineteenth-century Masonic lodge room. Surrounded by the ritual paraphernalia of the order, he is posed on a carpet ornamented with Masonic symbols. Even without the title, many Americans would recognize that the image celebrates Washington's Masonic membership, because he wears the brotherhood's characteristic ceremonial apron. Viewers attuned to the subtleties of Masonic ritual and etiquette will also perceive that Washington is being shown not just as a Mason but as the Master of a lodge. His status as the presiding officer of a local Masonic organization is indicated by the symbol of office hanging around his neck, by his prescribed ceremonial position standing at the top of three steps, and by the illuminated letter *G* above his head. His hands, positioned palms down before him, and his feet, at right angles to each other, further suggest that the lithographer was attempting to portray his subject enacting secret gestures familiar to nineteenth–century members of the fraternity.[2]

The Currier and Ives lithograph is one work in a long American tradition, which began during his lifetime and continues today, of representing Washington as a Freemason. Portrayals of him as the Master of a Masonic lodge are common in the nation's visual culture and have been produced in a range of media. Typically, these

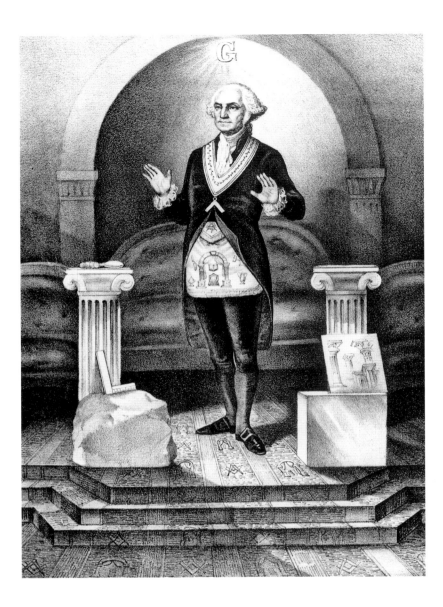

FIGURE 28

Unknown

Washington as a Mason, 1868

*Hand-colored lithograph,
13 3/8 × 9 1/2 in. Published by Currier
and Ives, New York. Museum of Our
National Heritage, Lexington,
Massachusetts.*

portraits include both a message meant to be understood by the general public and an esoteric meaning comprehensible only by those conversant with Masonic history and philosophy. In the lithograph, for example, the "public" reading is simply stated in the title. For members of the fraternity, the composition carries other, more complex meanings, associated with patriarchy and virtue. By examining some of the more notable renderings of Washington as a Freemason, this essay will argue that such portraits are coded images that address societal authority. They merge Washington's identity with that of King Solomon, the biblical builder of Israel's First Temple and Freemasonry's legendary first Grand Master.

FREEMASONRY AND SOLOMON'S TEMPLE

Freemasonry assumed its modern form in Britain at the end of the seventeenth century. Having been influenced by Rosicrucianism, Neoplatonism, and other esoteric ideas current in the late Renaissance, men of leisure began joining stonemasons' guilds. By the early eighteenth century, these organizations had lost most of their constituency of working stonemasons and had become ethical and philosophical societies composed of gentlemen.[3] Combining Enlightenment thought and ideas of

self-improvement with a respect for ancient knowledge, the transformed fraternity spread throughout England and the European continent. By 1765, there were lodges in each of the thirteen American colonies.

In the eighteenth century, the Masonic fraternity proclaimed itself to be the successor of the group of laborers who erected King Solomon's temple, the structure built to house the Ark of the Covenant on Mount Moriah in Jerusalem and to serve as the central worshiping place of Israel.[4] King Solomon, who was simultaneously the ancient Israelites' civil and religious leader, had supposedly organized the workers into a tripartite hierarchy, with each man assigned to a rank based on his competency in the craft of masonry. According to the Masonic creation legend, work on the temple site was overseen by King Solomon; Hiram, the king of Tyre; and an architect named Hiram Abiff. Within the fraternity's ritual, these figures are identified as "the three legendary Grand Masters."

An engraving by Louis Peter Boitard depicting the founding of the fraternity serves as the frontispiece to *The Pocket Companion and History of Free-Masons*, published in London in 1754 (figure 29).[5] King Solomon appears at the center of the composition, upon an elaborate throne decorated with zoomorphic carved arms. Hiram, the

king of Tyre, stands on Solomon's right, and Hiram Abiff, gesturing toward the fraternity's constitutions, is on his left. Aprons mark the two men in the foreground as Freemasons, while a symbolic depiction of the temple appears in the upper right. In this vignette, the black-and-white checkerboard-patterned floor is a Masonic allusion to the temple's interior chambers. The two columns flanking the floor and bearing the sun and the moon, respectively, represent the pillars Jachin and Boaz, mentioned in the Bible as having stood on the porch of the temple.[6]

Freemasonry inculcates into its members a system of ethics and morality based upon architectural allegories and metaphors. Thus, for example, the stone block on Washington's right in the Currier and Ives lithograph represents a rough ashlar block taken directly from the quarries. As raw material unsuited for building, it symbolizes a man in his natural state, before becoming a Mason. The perfect ashlar, on Washington's left, denotes a man after he has been schooled in the tenets of Masonry. Having shorn his character of the rough edges of unbridled emotion and irrational thought, as indicated by the stone's smooth surfaces, the initiate is transformed into a useful participant in a cohesive and stable society, symbolically composed of such building blocks.[7]

Similarly, in Freemasonry the historical and legendary figures involved in constructing Solomon's temple also are imbued with significance. Solomon represents wisdom; Hiram, the king of Tyre, is associated with strength; and Hiram Abiff, the architect, symbolizes beauty. By contrast, negative character traits are identified with three lawless ruffians—Jubelo, Jubela, and Jubelum—whose antisocial, self-serving behavior disrupted the building of the temple.

The ritual enactment of a legend concerning the building of the temple comprises the primary medium through which the fraternity's lessons are taught. A man becomes a Mason by undergoing a set of three progressively complex rituals, which are termed degrees. During the performance of these ceremonies, lodge members variously assume the roles of Solomon; Hiram, the king of Tyre; and Hiram Abiff. Specifically, the Master plays Solomon, the temple builder. More accurately, the act metaphorically transforms him into King Solomon, while the lodge room becomes Solomon's temple. In 1886 Arthur W. Clark, a Freemason from Michigan, explained this transubstantiation. "The Worshipful Master is no longer simply the Master of a Lodge," he wrote. "The lofty teachings to the Order lift him to the awful seat of Solomon, King of Israel."[8] In this role, the Master of a Masonic lodge occupies a ritually prescribed location at the top of three steps at one end of the lodge's meeting space.[9]

As the historian Barbara Franco has argued, Masonic imagery was largely standardized in America through the publication in 1819 of a volume entitled *The True Masonic Chart.*[10] This book, prepared by Jeremy Cross, a Masonic ritualist, and illustrated by Amos Doolittle, an engraver from New Haven, Connecticut, presented an iconographic representation of the Master of a lodge—and thus of Solomon—which became commonplace in Masonic culture.[11] Cross's text appeared in many editions during the nineteenth century, with Doolittle's illustrations only slightly modified. In each edition, the Master of the lodge was portrayed standing under a radiant letter *G* in a space defined by a vaulted ceiling and tiled floor (figure 30). The *G*, a deistic abbreviation for both *God* and *geometry,* is manifested materially in the lodge room itself. In most states, Masonic law mandates that a letter *G,* often composed of gilded wood, be positioned above the Master's station.

By the second quarter of the nineteenth century, then, American Masons understood the Master of a lodge to be a simulacrum of King Solomon and also had developed conventional symbols to represent this dual identity. Any man depicted standing

in a vaulted space and under a radiant *G* represented both the Master of a lodge and King Solomon. Solomon's temple, likewise, was represented by several iconographic features, including a black-and-white checkerboard floor, a pair of pillars, or a winding staircase with steps grouped into prescribed sets of three, five, and seven.[12]

WASHINGTON'S MASONIC CAREER

On November 4, 1752, a few months before his twenty-first birthday, George Washington was initiated into Freemasonry in Fredericksburg, Virginia. On August 4 of the next year, having passed through the first three degrees of Freemasonry, he became a Master Mason.[13] During the third quarter of the eighteenth century, numerous lodges were associated with regiments in the British army. With the onset of the American Revolution, however, colonists chartered their own lodges, which traveled with regiments of the Continental Army.[14] Because of his association with the military, Washington had many opportunities to attend meetings of traveling lodges.[15]

During the early years of the republic, Freemasonry redrew its institutional boundaries to reflect America's new political environment. Fraternal ties to England were

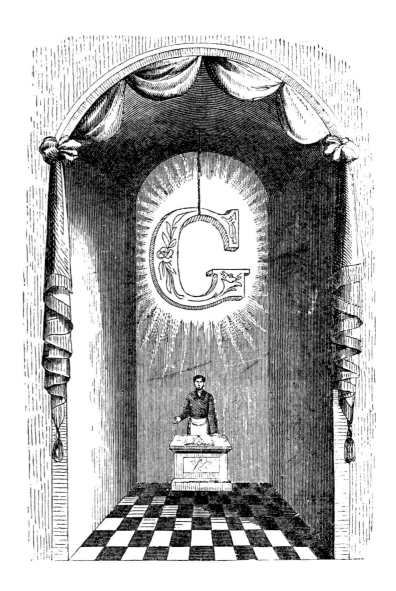

FIGURE 30

Unknown after **Amos Doolittle**
(American, 1754–1832)

Plate 17 from Jeremy Cross,
The True Masonic Chart, Twelfth
and Stereotype Edition (1819;
reprint, New York: A. S. Barnes
and Company, 1857)

Engraving, 4⅝ × 3 in. (plate).
Museum of Our National Heritage,
Lexington, Massachusetts.

loosened, and new American grand lodges were established to coordinate Masonic activities within the nation. During this transitional period, a lodge in Alexandria, Virginia, composed largely of Revolutionary War officers who had been operating under a charter from a grand lodge in Philadelphia, applied for a charter from the recently established Grand Lodge of Virginia. In the process of preparing a petition to the Virginia grand lodge, the Alexandria lodge received Washington's permission to identify him in its charter as its Master. He took office in April 1788, when the lodge was rechartered as Alexandria Lodge No. 22, and served for about twenty months, primarily in a nominal capacity.[16]

Robert R. Livingston, chancellor of New York State, administered the oath of office at Washington's presidential inauguration on April 30, 1789. At the time, Livingston was Grand Master of the Grand Lodge of Free and Accepted Masons of the State of New York. He swore Washington in using a Bible that was (and continues to be) owned by New York City's St. John's Lodge No. 1. Vowing to uphold the nation's constitution in the official presence of a Grand Master, his hand resting on a Bible used for Masonic initiation ceremonies, he became the first and only United States president to serve simultaneously as leader of his lodge.

During this period many perceived Freemasonry as, in the words of De Witt Clinton, "a moral institution, intended to promote individual and social happiness."[17] The historian Steven C. Bullock has noted that Freemasonry at this time identified itself with the ideals of the new nation and claimed to spread virtue, learning, and religious faith. To the extent that it taught concepts of republican virtue to the country's social and political leaders, Freemasonry served almost as a civil religion. Within this interpretation, Washington became, like Solomon, the de facto leader of intertwined religious and governmental structures. Solomon was at once king and priest; and as noted, Washington was, however briefly, both president and presiding Masonic officer.

His dual role became even more evident in the ceremony on September 18, 1793, that marked the laying of the cornerstone of the United States Capitol. President Washington, wearing a Masonic apron, placed a silver plate on a smooth ashlar that served as the building's cornerstone. This engraved sheet of precious metal linked Freemasonry with the nascent republic by recording that the stone was laid "on the thirteenth year of American independence . . . and in the year of Masonry, 5793." Contemporaries used a Masonic vocabulary to link construction of the Capitol with both the conceptual fabric of the government and the biblical building of Solomon's temple. Eulogizing Washington before the Grand Lodge of Massachusetts in 1800, Timothy Bigelow claimed, "Our remotest posterity, inheriting our freedom and independence, and that happy Constitution which alone can secure them, will never be unmindful of the Master, who presided at the building of the fair fabric of political glory."[18] Six decades later, Sidney Hayden, one of Washington's many Masonic biographers, made the connection even more explicit when, in describing the cornerstone–laying ceremony, he wrote that "[Washington] stood on that occasion before his brethren and the world as the representative of Solomon of old."[19]

THE WILLIAMS MASONIC PORTRAIT

In 1793–94 Washington sat for a Masonic portrait at the request of Alexandria Lodge No. 22. William Williams, a self-taught portraitist who worked in various coastal urban centers, had earlier applied directly to the president for the privilege of recording his

William Williams
(American, 1759–1823)

George Washington, 1793–94

*Pastel, 32 × 28 in. Collection of
Alexandria-Washington Lodge No. 22,
Alexandria, Virginia.*

likeness. Washington, who lived in Philadelphia, then the nation's capital, was too occupied with official duties to sit for every artist who desired his attention. But though he turned Williams down, the president added that he granted sittings when they were requested by "public bodies or for a particular purpose."[20] Armed with this knowledge, in August 1793 the artist proposed to the Alexandria lodge that he would execute a portrait for it in exchange for a letter asking for the great man's participation. The lodge, composed of men who knew Washington both as a public figure and as a private individual, provided Williams with the letter and, in October 1794, received his pastel drawing (figure 31).

Although this work was commissioned to represent Washington as a Freemason—and though the artist who created it may even have been a member of the fraternity—it differs from other Masonic portraits of the leader in that it was not intended to be reproduced extensively.[21] Rather than aspiring to be a fraternal symbolic manifesto, it is a likeness of an individual meant for the semiprivate use of the man's acquaintances. In fact, the lodge had instructed Williams to represent the president "as he is" rather than as an icon. The composition is uncomplicated. Portrayed in a half-length format, Washington wears a white shirt, a black coat with vest, and a Masonic apron, sash, and collar. Facial blemishes, including smallpox scars and a mole, record his natural appearance. The Masonic ceremonial jewel hanging from his collar, composed of a sun surrounded by a set of compasses and a quadrant, communicates his status as a former lodge Master. But apart from this inclusion of regalia, the artist eschewed the standard Masonic iconographic vocabulary. The composition is devoid of the checkerboard floors, sets of pillars, and other imagery that allude to Solomon's temple.

Although the Williams portrait was conceived as a single work of art rather than a commodity produced for mass distribution, eventually it was widely disseminated. As the only official Masonic portrait of Washington created during his lifetime, it became a touchstone proving the historical validity of his membership in the fraternity. Con-

sequently, it was reproduced in various books about Washington's Masonic involvement and served to inspire many later Masonic images of the subject. An engraving of the portrait signed "O'Neill," for example, was used as the frontispiece of the first edition of Sidney Hayden's *Washington and His Masonic Compeers* (1866) and in numerous subsequent editions over the next five decades.[22]

Nineteenth-Century Lithographs

Unlike the Williams portrait, most nineteenth-century images of Washington as a Mason were produced explicitly to foster Freemasonry's popularity.[23] The majority of these images were manufactured after the Civil War. During the 1820s and 1830s social forces, including evangelical Christianity and Jacksonian populism, combined to create a cultural environment that actively opposed Freemasonry. Anti-Masonic publications convinced many Americans that Freemasonry was elitist, antidemocratic, and sinful. As a result, many lodges ceased to exist and membership declined drastically.[24]

However, by the 1840s and 1850s, under the leadership of men such as the Kentuckian Robert Morris and the Ohioan Cornelius Moore, American Freemasonry was resurrected. By writing essays, editing Masonic journals, and lecturing widely, these activists brought Masonry back into the public eye and restored its respectability. In their attempts to strengthen the fraternity, Masons made extensive use of Washington's undiminished patriotic stature to reflect glory upon the brotherhood. For instance, Moore included extensive excerpts of the leader's Masonic correspondence in the early issues of his periodical, *Masonic Review*, which began monthly publication in 1846.[25]

Similarly, a speech by the journalist Joseph R. Chandler to Pennsylvania's Mount Moriah Lodge No. 155, "Masonic Character of Washington," was printed serially as the lead articles of the first two issues of Louisville's *The Freemason*, in July and August 1844.[26] In this address, Chandler, who served as Grand Master of the Grand Lodge of Pennsylvania from 1841 to 1842, presented two rhetorical points. First, he argued that Washington's personality illustrated the characteristics that Freemasonry promoted. The first president, he asserted, was dignified, courageous, generous, and patriotic, and he cared for his fellow man. In remarks aimed particularly at the younger lodge members, Chandler further offered Washington as an exemplar to be imitated by those brethren who wished to make themselves "better men":

> The glory of the name of Washington is in the sound integrity of his character, the purity and excellence of his motives, and the honorable perseverance with which he pressed forward in his duties. . . . Providence has laid before you the bright example of Washington, and made you acquainted with the straightforward path by which he ascended from your position to that upon which nothing less than an angel can look down.[27]

The speech had been delivered in a lodge room, a space reserved for the improvement of men through the presentation of a didactic tale concerning Solomon, the national ruler of a biblical kingdom. Chandler appropriated the same space and these rhetorical tools to teach similar lessons but substituted President Washington for King Solomon as the personification of civic ideals. Through the repetition of this syncretistic activity in lodge rooms nationwide, George Washington entered the American Masons' symbolic system as a representation of manly virtues.

FIGURE 32

Unknown after **Amos Doolittle**
(American, 1754–1832)

Plate 51 from Jeremy Cross, *The True Masonic Chart, Twelfth and Stereotype Edition*
(1819; reprint, New York: A. S. Barnes and Company, 1857)

Engraving, 4⁵⁄₁₆ × 2⁵⁄₁₆ in. (plate). Museum of Our National Heritage, Lexington, Massachusetts.

Many nineteenth-century lithographs depicting Washington expressed this rhetorical stance visually. In 1857 Middleton, Wallace, and Company of Cincinnati published one of the earliest popular prints addressing the theme (color plate 11). Entitled *Washington as a Freemason,* this work portrays him wearing a Masonic apron and sash. A scroll inscribed with a quotation supporting the fraternity appears in his left hand; this text fragment adds a note of verisimilitude to the composition. In his right hand he holds a trowel. In a Masonic context, this construction tool is said to be used to spread the cement of brotherly love that binds individuals into a cohesive societal structure; here, however, it may represent Washington's role in laying the cornerstone of the Capitol and his activities solidifying the edifice of American democracy.

Most revealingly, Washington is portrayed standing on a checkerboard floor below a radiant letter *G* in a space with a vaulted ceiling. As mentioned, this iconography, based on Jeremy Cross's *True Masonic Chart,* identifies Washington as the Master of his lodge and thus as a representation of King Solomon. The rows of receding pillars defining the space also are drawn from Amos Doolittle's images for Cross's ritual text (figure 32). Doolittle's engraving of this chamber in Solomon's temple illustrates the ritual of the Select Master's degree. The vignettes drawn in the four corners of the

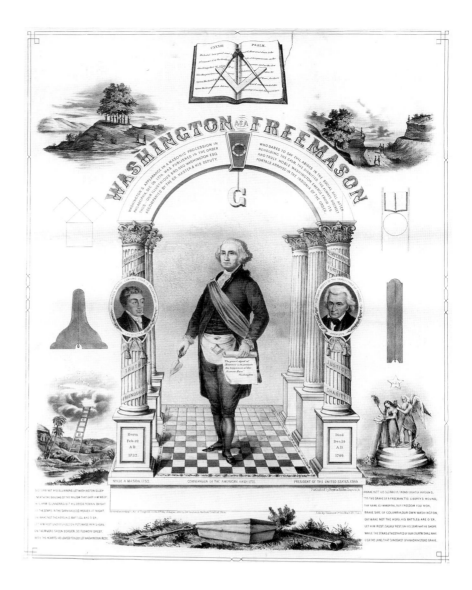

lithograph similarly are derived from images reproduced in popular nineteenth–century Masonic ritual manuals.

Washington is flanked in the Middleton, Wallace lithograph by cameos of the Marquis de Lafayette and President Andrew Jackson. Lafayette had practiced Freemasonry in France before traveling to America, while Jackson, also a member of the fraternity, served as the Grand Master of the Grand Lodge of Tennessee from 1822 to 1824.[28] These portraits may simply have been made to honor prominent Freemasons associated with American history. In nineteenth-century Masonic culture, however, the presentation of three men consistently signaled the three legendary Grand Masters.[29] If Washington is Solomon, then Lafayette and Jackson can be interpreted as Hiram, king of Tyre, and Hiram Abiff. This reading is reinforced by the fact that the former was a man of noble birth who came from a foreign land to assist Solomon, just as the Marquis de Lafayette arrived from France to fight by Washington's side in the American Revolution.

The Masonic conflation of Washington and Solomon also carried a subtext identifying the United States with ancient Israel. In this extrapolation, America became the promised land, the home of God's chosen people. The biblical Jews, under Solomon, had erected a temple to mark their covenant with Jehovah; and American Freemasons, led by Washington, established a democratic system of government dedicated to protecting man's inalienable, God-given rights.

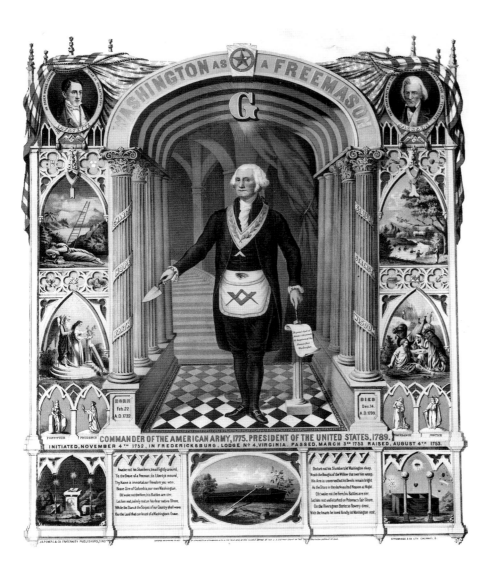

FIGURE 34

Strobridge and Company, Cincinnati

Washington as a Freemason, 1870

*Chromolithograph, 24 × 19¼ in.
Published by J. H. Power and Company,
Cincinnati. Museum of Our National
Heritage, Lexington, Mass.*

Several works derived from the Middleton, Wallace lithograph, which carried the same symbolic message, also were published in Cincinnati during American Freemasonry's boom years following the Civil War. Among these are *Washington as a Freemason,* distributed by Gibson and Company in 1865 (figure 33), and *Washington as a Freemason,* published by J. H. Power and Company and chromolithographed by Strobridge and Company in 1870 (figure 34). In the latter work, Washington's presence within Solomon's temple—that is, his symbolic identity—is reinforced by the depiction behind him of winding stairs, divided into sets of three, five, and seven steps.

WASHINGTON IN HISTORIC SURROUNDINGS

As the United States approached its centennial celebration in 1876, Americans manifested a greater consciousness of the nation's history. Many scholars have termed this revisiting of America's past the Colonial Revival.[30] Beginning in the 1870s, artists portraying Washington as a Mason rejected the timeless symbolic contexts utilized earlier and attempted to provide historical settings consistent with the colonial period. The furniture and other Washingtonian "relics" maintained by Alexandria-Washington Lodge No. 22 (as it had been renamed in his honor in 1805) played significant roles in these artists' endeavors to depict the man more correctly.[31]

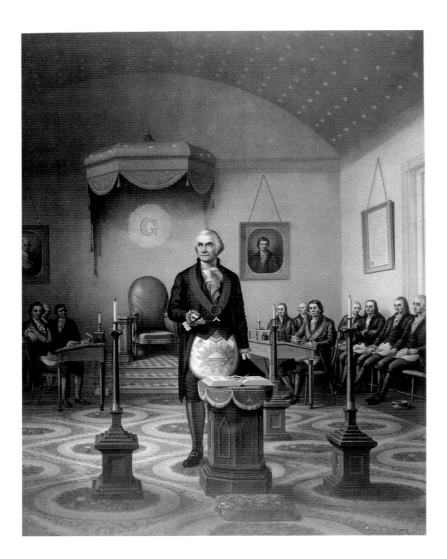

FIGURE 35

Unknown

Washington as a Master Mason, 1870

*Chromolithograph, 26⅛ × 20⅛ in.
Published by Duval and Hunter,
Philadelphia. Library of Congress,
Washington, D.C.*

An early example of this effort is the chromolithograph published in 1870 by the Philadelphia firm Duval and Hunter (figure 35). The caption below the image claims that it represents Washington presiding over a meeting of the lodge in Alexandria held immediately before he laid the Capitol cornerstone. The caption further notes that the lodge "carefully preserved" the regalia, furniture, and gavel depicted. An altar, Master's chair, Master's pedestal, secretary's desk, and a portrait of Grand Master Edmund Randolph from the lodge's collections are carefully delineated in the composition.[32]

Details such as the baldachin above the Master's chair and the pattern woven into the carpet identify this room as the one occupied by the lodge when the print was produced.[33] This hall was not, however, erected and occupied until 1802, nearly three years after Washington's death. Similarly, although the high-backed, leather–upholstered Master's chair has a relatively strong provenance linking it to Washington, the neo-Gothic pedestal and altar in the lithograph probably were acquired by the lodge during the nineteenth century.[34] Since Gothic Revival furniture was introduced to the United States in the early nineteenth century, it is unlikely that Washington ever used these pieces of ritual furniture.[35]

Although the Duval and Hunter print purports to be an accurate representation of a moment in Washington's life, it is also consistent with many of the iconographic formulas of the images noted above. Washington wears a Masonic apron and stands near a radiant *G* beneath a vaulted ceiling; the square hanging around his neck identifies him as the Master of the lodge. While representing a particular historical incident, this chromolithograph also melds Washington's identity into that of Solomon.

Numerous avowedly faithful images of Washington as a Mason continued to be produced during the opening decades of the twentieth century. While serving as editor of *The New York Masonic Outlook* in 1926, for example, H. L. Haywood commissioned John Ward Dunsmore to produce a portrait of Washington as the Master of his lodge for use on the magazine's cover. Dunsmore, whom Haywood described as "the foremost living painter of subjects pertaining to the period of the American Revolution," had come to the editor's attention through the exhibition of his 1926 painting *The Petition* at the National Academy of Design in New York City.[36] This work depicted a meeting of the American Union Lodge held in 1779 in Morristown, New Jersey, at which Washington and others discussed the possibility of establishing a national grand lodge.[37]

In order to execute his commission, Dunsmore traveled to Alexandria and, according to Haywood, "dressed a model in the clothes Washington had worn, and set out on the Master's dais the very furniture which Washington had used."[38] From the sketches he made there, Dunsmore created a painting that was reproduced on the cover of the February 1927 issue (figure 36).[39] The Grand Lodge of the State of New York distributed prints of this work in the late 1920s and 1930s; reproduction rights were granted to the Masonic History Company of Chicago in the 1940s.

Although Dunsmore obviously based the president's sash, collar, and officer's jewel upon those in the Williams portrait, his work exhibits many of the same anachronisms that characterize the Duval and Hunter chromolithograph. Once again the details of Washington's surroundings, including the baldachin and the wallpaper pattern, indicate that the artist portrayed the lodge room dedicated by the Alexandria

FIGURE 36

John Ward Dunsmore
(American, 1856–1945)

Washington as the Master of His Lodge, 1927

Cover illustration, The New York Masonic Outlook, *February 1927. Museum of Our National Heritage, Lexington, Massachusetts.*

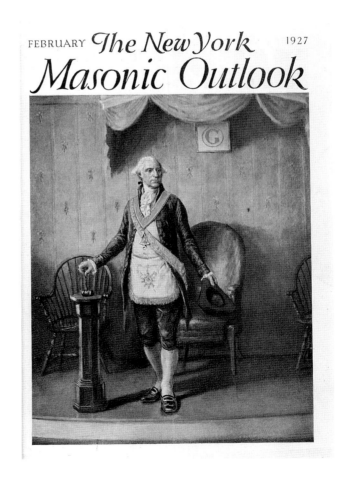

lodge in 1802.[40] With this work, Washington's Masonic accoutrements achieved iconographic significance: The leather-upholstered chair, tricornered hat, and Gothic Revival pedestal attained the status of mandatory attributes of any Masonic portrait of Washington.[41]

Approximately five years later, the artist Hattie E. Burdette once again used the chair, hat, and pedestal in a portrait of Washington as Master of the Alexandria lodge for the United States George Washington Bicentennial Commission. New York Congressman Sol Bloom, director of this body and a member of New York's Pacific Lodge No. 233, took pride in his agency's insistence on "realism."[42] In consultation with F. Walter Mueller, a member of Century Lodge No. 100 in South Orange, New Jersey, Bloom reviewed many Masonic portraits of Washington before rejecting them all as inaccurate. He then hired Burdette to create a portrait in which the figure was based upon Houdon's statue of Washington while the overall work incorporated the relics maintained by Alexandria-Washington Lodge No. 22.[43] Despite Bloom's push for authenticity, this image, too, featured the anachronistic baldachin and neo–Gothic pedestal. As well as appearing repeatedly both in the Masonic press and in publications of the Washington Bicentennial Commission, more than fifteen hundred photolithographic reproductions of Burdette's painting were distributed by congressmen to Masonic organizations throughout the United States (color plate 24).[44]

In the late 1940s, in a spirit similar to the one that had sparked the Burdette commission, the George Washington Masonic National Memorial Association hired the New York City–based sculptor Bryant Baker to produce a monumental statue of Washington for the entrance hall of its fantastic edifice in Alexandria.[45] Baker, a member of Constitutional Lodge No. 294 in Beverly, England, presented a number of preliminary models for his work to the association at its annual meeting in 1947. He informed the group that the statue would depict the president with the chair and pedestal and that Washington's regalia would be based upon "the Williams picture," while his clothing would represent "what any good costumer in New York knows." Baker also claimed that there were "plenty of good pictures" to which he could refer in preparing the work.[46]

The completed statue, seventeen feet tall, was largely funded by the Order of De Molay, a Masonic male youth group (figure 37). Cast in bronze by the Gorham Manufacturing Company of Providence, Rhode Island, the statue weighed eight tons.[47] At its unveiling on February 22, 1950, Harry S Truman was the featured speaker; he, like Washington, was both a Freemason and the president. He took the opportunity to urge Americans to keep alive the spirit of the American Revolution. "Since Washington's time," he stated, "the great principles for which the American Revolution was fought have become known throughout the world and have uplifted the hearts and hopes of generations of men."[48] His audience understood that when Truman, who had served as Grand Master of the Grand Lodge, A. F. and A. M (Ancient Free and Accepted Masons), of Missouri from 1940 to 1941, spoke of America's "great principles," he was also referring to the tenets of Freemasonry.

The Grand Lodge of the State of Louisiana, Free and Accepted Masons, commissioned a similar statue in 1960 as part of its sesquicentennial celebration, to take place two years later. Its members presented the work to the City of New Orleans and installed it on the grounds of the main public library.[49] The ten-foot-tall bronze figure is the work of Donald De Lue, a sculptor who for many years had served as Baker's assistant. Although De Lue's Washington holds his tricornered hat differently, is without a sash, and stands with the opposite foot extended, this work is similar in concep-

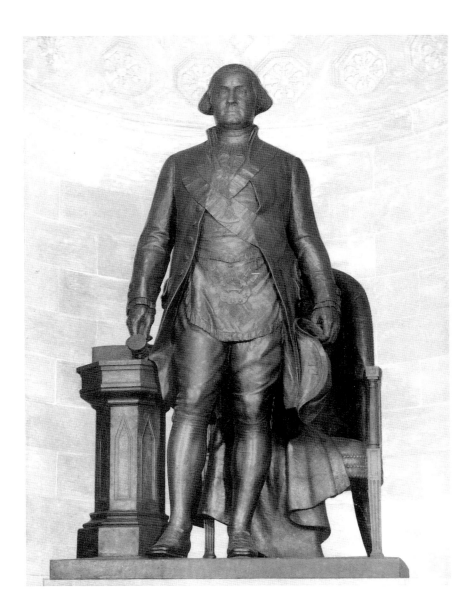

FIGURE 37

Bryant Baker
(American, 1881–1970)

Washington as Master of Alexandria Lodge No. 22, 1950

Bronze, h: 207 in. George Washington Masonic National Memorial, Alexandria, Virginia.

tion to Baker's towering figure.[50] Here again, Washington stands behind his neo–Gothic pedestal and wears the jewel seen in the Williams painting.

During preparations for the 1964 New York World's Fair, De Lue presented his original plaster model for the work to the Grand Lodge, F. and A. M (Free and Accepted Masons), State of New York. This eleven-foot-tall statue held the place of honor at the Masonic Brotherhood Center, a pavilion sponsored by the grand lodge (figure 38).[51] When the fair closed, the work was installed in New York City's Masonic Hall.[52]

The Dunsmore, Burdette, Baker, and De Lue works are visually similar because they were conceptually identical. The Masonic groups and individuals who commissioned them all desired a specific image. The artists were hired not to produce an innovative composition but to create an image following strictly prescribed formulaic criteria. In each case, Washington was to be recognizable as the father of his country, to display the attributes of the Master of a Masonic lodge, and to appear with the relics of Alexandria-Washington Lodge No. 22. These artistic statements were solicited to express the Masonic conflation of Masonry and Americanism.

In all these works Washington's identity merges with that of King Solomon. As noted, both men served as didactic symbols of righteous and wise patriarchal authority. Within American Masonic culture, however, the layering of identity upon this figure continued further: Many men looked at these works of art and saw themselves.

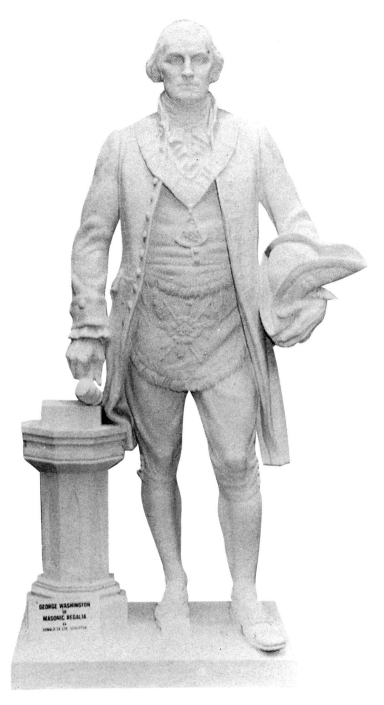

FIGURE 38
Donald De Lue
(American, 1897–1988)
George Washington as the Master of His Lodge, 1960
Plaster, h: 135 in. Courtesy Livingston Masonic Library, New York.

During the nineteenth and twentieth centuries, hundreds of thousands of American men served as Masters of Masonic lodges. In each instance, in a modified version of apostolic succession, the new Master was inducted into the "oriental chair of King Solomon, . . . as Masters have done in all ages before."[53] Many Freemasons had formal photographic portraits taken with the tokens of their office in order to record their ascension to this elevated station. In these portraits, members of the fraternity appropriated the brotherhood's iconography, just as the portraitists had with Washington. For example, a photograph of John H. Brennan of Brooklyn, New York's Clinton Lodge No. 453, produced by Gardner and Company of that city, shares many formal qualities with the images of Washington: The subject stands by a pedestal, wears a Masonic apron, displays a square, carries a Masonic "working tool," and is portrayed with a hat (figure 39).

Gardner and Company,
Brooklyn, New York

John H. Brennan, Master of Clinton Lodge No. 453, ca. 1890

Photograph, 6¹/₂ × 4¹/₂ in. Courtesy Livingston Masonic Library, New York.

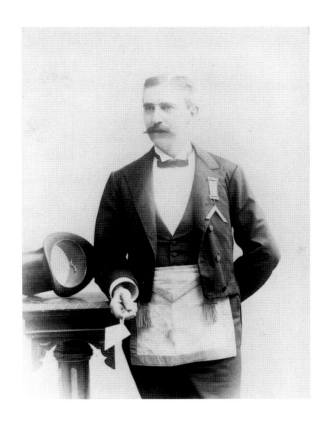

For Freemasons such as Brennan, the portraits of Washington as Master of his lodge conveyed many complex meanings. To the profane world, these works of art reflected glory upon the fraternity by communicating that Washington, the *pater patriae,* was a Freemason. For those conversant with Masonic symbolism, they spoke of the esoteric, symbolic conflation of Washington and Solomon and, thus, of America and ancient Israel as the God-given homes of Jehovah's chosen people. For the Masters of American Masonic lodges, these formulaic artistic compositions confirmed the value of the roles and responsibilities they had chosen to assume by positing an institutional genealogy that included great historical and biblical leaders. For those who had not yet attained fraternal leadership, the Masonic portraits of George Washington presented an ideal of virtuous, patriarchal authority and social involvement to which they could aspire.

NOTES

The authors wish to thank Georgia Hershfeld and Jennifer Somerwitz of the Livingston Masonic Library, New York, whose assistance made this essay possible. Charlotte Emans Moore contributed essential editorial expertise.

1. Harold Holzer, *Washington and Lincoln Portrayed: National Icons in Popular Prints* (Jefferson, N.C., and London: McFarland and Company, 1993), 39.

2. For a discussion of Masonic ritual hand and foot gestures, see Malcolm C. Duncan, *Duncan's Masonic Ritual and Monitor*, 3d ed., with additions and corrections (Philadelphia: Washington Publishing Company, ca. 1866), 16–17, 93. This book is an exposé of secret Masonic ritual and is thus controversial, but it nonetheless appears to be an accurate account of ceremonial practices.

3. David Stevenson, *The Origins of Freemasonry: Scotland's Century, 1590–1710* (Cambridge: Cambridge University Press, 1988); Frances A. Yates, *The Rosicrucian Enlightenment* (1972; reprint, New York: Barnes and Noble, 1996), 206–19.

4. The First Temple is described in the Hebrew Bible in 1 Kings (6–7); 2 Chron. (2–4), and Ezek. (40–43).

5. *The Pocket Companion and History of Free-Masons* (London: Printed for J. Scott, 1754). See also Erich J. Lindner, *Die königliche Kunst im Bild* (Graz, Austria: Akademische Druck–u. Verlagsanstalt, 1976), 176.

6. Daniel Sickels, *The General Ahiman Rezon and Freemasons' Guide* (New York: Masonic Publishing and Manufacturing Company, 1869), 81–82, 127–30.

7. Albert G. Mackey, *A Manual of the Lodge* (New York: Clark and Maynard, 1870), 52–53.

8. Arthur W. Clark, *The Masonic Chronicle* 5, no. 8 (May 1886): 91.

9. "A Model Lodge," *The Masonic Chronicle* 3, no. 5 (February 1884): 54.

10. Barbara Franco, "Masonic Imagery," in James F. O'Gorman, ed. *Aspects of American Printmaking, 1800–1950* (Syracuse, N.Y.: Syracuse University Press, 1988), 21–24.

11. In the first edition, the image discussed appears as plate 15. For Cross, see Ray V. Denslow, "Jeremy L. Cross and the Cryptic Rite," *Transactions of the Missouri Lodge of Research* 29 (1972): 170–85. For Doolittle, see Robert W. Reid, "Some Early Masonic Engravers in America," *Transactions of the American Lodge of Research* 3, no. 1 (1938–39): 105–7.

12. For a discussion of the winding staircase, see Mackey, *Manual of the Lodge*, 87–94.

13. Washington's Masonic activities are amply documented in Charles H. Callahan, *Washington: The Man and the Mason*, 6th ed. (Alexandria, Va.: Memorial Temple Committee of the George Washington Masonic National Memorial Association, 1913). Callahan records Washington's initiation on p. 253.

14. Robert Freke Gould, *Military Lodges: The Apron and the Sword, or Freemasonry under Arms* (London: Gale and Polden, 1899), 215–23.

15. Among the best documented of Washington's Masonic activities during the Revolutionary War are two visits he made in 1779 to the American Union Lodge, which had been established in Roxbury, Massachusetts, in 1776 before it was moved to New York State. See Charles S. Plumb, *The History of American Union Lodge No. 1, Free and Accepted Masons of Ohio, 1776–1933* (Marietta, Ohio: American Union Lodge No. 1, F. and A. M.,

1934), 43–47. See also Herbert T. Singer and Ossian Lang, *New York Freemasonry: A Bicentennial History, 1781–1981* (New York: Grand Lodge of Free and Accepted Masons of the State of New York, 1981), 41–44.

16. Callahan, *Washington*, 284–88.

17. Quoted in Steven C. Bullock, *Revolutionary Brotherhood: Freemasonry and the Transformation of the American Social Order, 1730–1840* (Chapel Hill and London: University of North Carolina Press, 1996), 139.

18. *Eulogies and Orations on the Death of General George Washington, First President of the United States of America* (Boston: Manning and Loring, 1800), 130–31.

19. Sidney Hayden, *Washington and His Masonic Compeers*, 3d ed. (New York: Masonic Publishing and Manufacturing Company, 1866), 159.

20. Quoted in John F. Williams, Jr., *William J. Williams: Portrait Painter and His Descendants* (Buffalo, N.Y.: C. C. Brock, 1933), 16.

21. For references to Williams's possible Masonic affiliation, see Williams, *William J. Williams*, 7–11.

22. Although an imprint of this work from 1905 asserts that it is the eighth edition, this title probably appeared in a larger number of editions and was distributed by at least four different publishers. The Livingston Masonic Library, New York, owns copies bearing imprints from Anderson and Company Masonic Publishers, the Macoy Publishing and Masonic Supply Company, the Masonic Publishing Company, and the Masonic Publishing and Manufacturing Company. An adequate history of American Masonic publishing in the nineteenth century does not yet exist. See also Allen E. Roberts, *G. Washington: Master Mason* (Richmond, Va.: Macoy Publishing and Masonic Supply Company, 1976), in which the Williams portrait is used as the frontispiece. Two other books in which it is the frontispiece are: John J. Lanier, *Washington: The Great American Mason* (New York: Macoy Publishing and Masonic Supply Company, 1922); and Bullock, *Revolutionary Brotherhood*.

23. For a representative sampling of nineteenth-century Masonic lithographs of Washington, see *George Washington, Master Mason* (Washington, D.C.: Masonic Service Association, September 15, 1952).

24. For a discussion of the anti-Masonic period, see Bullock, *Revolutionary Brotherhood*, 277–318.

25. "General Washington as a Mason: His Masonic Correspondence," *Masonic Review* 1, no. 4 (January 1846): 73–78; "General Washington as a Mason: His Masonic Correspondence," *Masonic Review* 1, no. 5 (February 1846): 103–8; "Letter from Gen. Washington," *Masonic Review* 1, no. 7 (April 1846): 161.

26. Joseph R. Chandler, "Masonic Character of Washington," *The Freemason* 1, no. 1 (July 1844): 1–7.

27. Joseph R. Chandler, "Masonic Character of Washington," *The Freemason* 1, no. 2 (August 1844): 35.

28. W. P. Strickland, "Marquis de La Fayette [*sic*]," in C. Moore, ed., *Leaflets of Masonic Biography* (Cincinnati: Masonic Review Office, 1864), 296; H. L. Haywood, *Famous Masons*, 2d ed. (Chicago: Masonic History Company, 1944), 35.

29. For example, in 1871 J. Hale Powers and Company of Cincinnati published a lithograph featuring portrait busts of King Solomon, Hiram Abiff, and Hiram, the king of Tyre. This image is reproduced in *Old Masonic Art* (Washington, D.C.: Masonic Service Association, March 15, 1952), 10.

30. Karal Ann Marling, *George Washington Slept Here: Colonial Revivals and American Culture, 1876–1986* (Cambridge: Harvard University Press, 1988). See also Alan Axelrod, ed., *The Colonial Revival in America* (New York and London: W. W. Norton, 1985).

31. See F. L. Brockett, *The Lodge of Washington: A History of the Alexandria Washington Lodge, No. 22, A. F. and A. M., of Alexandria, Va., 1783–1876* (Alexandria, Va.: G. H. Ramey and Son, 1899), 23.

32. For a discussion of the lodge's collecting and museum activities, see Brockett, *The Lodge of Washington*, 85–92. See also Charles H. Callahan, "Alexandria-Washington Lodge No. 22," *The Builder* 2, no. 2 (February 1916): 35–39.

33. A comparison of the print with contemporary photographs of the lodge room reveals that this image accurately portrays the room. See the photograph reproduced in *The Lodge of Washington and His Masonic Neighbors* (Alexandria, Va.: Alexandria-Washington Lodge No. 22, 1950), 6.

34. Brockett, *The Lodge of Washington*, 35, 91.

35. Katherine S. Howe and David B. Warren, *The Gothic Revival Style in America, 1830–1870*, exh. cat. (Houston: Museum of Fine Arts, 1976).

36. H. L. Haywood, "Trestle Board," *The New York Masonic Outlook* 4, no. 5 (January 1928): 131.

37. The Grand Lodge of Free and Accepted Masons of the State of New York presented Dunsmore with an award of artistic merit on April 10, 1934. During the annual meeting of the Grand Lodge following this ceremony, *The Petition* was on view at the Grand Lodge's library and museum at 71 West Twenty-third Street. See *Proceedings of the Grand Lodge of Free and Accepted Masons of the State of New York, 1934* (New York: Gettinger Printing Corporation, 1934), 36. See also "The Grand Master's Medal First Award Presented to a Distinguished American Artist and Mason," *The New York Masonic Outlook* 10, no. 9 (May 1934): 139.

38. H. L. Haywood, "Masterpieces of Masonic Paintings," *Grand Lodge Bulletin, Grand Lodge of Iowa, A. F. and A. M* 51, no. 10 (December 1950): 726.

39. A Dunsmore painting depicting Benjamin Franklin printing the Masonic constitution appeared on the cover of the January 1928 issue of *The New York Masonic Outlook*. It is noteworthy that Dunsmore depicted Franklin, who served as Grand Master of the Grand Lodge of Pennsylvania, practicing his trade without regalia, while Washington, who was a Masonic officer in title more than in fact, was portrayed in full regalia. Also, even though Franklin was a more active and higher-ranking Freemason than Washington, he was popularly imag-ined as an artisan, while Washington is almost always pictured as a presiding officer.

40. The building that included this room burned down on May 19, 1871, so it no longer existed when Dunsmore visited Alexandria. See Brockett, *The Lodge of Washington*, 35.

41. The hat Washington carries in many Masonic portraits also probably signifies his status as Master of a lodge, since Masons understand that wearing a hat in the lodge room is a symbol of office. See Henry Wilson Coil, *Coil's Masonic Encyclopedia* (New York: Macoy Publishing and Masonic Supply Company, 1961), 303.

42. Robert S. Allen, "I Know My Washington," *The New Yorker* 8, no. 1 (February 20, 1932): 24–28; "Memorial to Sol Bloom Unveiled," *The New York Masonic Outlook* 28, no. 1 (August–September 1951): 15. For another discussion of Bloom and his commission, see Marling, *George Washington Slept Here*, 325–64.

43. F. Walter Mueller, "George Washington's 'Official' Masonic Portrait," *The Northern Light* 2, no. 5 (November 1971): 12–13.

44. For examples, see *History of the George Washington Bicentennial Celebration* (Washington, D.C.: United States George Washington Bicentennial Commission, 1932), 1:178, and *The Montana Mason* 12, no. 4 (May 1932): 1.

45. See William Adrian Brown, *History of the George Washington Masonic National Memorial, 1922–1974: Half Century of Construction*, 2d ed. (publisher unknown, 1980).

46. *Minutes of the Thirty-seventh Annual Convention of the George Washington Masonic National Memorial Association* (1947), 45.

47. Pat Dwyer, *Casting the Large Statue of Washington* (Providence, R.I.: Gorham Manufacturing Company, 1950), 3–4.

48. An excerpt of Truman's speech appears in William Moseley Brown, *George Washington, Freemason* (Richmond, Va.: Garrett and Massie, 1952), 429–30.

49. Glen Lee Greene, *Masonry in Louisiana: A Sesquicentennial History, 1812–1962* (New York: Exposition Press, 1962), 286–87.

50. For a biography of this artist, see D. Roger Howlett, *The Sculpture of Donald De Lue: Gods, Prophets, and Heroes* (Boston: David R. Godine, 1990). See also the essay by H. Nichols B. Clark in this volume.

51. *Masonic Brotherhood Center at the New York World's Fair, 1964–65* (New York: Masonic World's Fair Commission, Grand Lodge, F. and A. M., State of New York, 1964), 12.

52. *Masonic Hall, New York City* (New York: Grand Lodge of Free and Accepted Masons of the State of New York, 1989), 10.

53. Sickels, *General Ahiman Rezon and Freemasons' Guide*, 244–46.

WILLIAM AYRES

AT HOME WITH GEORGE:
COMMERCIALIZATION OF THE WASHINGTON IMAGE, 1776–1876

George Washington surely holds the record for the number of times the image of a historical figure has appeared on goods made for the American home. The list of objects is almost endless: It includes prints, broadsides and posters; newspaper, magazine, book and calendar illustrations; ceramic cups, plates, pitchers, bowls, and plaques; glass flasks, medallions, and paperweights; printed, woven, pieced, and appliquéd textiles; metal buttons, knobs, and brooches; wooden carvings and plaster statuary; postage stamps, currency, and coins.

Although there have been changes in the image itself and in the ways and reasons it has been used, there is one constant: commercial entrepreneurship. During Washington's lifetime and for the century after his death—and, for that matter, today—makers, sellers, and promoters of goods found it profitable and prestigious to associate his name and visage with their wares. And, interestingly, Washington became in effect an endorser of *new* types of wares—for instance, copperplate-printed textiles, transfer-printed ceramics, and "Parian" statuary—as they appeared on the market. His image came to be used as a tool of legitimation—providing assurance, to anyone who might have doubts, that the march of technological progress was sanctioned by a superior power, somehow almost preordained—an integral part of what being "American" was all about.

A Living Hero: The Household Image during Washington's Lifetime

During the last quarter-century of Washington's life—his military leadership in the Revolution, his first retirement to Mount Vernon, his two terms as president, and finally his brief second retirement before his death—he was portrayed again and again on manufactured articles sold for use in the American home. Some depictions were based on actual likenesses; others were fanciful representations. Some were American-made; others were imported. Some were one-of-a-kind, but many more were produced in multiples. Some were produced by amateurs for limited use, but most were produced by entrepreneurs for widespread sale.

As early as the mid-1770s, during the Revolutionary War, various crude woodcuts purporting to be likenesses of Washington were printed and circulated in newspapers and journals and on broadsides.[1] Also at this time or shortly afterward, utilitarian articles bearing the general's image appeared. Among these were textiles (hand-printed handkerchiefs, banners); metalwork (firebacks, buttons, buckles); ceramics (both stoneware and earthenware vessels), and glass. But these items were very limited, in both quality and quantity, until after 1783, when most impediments to trade with Europe were removed by the signing of the formal peace treaty with Great Britain—for, in most areas of production, neither American design nor manufacturing expertise was yet up to the challenge of making goods of superior quality, cheaply and in large numbers.

The images that appeared on these early goods were varied, and most were conjectural. Washington was often pictured as a nondescript, generalized, and stylized military or classical figure or even as some other, identifiable figure—such as in the series of coins and medals from the 1780s on which his name appears under the same image that had previously been circulated as representing George III![2] Thus widely divergent depictions were seen in newspapers, magazines, almanacs, broadsides, and engravings.

Eventually a standard image began to emerge. Charles Willson Peale's 1776 portrait (figure 19, p. 57), done from life in Philadelphia, was probably the first to be issued in multiples and in sizable numbers—in American prints and periodical illustrations. One spurious representation was in prints after "Alexander Campbell," an artist apparently as fictitious as the likeness of Washington portrayed. The prints, nevertheless, did serve as the source for a number of other Washington images.[3]

The definitive Washington as a decorative element, however, would not appear until the 1790s. Joseph Wright's 1790 etching of the subject in profile had a limited popularity but was often clearly the prototype for silhouettes offered for sale. The most important three-dimensional representations were the likenesses created by Jean-Antoine Houdon, whose bust and full-length sculptural portraits of the late eighteenth century (figures 9 and 10, pp. 40 and 41) would become the most often utilized prototypes for reproductions in various media. Not until Gilbert Stuart's "Athenaeum" portrait of 1796, however, did anyone succeed in creating a truly definitive image—the one from which the great majority of subsequent Washington likenesses would spring (figure 5, p. 33). This came to be true for utilitarian goods as well as works of art.

The transmission of the Washington image from paintings to household objects was usually made through the intermediate step of an engraving or a woodcut. Often a smaller copy of a painting was made, by the painter or another artist, to ship to an engraver, who would recopy it, this time on a wood block or copperplate, which was placed in a printing press from which the prints were pulled. The prints were then

FIGURE 40

Unknown

America Presenting at the Altar of Liberty Medallions of Her Illustrious Sons
(British, ca. 1785)

Textile; copper-plate printed cotton, 30½ × 37½ in. Courtesy Winterthur Museum, Winterthur, Delaware.

sold and the majority of them displayed in private residences, public buildings, and places of business. But, more important for the purposes of this essay, some of these prints were purchased by entrepreneurs to copy and replicate on their products, whether these were other prints, broadsides, illustrations in newspapers or other periodicals, or, finally, objects for use in the home.

As most Washington prints were derived from paintings, many illustrations on household objects were derived from prints—in two ways. First, the designs on ceramics, glass, or other objects were often copied from those on prints. Second, the printing process itself was frequently employed in decorating these objects. One example of this is the copperplate-printing technique used on textiles; another is the transfer-printing process for placing designs on ceramics and the like.

By the middle of the eighteenth century, British textile manufacturers had perfected the copperplate process, which was related to intaglio printing on paper. Some of their printed textiles featured designs with American themes, which were popular in England as well as across the Atlantic. Trade with England effectively ceased during the Revolutionary War, but it resumed shortly after the signing of the Treaty of Paris in 1783, by which time depictions of American heroes such as Washington and Benjamin Franklin had been added to the repertory, in anticipation of their popularity. British manufacturers thus proved immediately that any anti-American political convictions they might hold would not impede their making a profit on whatever would sell. An example is the textile *America Presenting at the Altar of Liberty Medallions of Her Illustrious Sons,* designed and printed in England (ca. 1785, figure 40). The figure of Washington on the fabric had its source in a 1780 portrait painted from life by John Trumbull—which was shortly thereafter translated into an engraving by Pierre Eugène du Simitière, a Swiss artist living in Philadelphia. By 1785 the engraving had been taken to England, where it was incorporated by professional fabric designers into an elabo-

rate copperplate design, which was in turn printed on English fabric and exported to the United States. This pattern of creation and production would continue until well into the nineteenth century.[4]

Eighteenth-century American printed textiles were much cruder than their British counterparts. An example is the handkerchief from the last quarter of the eighteenth century attributed to John Hewson but possibly created by some other Philadelphia manufacturer (figure 41). This, too, was an adaptation of an earlier print—one by C. Shepherd after "Alexander Campbell."[5] The "Campbell" print was similarly used on ceramics, which were also rather crudely designed and produced. This is understandable, for again neither the industrial design nor decorative printing trades were firmly established in America before 1800. That situation would change dramatically in the next century.

As the historian Paul Longmore and others have amply demonstrated, the process of creating Washington images for sale during his lifetime was not without his personal consent, even encouragement.[6] Nor were products bearing Washington's image, whether by foreigners or Americans, always created and produced solely, or even primarily, for patriotic reasons; the profit motive was usually at the forefront. Take, for example, the case of Edward Savage, the American painter and engraver then working in Philadelphia, who wrote to Washington in 1798:

> As soon as I got one of the prints ready to be seen I advertised in two of the papers that a subscription would be open for about twenty days. Within that time there was 331 subscribers to the print and about 100 had subscribed previously. . . . In consequence of its success and being generally approved of I have continued the Subscription. There is every probability at present of its producing me at least $10,000 in one twelve month. As soon as I have one printed in colours I shall take the liberty to send it to Mrs. Washington.[7]

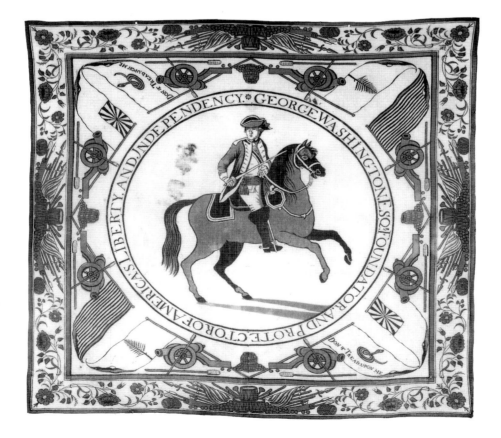

FIGURE 41

Attributed to **John Hewson**
(American, fl. late 18th century)

Handkerchief, 1775–1800

Printed cotton, 30¼ × 33 in. Courtesy Winterthur Museum, Winterthur, Delaware.

If profit could be made from Washington-based products while he was alive, think of the bonanza that would await entrepreneurs upon his death! At least "Parson" Mason Locke Weems thought in these terms. As he confided to his future publisher and agent, Mathew Carey:

> I have nearly ready for the press a piece christen^d, or to be christen^d, "The Beauties of Washington."...Go thy way old George. Die when thou wilt.... [It] will sell like flax seed at quarter of a dollar. I cou'd make you a world of pence and popularity by it.[8]

A few months later Washington did die, and "a world of pence and popularity" would thereafter indeed be made. And, increasingly, many of the goods involved in the growing trade in Washington images would be specifically tailored for sale to the expanding American middle class.

In Heaven or in Earth?
Apotheosis Scenes and Mourning Pictures

After Washington's death, on December 14, 1799, the nation went into a prolonged period of mourning and commemoration. In 1811 a Russian diplomat, Pavel Svinin, observed that "every American considers it his sacred duty to have a likeness of Washington in his home, just as we have images of God's saints."[9] This kind of memorializing coincided with a period of American economic improvement and substantially increased consumer spending. His image was modified to suit the circumstances and the demand. Memorial depictions took two basic forms: Washington as immortal, a demigod ascending into the heavens; and Washington as a secular hero, mourned as a national founder and leader, only a man—although, to be sure, the finest man imaginable.[10]

The engraving *Commemoration of Washington* was first published in 1800 by John James Barralet, an Irish-born painter and engraver working in Philadelphia (figure 23, p. 62). It is a pastiche of styles and influences, with interesting antecedents. The composition was probably borrowed from a print based on a Renaissance painting. As described in an advertisement in the Philadelphia newspaper *Aurora*, the engraving shows "General WASHINGTON raised from the tomb, by the spiritual and temporal GENIUS—assisted by Immortality." Washington's face is taken, reversed, from Stuart's "Athenaeum" portrait, probably again via a print made after it. In turn, the Barralet print was to form the basis for a number of other artifacts. In at least one case, the print traveled as far as China, where it was copied, in the form of a reverse painting on glass, for the American market. In another instance, a copy was shipped to England, where engravers and potters in Liverpool transfer-printed it onto pitchers, also primarily intended for sale in America (figure 42).[11]

A number of other prints produced during this period were very different, memorializing Washington as a mortal hero. An example is the New York/Philadelphia artist Enoch G. Gridley's *Pater Patriae*, issued in 1800, featuring a medallion of Washington on a tomb with the inscription, "Sacred to the Memory of the truly Illustrious GEORGE WASHINGTON...a GREAT and GOOD MAN." Here again is the familiar pattern: The print was engraved after a painting (by John Coles, Jr., a Boston artist); the painting was a copy of an earlier work (the medallion portrait is after Edward Savage); and the print then became the basis for other works, especially needlework pictures, most of them

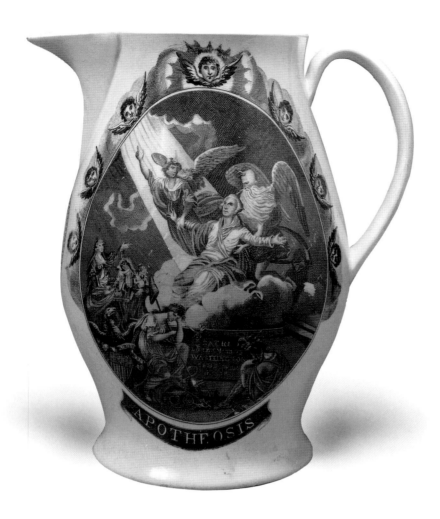

FIGURE 42

Unknown

Jug
(British [Liverpool],
1805–10)

*Transfer-printed ceramic
(creamware), 9⅞ × 4⅞ (base
diam.) × 6⅛ in. (top diam.).
The Museum of Fine Arts,
Houston; The Bayou Bend
Collection, gift of Miss Ima
Hogg.*

produced in girls' schools of the day. In many cases, the print was slavishly copied, often with a teacher's assistance; in others, significant, sometimes whimsical, variations were made (figure 43).[12]

A similar process took place with respect to the mourning picture *America Lamenting Her Loss at the Tomb of Washington,* also published in 1800. The engravers and publishers, James Akin and William Harrison, Jr., of Philadelphia, inscribed their work "as a Tribute of respect paid to departed Merit & Virtue, in the remembrance of that illustrious Hero and most Amiable man." As for progenitors, the portrait medallion was adapted from the 1790 profile by Joseph Wright. And among the progeny of the image is an early-nineteenth-century English creamware pitcher, emblazoned "Washington in Glory" and "America in Tears," adding a religious note and a degree of emotion not present in the print.

To satisfy demand, numerous new and ingenious adaptations of Washington images were created. The French artist C.-B.-J.-F. de Saint-Mémin designed a tiny profile from a sketch he claimed was "the last portrait drawn from [Washington's] life"; printed versions of this were then placed under glass, mounted onto gold rings, and widely retailed (figure 44).[13] In addition, at least two examples of Washington memorial wallpaper survive, one with a weeping Liberty pictured at an urn-capped tablet labeled "Sacred to Washington" and another featuring an obelisk labeled "Washington." Both of these are American, but, interestingly, their manufacturers inserted the Washington imagery into preexisting English patterns.[14] English design and production capability in decorative objects still remained supreme and would continue to exert an enormous influence in America through most of the nineteenth century.

FIGURE 43

E. S. Sefford

(American, fl. early 19th century)

Needlework picture,
ca. 1800–1810

*Silk embroidery and watercolor on silk,
15¼ × 16¾ in. Courtesy Winterthur
Museum, Winterthur, Delaware.*

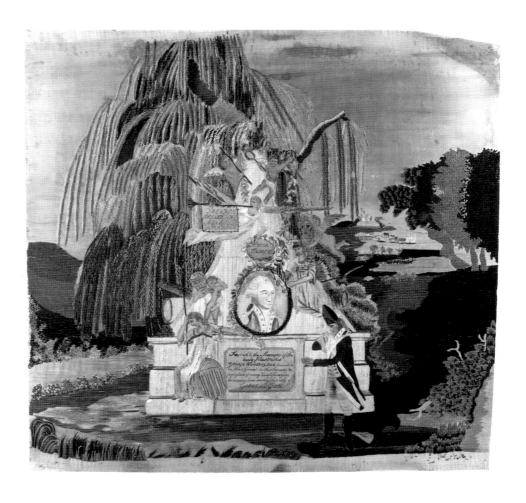

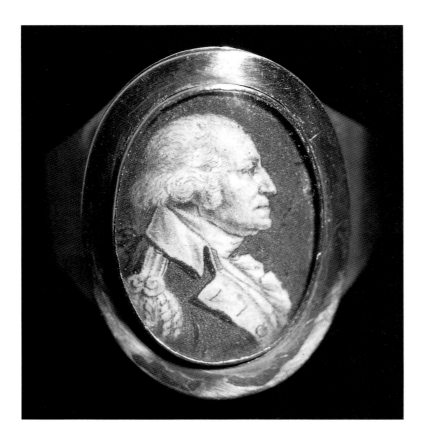

FIGURE 44

**Charles-Balthazar-Julien-Févret
de Saint-Mémin**

(French, 1770–1852)

Mourning ring, 1800

*Engraving mounted in
gold ring, 5/8 × 3/8 in.
The Hendershott Collection.*

WASHINGTON IMPORTED AND CONSUMED:
HOUSEHOLD WARES FROM ENGLAND, FRANCE, AND CHINA

Along with many others, Ralph Waldo Emerson noted the marked increase in imported goods that had become available to middle-class American consumers during the first decades of the nineteenth century:

> [I saw an] endless procession of wagons loaded with the wealth of all the regions of England, of China, of Turkey, of the Indies which from Boston creep by my gate to all the towns of New Hampshire and Vermont.... The train goes forward at all hours, bearing this cargo of inexhaustible comfort and luxury to every cabin in the hills.[15]

Indeed, by the second decade of the century there was a virtual glut of overseas commodities on the American market. Native manufacturers, in fact, complained that Europeans, particularly the English, were engaging in the practice of "dumping," or selling goods below cost to drive out competition.[16] This was often the case. The explanation lay partly in European politics, for the Napoleonic wars had virtually cut off the Continent from British imports; if England's factories were to continue running profitably, their products had to be sold somewhere. And America was the most logical place to send them.

America's reliance on imports dated back to the late seventeenth century; their centrality is illustrated by the importance of boycotts in the years just before the Revolutionary War. The historian Cary Carson noted the significance of goods from abroad in the process of acculturation:

> Widespread possession and use of fashion-bearing, status-giving artifacts gave this nation of newcomers unusually easy access to the American social system. Moreover, as the supply of factory-made goods increased and prices dropped, participation in the country's consumer culture acted as a powerful engine of democratization. Specifically British manufactured goods and fashions served additionally to induce many ethnic peoples to accommodate themselves willingly or unwillingly to the dominant English culture.[17]

Though this process was still at work in the early 1800s, there were changes in the wind. By midcentury both American tastes and American manufactures would assert their distinctiveness and, increasingly, their independence.

The English were far from having a monopoly on the American import trade, or on Washington-emblazoned products. In fact, both French and Chinese merchandise competed with English items, especially at the more expensive end of the spectrum. French goods benefited from the political preferences left over from the Revolutionary period, and Chinese wares had boomed after America opened trade with China in the 1790s. Both nations were renowned for the quality of their materials and workmanship, the French especially for metalwork and the Chinese for porcelains. A number of French-made Washington busts and statuettes, often mounted on clocks, were imported for the luxury market (color plate 7). And the time-honored custom of sending Washington prints to be copied onto household objects was extended to the China trade; these were exactingly hand-copied in enamels onto porcelains by Chinese artisans, even to the extent of including the prints' characteristic hatching and stipple marks (figure 45).

English goods did, however, succeed in dominating the middle and lower ranges of the household-goods market, especially the trade in transfer-decorated ceramics. Among them were a remarkable variety of Washingtons. Early on, both apotheosis and

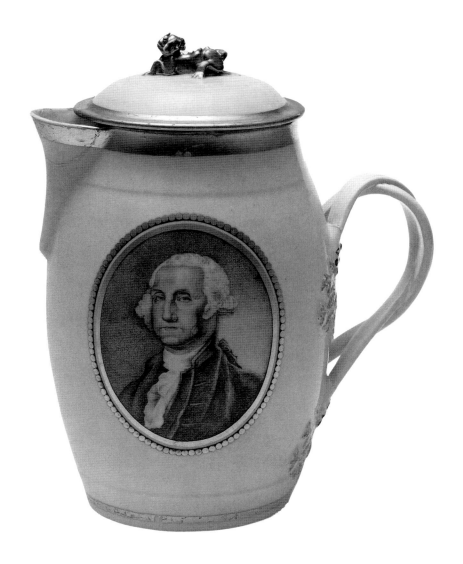

mourning scenes appeared, copied from many of the same prints as the needlework pictures discussed above. Variations on the Joseph Wright profile were especially popular, perhaps because of the availability of prints based on that source, but probably also because of the relative simplicity of the design. In other cases, one of the Gilbert Stuart likenesses, most often the "Athenaeum" portrait, was used. Typically, these wares—flagons, pitchers, plates, and bowls—also bore other American patriotic symbols and decorative devices—sometimes along with bombastic anti-British verse.[18]

Apparently these items sold well. The same was true of other British goods of the period: printed textiles of every sort, books, prints, and an amazing range of metalwork—including buttons, brooches, doorknobs, curtain tiebacks, and, for some reason, a large selection of razors, all bearing Washington's image.

GEORGE WASHINGTON, MODEL MAN: THE HOUSEHOLD IMAGE STANDARDIZED AND AMERICANIZED

By the 1830s American production and design capability had progressed significantly; at the same time, the United States had become less crucial as an outlet for European manufacturers, due to the reopening and development of other markets. The American printing industry, in particular, swelled by the immigration of trained crafts-

men from Europe, had developed impressively. By the end of the decade, enterprising Americans had patented a number of devices that resulted in the mechanization of the type-foundry industry.[19] This facilitated the production and dissemination of many new typefaces and decorative elements, which were available through catalogues to publishers. Among these were ornamental "cuts," designs in the form of lead slugs that printers could buy for direct use, along with type, on their presses. Interestingly, among hundreds of flags, shields, eagles, personifications of Columbia and Liberty, and other patriotic designs, the image of only one American historical figure appears repeatedly and in a range of configurations. This, of course, is Washington. By the 1840s, not only had the number of two-dimensional Washington representations increased greatly, but there was also an increasing similarity among them; for, whatever the form (in a medallion or a rectangular format, surrounded by various patriotic devices or not, facing right or facing left), the image was virtually always taken from the "Athenaeum" portrait.[20] For the rest of the century, and thereafter, Americans saw this likeness countless times, wherever they turned—to books, newspapers, magazines, almanacs, broadsides, posters, and advertisements.

Other developments in the 1840s further standardized and greatly increased the dissemination of the "Athenaeum" image. In 1847 the first national postage stamps were issued. On the original five- and ten-cent stamps appeared the visages of Benjamin Franklin and George Washington, respectively. The pose chosen for the latter was taken from the Stuart portrait, via a "pre-existing engraving, probably from an engraver's sample book."[21] Henry Tuckerman, the eminent art historian and chronicler of taste of the period, observed, only partly in jest, that Washington's face on the stamp, "coming hourly before the American vision, ought to reform, by the silent monition, political varlets and degenerate citizens."[22]

At the same time, and even earlier, American popular printmakers were prospering. Foremost among them were Nathaniel Currier and James M. Ives. The Currier and Ives catalogue raisonné lists dozens of prints bearing depictions of Washington, overwhelmingly derived from the "Athenaeum" portrait, and these and similar images issued by other companies were seemingly everywhere.[23] In 1836 *American Magazine* reported that "prints of Washington, dark with smoke are pasted over the hearths of so many American houses—And long may he live there!" (figure 46). In 1842 a visiting Charles Dickens reported his amazement at the number and variety of such images.[24]

Great technical progress was also being made in producing three-dimensional images. This coincided with, and helped encourage, the Victorian craze for statues in the home. In the 1840s English firms developed "Parian," a type of porcelain that closely resembled marble. The leading English ceramic companies (such as Copeland, Minton, and Wedgwood) all put out Parian statuettes by the thousands. Among these were depictions of classical and religious figures, royalty, musicians, artists, literary lions, and statesmen. Each manufacturer included in its Parian line one American: Washington.[25] American factories were soon also producing parlor statues, and at least one manufacturer, John Rogers, took the process a step further, issuing, in multiples, lively genre groups of sculptural figures for display as conversation pieces. One item in his widely advertised line of sculptures was a statuette of Washington, described by the manufacturer as distinctive, "for it tells no story & is simply George standing alone."[26]

Some American furniture makers followed suit and began adding figures of Washington to select pieces. For instance, at New York's Crystal Palace Exposition in 1853, John Henry Belter of New York showed a table that incorporated ivory busts of Washington and other American statesmen. Another Rococo Revival maker, Christian

FIGURE 46

John L. Krimmel

(American, 1789–1821)

The Quilting Frolic, 1813 (detail)

Oil on canvas, 16⅞ × 22⅜ in. Courtesy Winterthur Museum, Winterthur, Delaware.

Miller, produced furniture surmounted by solid carved-wood busts of Washington, Franklin, and Thomas Jefferson.[27] Also in the 1850s, as if to accompany this furniture, French firms produced trompe-l'oeil "wallpaper statuary" panels depicting the same American heroes (plus Lafayette), which sold well in the United States.[28]

Many other American industries had also made great strides by the 1830s and 1840s, and the pattern of development was similar in almost every one. Typically, the founding entrepreneurs studied, and sometimes copied, European products and technology. Often, the craftsmen originally involved were born and trained in Great Britain or elsewhere in Europe. Characteristically, too, the competition with European imports at first seemed almost insurmountable—in terms of both quality and cost of production. Eventually, however, the tables started turning, and American goods became competitive: "Yankee" manufacturers began acquiring their worldwide reputation for ingenuity and inexpensive quality production.

The glass industry, for example, became well established, both in New England and in western Pennsylvania. As early as 1825, Benjamin Bakewell (an Englishman who had settled in Pittsburgh) and his associates were producing glassware of extraordinary distinction. Their capabilities included the complex process of embedding cameolike depictions, called "sulphides," into molten glass. Not surprisingly, George Washington was among the heroes Bakewell chose to commemorate in this manner. The Washington chosen for the plaque pictured here (figure 47) was taken, in time-honored fashion, from an existing source—this time probably a medal available

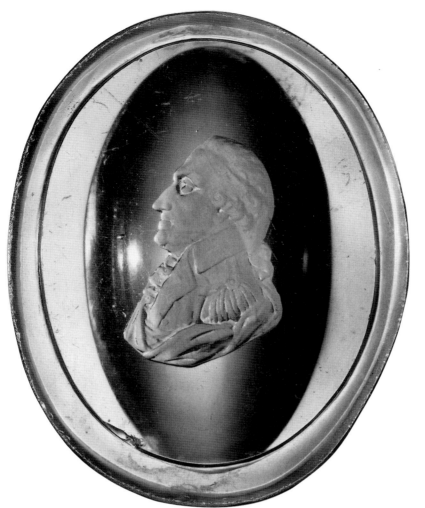

FIGURE 47
Benjamin Bakewell
(British, fl. early 19th century)
Plaque, ca. 1825
*Glass with embedded "sulphide"
image, h: 1¹/₁₆ × w: 2¹/₂ × l: 3¹/₄ in.
Courtesy Winterthur Museum,
Winterthur, Delaware.*

through catalogues, in the form of a pressed-clay impression.[29] A number of blown–
and-molded glass flasks memorializing Washington also date from this period (color
plate 8).

American wares decorated with images of Washington were by no means pro-
duced only by large factories or even through commercial undertakings. Many makers
of rather crude and simply ornamented eathernwares and stonewares portrayed him
in painted, incised, or raised decorations, as did workers in painted-tin wares. Nor
were these memorializers only men. The leader's visage appeared again and again on
quilts and coverlets, made both by amateurs (mostly female) and professionals (mostly
male) (color plate 14).

In the years just before the Civil War, Washington images were available, and
sought after, in unprecedented numbers. In 1859 the *Home Journal* observed that "In
all branches of Art and in all shapes of Literature, WASHINGTON is now the leading
subject—dwelt upon in essay, oratory and poetry, and represented in engraving, paint-
ing and marble." And as Henry Tuckerman further noted, this extended to other
types of objects as well:

> All over the land, his majestic figure stood prominent among the wax groups on
> which children gazed with delight, solemn in black velvet, ruffles, and hair-powder;
> grotesque transparencies on festal nights, Liverpool ware, primitive magazines, the
> figure-heads of ships, the panels of coaches, and engraved buttons, rude cotton

prints, and melancholy samplers—every object in the economy of trade and domestic life, was decorated, more or less truthfully, with that hallowed countenance.[30]

During the Civil War and the years leading up to it, the first president's name was invoked by both North and South in support of their respective causes. His image, however, was virtually co-opted by Northerners and was featured in a large variety of prints, book illustrations, banners, badges, and so forth—often in conjunction with Abraham Lincoln's likeness—as the avatar of stability and Union (figure 27, p. 66).[31] As in period literature and oratory, the emphasis was on Washington the Federalist; Washington the slave-owning Southerner remained conveniently in the background.[32] Sermons and orations expounded on his virtues, some going so far as to claim that only in the emulation of him as "the model man" could America steer the proper course in perilous times.[33] Soon after the war ended he was placed on the dollar bill, and there he has remained, the model man for all Americans (figure 48).[34]

THE CENTENNIAL WASHINGTON

The United States International Exhibition, held in Philadelphia in 1876 and popularly known as the Centennial Exposition, officially observed the hundredth anniversary of the United States' declaration of independence from Great Britain. A secondary agenda was to celebrate the nation's emergence, in this scant one hundred years, as a major industrial power—in effect, a second declaration of independence from Europe. These twin purposes sometimes converged but also, and perhaps more often, competed with each other. From the opening of the exposition, its rather understated

FIGURE 48

U.S. Department of the Treasury

One-dollar note, 1869

Engraved paper, 7³/8 × 3¹/8 in. Douglas Mudd National Numismatic Collection, Smithsonian Institution, Washington, D.C.

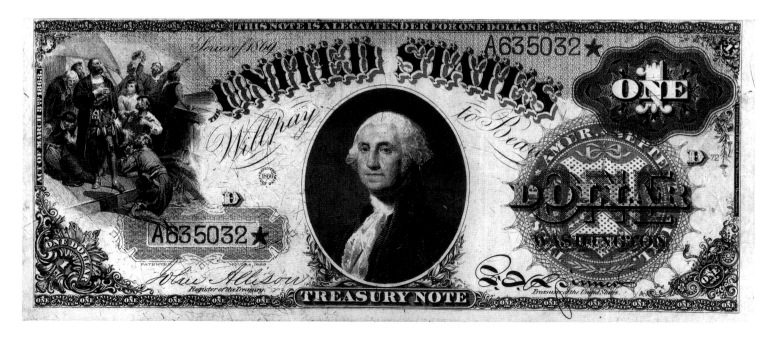

commemorative and historical offerings were overwhelmed by the more popular cele-
brations of the present and the evocations of a seemingly boundless future, presented
by the aggressively self-promoting industrial displays. Washington imagery played a
part in each segment of this rather schizoid affair. In the United States Building, a
selection of "relics"—artifacts related, or supposedly related, to his life—were proudly
displayed in an exhibit presented by the U.S. Department of the Interior. In the manu-
facturing sections, he was represented in printing and lettering demonstrations as well
as on countless gizmos and geegaws, glass and ceramics, badges and plaques, furni-
ture, and textiles and wallpaper (for example, figure 49). Among these were Nelson,
Matter and Company's Renaissance Revival bedroom-furniture suite, which featured
large niches holding full-figure statuettes of Washington and other patriots.[35] Perhaps
the most celebrated item was the Union Porcelain Works' "Century Vase," which
boasted a ceramic silhouette of Washington (after Saint-Mémin) on each side, sur-
rounded by reliefs and other decorations featuring historical scenes and American
inventions heralding "the progress of the United States during its first century" (color
plate 15).[36] There were also many other portrayals of Washington, both two- and
three-dimensional, in the formal art displays.[37]

 The cultural historian Karal Ann Marling has noted a "fundamental contradic-
tion" that pervaded the fair's historical displays, "between seeing colonial history-in-the-

-round as a place of refuge from the present—a make-believe alternative to change—and viewing the past as a distant benchmark against which the giddy pace of progress could be measured."[38] And if these relics seemed somewhat out of place, all the more so did the historical referents grafted gratuitously and sometimes awkwardly onto all manner of manufactured items.

Some visitors began looking cynically at the cult of Washington. The hallowed image was beginning to suffer from overexposure. Wags referred to a statue that showed the hero soaring heavenward on the back of an American eagle as "Washington on a Lark."[39] The prevailing mood was such that "Samantha at the Centennial" could exclaim:

> Oh! what feelings I did feel as I see that coat and vest that George had buttoned up so many times over true patriotism, truthfulness, and honor. When I see the bed he had slept on, the little round table he had eat on, the wooden bottomed chair he had sot down on, the belluses he had blowed the fire with in cold storms and discouragements.... Why they all rousted up my mind so ..., as much so as if my emotions had been all stirred up with that little hatchet that G. W. couldn't tell a lie with.[40]

This sort of irreverence would not have been tolerated a mere decade earlier. But now, in the eyes of many, Washington's memory and his image had lost much of their potency and sanctity.

At the same time, in a remarkable shift, Washington became the mascot of a newly distinct social, cultural, and ethnic movement that was to emerge from the same exposition: the Colonial Revival. As if a spiritual conversion had taken place, Washington changed from a symbol associated with Progress into one of Regress. His image was somehow converted into a badge to be worn on the sleeves of those who felt that America had made a wrong move in its headlong embrace of industrialization and the rapid urbanization and increased immigration that accompanied it. If the Washington image entered the International Exhibition gates an active proponent of the American future—a booster of industry, an enhancer of American goods—by the end of the fair it had become, for most, a static emblem of a long-gone, and irretrievable, past.

NOTES

Research for this essay was supported by a Winterthur Research Fellowship. I wish to acknowledge, in particular, the invaluable assistance and advice of E. McSherry Fowble, Director of Museum Collections, Henry Francis du Pont Winterthur Museum, and Neville Thompson, Librarian, Printed Book and Periodical Collection, Winterthur Library, Winterthur, Delaware.

1. One of the more interesting of these popularly disseminated early images appeared in a Pennsylvania German almanac of 1778, where, in a suspended medallion, a "Waschington" is referred to for the first time on record as "Des Landes Vater," or the Father of His Country. David L. O'Neal, *Early American Almanacs* (Privately published, ca. 1979), 134; Wendy C. Wick, *George Washington, An American Icon: The Eighteenth-Century Graphic Portraits*, exh. cat. (Washington, D.C.: Smithsonian Institution Traveling Exhibition Service and the National Portrait Gallery, 1982), 9.

2. *The Standard Catalogue of United States Coins from 1616 to Present Day* (New York: Wayte Raymond, 1957), 33.

3. See, for example, Wick, *George Washington, American Icon*, 9. Peale is generally credited with producing the initial authentic likeness of Washington; his first portrait (1772, color plate 1) showed Washington wearing the uniform of a colonel in the Virginia militia. See Charles Coleman Sellers, "Portraits by Charles Willson Peale," *Transactions of the American Philosophical Society* 42, pt. 1 (1952): 220, and the essay by David Meschutt in this volume.

4. Florence M. Montgomery, *Printed Textiles: English and American Cottons and Linens, 1700–1850* (New York: Viking Press, 1970), 28–29; Patricia A. Anderson, *Promoted to Glory: The Apotheosis of George Washington*, exh. cat. (Northampton, Mass.: Smith College Museum of Art, 1980), 54–55.

5. Montgomery, *Printed Textiles*, 183.

6. Paul K. Longmore, *The Invention of George Washington* (Berkeley: University of California Press, 1988).

7. Edward Savage, letter to George Washington, June 3, 1798, as quoted in Wick, *George Washington, American Icon*, 43. Ann Fairfax Withington has asserted, without supporting documentation, that the profit motive in Washington-adorned goods was operative during his lifetime only in the case of foreign imports. Ann Fairfax Withington, "Manufacturing and Selling the American Revolution," in Catherine E. Hutchins, ed., *Everyday Life in the Early Republic* (Winterthur, Del.: Henry Francis du Pont Winterthur Museum, 1994), 291–92. With the example of Savage. quoted here, and other Americans in similar circumstances, this distinction is questioned. The profit motive seems to have been primary on both sides of the Atlantic.

8. Quoted by Marcus Cunliffe, introduction to Mason Locke Weems, *The Life of George Washington* (1800; reprint, Cambridge: Harvard University Press, 1962), xiv. See also the essay by Barbara J. Mitnick in this volume.

9. Pavel Petrovich Svinin, *Picturesque United States of America: 1811, 1812, 1813, Being a Memoir on Paul Svinin, Russian Diplomatic Officer, Artist and Author, Containing Copious Excerpts from His Account of His Travels in America, with Fifty-two Reproductions of Water Colors in His Own Sketchbook, by Avrahm Yarmolinsky,* with an introduction by R. T. H. Halsey (New York: William Edwin Rudge, 1930), 34; Harold Holzer, *Washington and Lincoln Portrayed: National Icons in Popular Prints* (Jefferson, N.C., and London: McFarland and Company, 1993), 6.

10. There were relatively few realistic deathbed depictions during this period. At least one, by an unidentified, presumably American etcher, was circulated as a print and was even the basis for a Scottish-produced handkerchief or textile panel, but it seems to have had little influence otherwise. Wick, *George Washington, American Icon*, 142; Carleton L. Safford and Robert Bishop, *America's Quilts and Coverlets* (New York: E. P. Dutton, 1972), 122.

11. *Aurora, for the Country* (Philadelphia, December 19, 1900), as quoted in Anderson, *Promoted to Glory*, 32, and Davida Tenenbaum Deutsch, "Washington Memorial Prints," *The Magazine Antiques* 111, no. 2 (February 1977): 329. The information about the print's several manifestations is in Wick, *George Washington, American Icon*, 166–67, and Anderson, *Promoted to Glory*, 31–33, 61.

12. W. S. Baker, *The Engraved Portraits of Washington, with Notices of the Originals and Brief Biographical Sketches of the Painters* (Philadelphia: Lindsay and Baker, 1880), 190; Margaret Fikioris, "A Needlework by E. S. Sefford . . ." (undated typescript, Registrar's Office files, Henry Francis du Pont Winterthur Museum, Winterthur, Del.); Betty Ring, *American Needlework Treasures*, exh. cat. (New York: E. P. Dutton in association with the Museum of American Folk Art, 1987), 62.

13. Wick, *George Washington, American Icon*, 144.

14. "Wallpaper: A Picture Book of Examples in the Collection of the Cooper Union Museum," *Cooper Union Museum Chronicle* 3 (October 1961): 17; Catherine Lynn, *Wallpaper in America* (New York: W. W. Norton, 1980), 86–87.

15. Ralph Waldo Emerson, April 12, 1837, in Edward Waldo Emerson and Waldo Emerson Forbes, eds., *The Journals of Ralph Waldo Emerson, with Annotations* (Boston: Houghton Mifflin, 1910), 4:203–4, as quoted in Cary Carson, "The Consumer Revolution in Colonial British America: Why Demand?" in Cary Carson, Ronald Hoffman, and Peter J. Albert, eds., *Of Consuming Interests: The Style of Life in the Eighteenth Century* (Charlottesville: University Press of Virginia, 1994), 664.

16. See, for example, E. McSherry Fowble, *Two Centuries of Prints in America, 1680–1880: A Selective Catalogue of the Winterthur Museum Collection* (Charlottesville: University Press of Virginia, 1987), 15.

17. Carson, "Consumer Revolution in Colonial British America," 664–65.

18. See, for example, Alan Smith, *The Illustrated Guide to Liverpool Herculaneum Pottery* (London: Barrie and Jenkins, 1970), 58.

19. Maurice Annenberg, *Type Foundries of America and Their Catalogs* (Baltimore and Washington, D.C.: Maran Printing Services, 1975), 37.

20. The Winterthur Library, Winterthur, Del., has a comprehensive collection of type-foundry catalogues from this period.

21. Peter T. Rohrbach and Lowell S. Newman, *American Issue: The U.S. Postage Stamp, 1842–1869* (Washington, D.C.: Smithsonian Institution Press, 1984), 68. Earlier stamps with more limited circulation (the 1842 "City Dispatch" stamps, and the later 1840s "postmasters' provisionals") bore similar "Athenaeum" Washington images. See Rohrbach and Newman, *American Issue*, 45, 46.

22. Henry T. Tuckerman, *The Character and Portraits of Washington* (New York: G. P. Putnam, 1859), 34–35.

23. Gale Research Company, with an introduction by Bernard F. Reilly, *Currier & Ives: A Catalogue Raisonné,* 2 vols. (Detroit: Gale Research Company, 1983).

24. *American Magazine,* March 1836, as quoted in Thistlethwaite, *Image of George Washington,* 4; Charles Dickens, *American Notes: A Journey* (1842; reprint, New York: Fromm Publishing, 1985), 88, 183.

25. Paul Atterbury, ed., *The Parian Phenomenon: A Survey of Victorian Parian Porcelain Statuary and Busts* (Shepton Beauchamp, England: Richard Dennis, 1989), figs. 455, 613, and 659.

26. David H. Wallace, *John Rogers: The People's Sculptor* (Middletown, Conn.: Wesleyan University Press, 1967), 238.

27. Marvin D. Schwartz, Edward J. Stanek, and Douglas K. True, *The Furniture of John Henry Belter and the Rococo Revival* (New York: E. P. Dutton, 1981), figs. 34, 52, and 52a. The Christian Miller furniture, now in the collection of the Henry Francis du Pont Winterthur Museum, Winterthur, Del., was originally attributed to Belter; the Miller attribution is based on an inscription later found on the piece.

28. Lynn, *Wallpaper in America,* 243.

29. Arlene Palmer, "American Heroes in Glass: The Bakewell Sulphide Portraits," *American Art Journal* 11, no. 1 (January 1979): 4–26.

30. "Mere Mention: George Washington at Home," *Home Journal,* no. 720 (November 26, 1859): 2, as quoted in Tuckerman, *Character and Portraits of Washington,* 34–35.

31. See Holzer, *Washington and Lincoln Portrayed,* sect. 4. Even though Confederate rhetoric frequently evoked Washington, visual images of him were rarely employed to promote the cause. See Mark E. Neely, Jr., et al., *The Confederate Image: Prints of the Lost Cause* (Chapel Hill: University of North Carolina Press, 1987).

32. In fact, Washington portrayals calling attention to his slave-holding had been altered by Northern publishers as early as the 1840s. For instance, Nathaniel Currier and the E. B. and E. C. Kellogg Company produced prints after Edward Savage's *The Washington Family* in which the figure of Washington's personal attendant, William Lee, was removed. See Barbara J. Mitnick, *The Changing Image of George Washington,* exh. cat. (New York: Fraunces Tavern Museum, 1989), 32–35.

33. See, for example, T. W. Holt, *The Model Man: An Oration on Washington, in Which He Is Compared with the Sages and Heroes of Antiquity, Together with an Analysis of His Character, and the Annunciation of Him as the Model Man* (St. Louis: T. W. Ustick, 1866).

34. Robert Friedberg, *Paper Money of the United States* (New York: Coin and Currency Institute, 1968). See note 1 in the essay by Raymond H. Robinson in this volume for citation of an early use of the Washington image on a federal interest-bearing note.

35. David P. Lindquist and Caroline C. Warren, *Colonial Revival Furniture* (Radnor, Pa.: Wallace Homestead Book Company, 1993), 19.

36. Alice Cooney Frelinghuysen, *American Porcelain, 1770–1920* (New York: Metropolitan Museum of Art, 1989), 177–79.

37. James D. McCabe, *The Illustrated History of the Centennial Exhibition* (Cincinnati: Jones Brothers, 1876), 585–88.

38. Karal Ann Marling, *George Washington Slept Here: Colonial Revivals and American Culture, 1876–1986* (Cambridge, Mass.: Harvard University Press, 1988), 42.

39. Ibid., 50.

40. Josiah Allen's Wife [Marietta Hawley], *Samantha at the Centennial* (Hartford, Conn.: American Publishing, 1879), as quoted in Marling, *George Washington Slept Here,* 30. For a reverential appreciation of the Washington relic display, see McCabe, *Centennial Exhibition,* 617–18.

RAYMOND H. ROBINSON

THE MARKETING OF AN ICON

distinct group of artists born in the second half of the nine-
teenth century shared with many of their compatriots an inter-
est in and admiration for the history, architecture, and heroes of
the late eighteenth and early nineteenth centuries. In the year of
the 1876 centennial and for several decades afterward—a
period known today as the Colonial Revival—George Washington
perfectly symbolized for these Americans both the nation's past and its hopes for the
future.

A number of the artists—Jennie Brownscombe, Howard Pyle, John Ward
Dunsmore, Henry A. Ogden, E. Percy Moran, Jean Leon Gerome Ferris, and John
Henry Hintermeister—were born between 1850 and 1870. Others, including Clyde O.
DeLand, Henry Hintermeister, Walter Haskell Hinton, and Walter Beach Humphrey,
were born between 1872 and 1897. All of them were intrigued by Washington and
devoted significant portions of their careers to portraying public and private events
from his life. And all had access to reproductions of life portraits of the first president,
especially to replicas of Gilbert Stuart's 1796 "Athenaeum" portrait (figure 5, p. 33).
That image appeared on one of America's first postage stamps as early as 1845, on the
dollar bill beginning in 1869 (figure 48, p. 103), and, after 1932, in virtually every
schoolroom in America, particularly in framed cardboard versions issued by the
United States George Washington Bicentennial Commission.[1] Perhaps of even greater
significance were the copies, large and small, of the bust Jean-Antoine Houdon cre-
ated in 1785 (figure 10, p. 41). Many artists collected these artifacts to use as sources;

the descendants of Jean Leon Gerome Ferris, for example, possess a small copy of the Houdon bust that Ferris had at hand as he depicted Washington's head from various angles.[2]

The artists learned about events in Washington's life by reading the numerous biographies that had begun appearing during his lifetime and that proliferated after his death in 1799. The very next year, Mason Locke Weems hurriedly produced a life of Washington that contained both real and fictional episodes. In his fifth edition, published in 1806, Weems introduced the famous, made-up cherry-tree incident, which he reported as a dialogue between young George and his father. A more serious biography, by Chief Justice John Marshall, appeared in five volumes between 1804 and 1807; Aaron Bancroft summarized Marshall's content in his own single volume of 1807. In the 1830s, continuing in the Marshall style, Jared Sparks wrote a one-volume life based on his edition of Washington's writings. These early works were uniformly worshipful. At mid-century, Washington Irving humanized the president in his own five-volume set. Countless other authors contributed to the literature, enabling artists to verify details as they created their visual images of incidents in Washington's public and private life.[3]

Drawing upon both artistic and literary sources, the eleven artists noted here produced more than three hundred pictures. Many of these were intended for the marketplace. At times, when literary and artistic inspiration eluded them, they found ideas in the works of others. For example, at least three—Ogden, Dunsmore, and Hinton—portrayed Washington's last birthday, on February 22, 1799, which coincided with the wedding of Martha Washington's granddaughter, Eleanor (Nelly) Custis, to her husband's nephew, Lawrence Lewis, at Mount Vernon.

In Ogden's charming 1899 work, Washington offers his arm as Nelly descends the staircase, followed by her grandmother. The bridegroom bows as guests look on (figure 50). The artist, who worked in the New York office of the Cincinnati-based Strobridge lithographic company from 1881 to 1932, specialized in historical paintings, particularly illustrations of military uniforms and scenes from Washington's life.[4] In 1909 Dunsmore painted his version of the wedding. In 1894, four years after being appointed director of the Detroit School of Arts, he had decided to pursue a lifelong dream of becoming a history painter; he established a studio in New York City and focused on American historical subjects, especially the life and career of Washington. Dunsmore's *The Marriage of Nellie* [sic] *Custis at Mount Vernon* typifies the emphasis on nostalgia and sentiment so popular at the time (figure 51).[5] Hinton, a commercial artist, produced more than twenty pictures featuring George Washington; his 1976 work *The Double Celebration* shows Nelly descending a stairway on her grandfather's arm (color plate 16).[6] The survival of Colonial Revival sentiment is evident at this late date, along with inspiration emanating from celebrations marking the bicentennial of the Declaration of Independence.

Markets for the historical works of these artists were readily available. Some sold to individuals for private collections, but most of the compositions were published commercially—as illustrations in magazines and books, as jigsaw puzzles, as artwork for advertising, and as material for the art-calendar industry.[7] As new techniques of color separation replaced the older and more laborious lithographic process, which required individual applications of color to stone surfaces, many of these reproductions were printed in color. Toward the end of the nineteenth century, a four-color technique that added black for greater depth supplanted the three-color process, wherein reds, blues, and yellows were printed separately. The result was the manufacture of much more realistic reproductions of paintings than had previously been possible.[8]

FIGURE 50

Henry A. Ogden (American, 1856–1936)

Washington's Last Birthday, 1899

Christmas greeting-card illustration (after a watercolor of ca. 1899 in the collection of Fraunces Tavern Museum, New York). Private collection.

FIGURE 51

John Ward Dunsmore
(American, 1856–1945)

The Marriage of Nellie Custis at Mt. Vernon: Washington's Last Birthday, 1799, 1909

Oil on canvas, 24 × 34 in. Fraunces Tavern Museum, New York.

Howard Pyle, a contemporary of Dunsmore and Ogden, produced some thirty-three hundred illustrations for magazines and books during his thirty-five-year career. And in his role as an instructor of numerous younger painters in this genre, he was identified as America's "most important teacher of illustrators."[9] Pyle's initial Washington series grew out of a contract in 1895 between Henry Alden, the editor of *Harper's New Monthly Magazine,* and Woodrow Wilson, then a political science professor at Princeton University. The agreement itself suggests the turn-of-the-century marketability of the

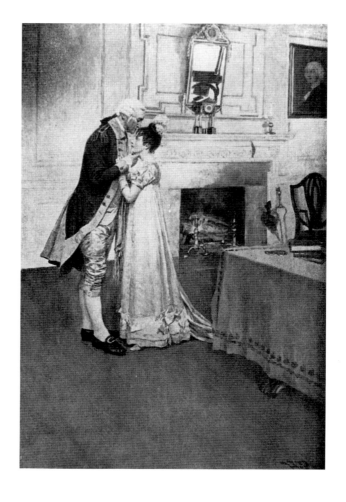

FIGURE 52

Howard Pyle (American, 1853–1911)

Washington and Nelly Custis, ca. 1896

Illustration from Woodrow Wilson, George Washington *(New York: Harper and Brothers, 1897). Private collection.*

literary and visual image of Washington. Noting that "there is now a growing popular demand for an adequate view of Washington's place in American history," Alden offered Wilson a total of $1,800 for six articles, to be published at two-month intervals in *Harper's.* Wilson accepted, adding that "illustrations would be very helpful to the series, if they were made truly illustrative." In late August, Alden informed Wilson that Pyle had agreed to do the illustrations, and author and illustrator met at Princeton to discuss the subject matter of the first article. They decided that Wilson would send Pyle finished drafts of each article, and that Pyle would then submit his artwork for Wilson's approval. "I will look up authorities and make a sketch or two which I will send you so that you may see that they will agree with the text," suggested Pyle. Wilson wrote back, "I expect to like them a great deal better than I like the text." Indeed, when the articles began appearing in print, Wilson warmly congratulated Pyle. "[The illustrations] seem to me in every way admirable," he wrote. "They heighten the significance of the text [and are] perfect in their kind."[10]

In May 1896, after the third article appeared, Harper and Brothers offered Wilson a contract for a book compiling the articles. Wilson agreed, indicating that he desired the Pyle pictures as illustrations.[11] Published the next year, *George Washington* includes, among others, Pyle's *Washington and Nelly Custis* and *The Clerk of Congress Announcing to Washington His Election to the Presidency* (figures 52 and 53). One book reviewer praised Pyle's technique and his "fidelity to truth. . . . It was a fine idea to bring the two men together in a performance of this character," he wrote. "The reader of this volume will find no friction between the conceptions of author and illustrator."[12]

Many of Ferris's Washington paintings, too, appeared as magazine and book illustrations. Trained by his father, a noted Philadelphia portrait painter, and by the French artists Adolphe Bouguereau and Jean-Léon Gérôme (for whom he was named), Ferris focused his energies on producing an American historical series. After creating his first

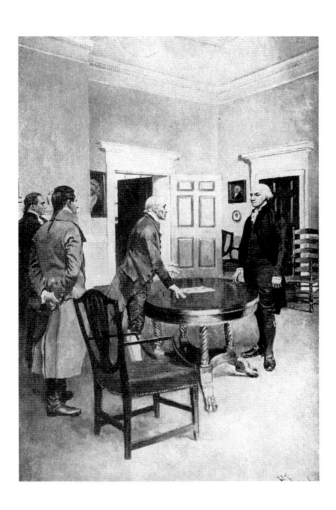

FIGURE 53

Howard Pyle (American, 1853–1911)
The Clerk of Congress Announcing to Washington His Election to the Presidency, ca. 1896

Illustration from Woodrow Wilson, George Washington *(New York: Harper and Brothers, 1897). Private collection.*

important such subject, *General Howe's Levee, 1777,* which he sold in 1898 for the then-enormous sum of $1,800, he decided to spend the rest of his life painting a panorama of American history; he would retain the works as a set and sell the reproduction rights. In his autobiography, Ferris recalled that "modern reproductive processes" enabled him to realize his initial goal; his ledger is full of financial details about rights payments he received. The paintings themselves were eventually exhibited at Congress Hall in Philadelphia from 1916 to 1931.[13]

Ferris's experience illustrates the marketability of Washington and other historical imagery during the Colonial Revival. For example, between 1917 and 1919, the artist received more than $11,000 from the Curtis Publishing Company for permission to reproduce thirty-one of his paintings in color in *The Ladies' Home Journal.* Presumably the publisher, Cyrus Curtis, and the editor, Edward Bok, believed that pictures from the well-received Congress Hall exhibition would enhance their magazine, so they ran them as full-page illustrations. Many featured Washington, a favorite subject of the artist, who included him in more than one-third of his historical paintings. In most cases, Ferris preferred a private, domestic portrayal, such as *The Day's Beginning, 1786* (ca. 1915), which shows the great leader at an ordinary family breakfast at Mount Vernon, and *Washington's Silver Wedding Anniversary, 1784* (ca. 1913). Of the ten Washington pictures published in *The Ladies' Home Journal,* only two showed the public man: *Paul Jones at the Constitutional Convention, 1787* (ca. 1917) and *Washington's Inauguration at Independence Hall, 1793* (ca. 1913).[14] Ferris also sold, for $4,500, reproduction rights to forty-five pictures to Funk and Wagnalls to be used as covers for its *Literary Digest* magazine; the issues appeared between July 7, 1928, and April 2, 1932.[15] Fourteen of these depicted Washington, including *The Courtship of Washington, 1758* (ca. 1917, color plate 21), *The Painter and the President, 1795* (ca. 1930, color plate 22), and *Washington's Birthday, 1798* (ca. 1920, figure 54).

FIGURE 54

Jean Leon Gerome Ferris
(American, 1863–1930)
Washington's Birthday, 1798, ca. 1920
Cover illustration, The Literary Digest,
February 21, 1931. Private collection.

Manufacturers of jigsaw puzzles provided another outlet for Washington pictures. During World War II, the makers of Perfect Picture Puzzles reproduced Clyde O. DeLand's *Oath of Allegiance at Valley Forge, 1778* (ca. 1915, color plate 17 and figure 55) for this purpose. A student of Howard Pyle at Drexel Institute, DeLand went on to portray such "firsts" in American history as the first steamboat, automobile, locomotive, and street railway. Apparently, he was also influenced by Ferris, a neighbor in Philadelphia. Like Ferris, DeLand produced numerous pictures with Revolutionary War themes, many featuring Washington. Some, such as *Washington and Jefferson Discuss Matters of State* (ca. 1938), depicted events from his presidency. Still others were scenes from his domestic life, such as *A Garden Party at Mount Vernon* (ca. 1909).[16]

Firms seeking pictures for advertising comprised yet another market. One was the Illinois-based Washington National Insurance Company, established in 1911 and named after the first president, whose principles, its founders declared, were the "unvarying guide for the operation of the business." Interested in gathering a collection of Washington paintings for display in company headquarters and for use in advertising, the firm asked Walter Haskell Hinton to paint scenes from its namesake's life. The first eleven works in the series illustrated *George Washington: Pictures of His Early Life,* a pamphlet containing descriptions of the pictures, which included *Breaking the Colt, Running the Ferry,* and *The Young Surveyor.* In 1963 and 1965 the company published separate versions of *George Washington: Pictures of Little-Known Events,* containing fifteen and seventeen reproductions, respectively. The last version of the booklet, issued in 1975 and retitled *George Washington and the American Revolution Bicentennial,* eliminated three of the earlier works and included two new pictures, for a total of sixteen reproductions. The company dubbed Hinton the "Painter of Our National Heritage," claiming that he had been commissioned to produce the paintings because "there exists too little of a pictorial record of Washington" and adding that the artist, "a capable draftsman and colorist" who was "well-versed in the history of his Country and in the Life of Washington," seemed to be the ideal choice to fill the void.[17] Apparently, company executives were unaware of the flood of Washington imagery that had appeared earlier.

Art-calendar companies, which for many years furnished one of the most reliable ongoing markets for artists interested in portraying Washington, first emerged near the end of the nineteenth century. While there is debate about which firm began the modern calendar industry, trade-association publications generally credit two men, Edmund Osborne and Thomas D. Murphy, who met as students at Simpson College in Indianola, Iowa, in the 1880s. Osborne left before graduation when his father-in-law, who owned a struggling newspaper in Red Oak, Iowa, fell ill and died. Osborne subsequently took over the paper and urged Murphy to join him. Murphy agreed, and the two celebrated the building of a new courthouse in Montgomery County by printing a calendar for 1890 with a picture of the edifice surrounded by local advertisements; the venture netted them $300.

Flushed with this initial success, the partners purchased photogravures and halftones from Eastern suppliers for use as illustrations on calendars, but soon they decided to manufacture their own artwork. Organizing the Hawkeye Art Printing Company in 1891, they purchased paintings from artists outright, used the three-color (or colortype) process to reproduce the art, and incorporated as Osborne and Murphy in 1894. But after only a year, the two men quarreled and decided to separate. Osborne remained in the calendar business; Murphy took over the newspaper and promised to stay out of the calendar trade for five years. By 1898 Osborne, tiring of small-town life in Iowa, moved his company to Newark, New Jersey, where he became a major figure in the art-calendar business. Although he died in 1917, the company remained a vital participant in the trade.[18]

Figure 55

Clyde O. DeLand (American, 1872–1947)

Oath of Allegiance at Valley Forge, 1778, ca. 1915

and **E. Percy Moran** (American, 1862–1935)

Washington Returns to Mount Vernon, n.d.

Illustrations on Perfect Picture Puzzles, ca. 1943. Private collection.

Osborne and his successors in the firm continued buying art, but some artists, such as John Henry Hintermeister and his son, Henry, chose to retain ownership of their works while selling reproduction rights for calendars. The senior Hintermeister had emigrated to the United States from Switzerland in 1892. His son studied at the Pratt Institute in Brooklyn and with his father. Under contract to the Osborne Company, father and son produced a Washington subject annually for several years. The father's initial Osborne calendars were *Founding the First National Bank* (1923) and *Signing of the Constitution* (1925); the latter depicted Washington presiding as delegates added their names to the crucial document (figure 56). Most of the elder Hintermeister's canvases showed Washington during the American Revolution, but a few portrayed other public events as well as episodes from his private life. The younger Hintermeister produced his first Washington painting in 1943, a scene of George introducing a French general to Martha's grandchildren. He followed this with *The Washingtons at Williamsburg* (1945) and, eventually, with fifteen more works, including *Leaving Independence Hall after Signing the Constitution* (1950, figure 57).[19]

Murphy reentered the calendar business five years after breaking with Osborne, in keeping with their agreement. His new firm, the Thomas D. Murphy Company, was headquartered in Red Oak. He oversaw the printing operations at a state-of-the-art facility, and his brother-in-law William Cochrane directed marketing and sales. After Murphy's death in 1928 and Cochrane's in 1941, other family members assumed control. The company followed the practice of the earlier Osborne and Murphy establishment of generally purchasing original artwork for reproduction. The originals were either retained for exhibition at the headquarters or awarded as prizes to salesmen who sold the most calendars.[20]

Among the most durable of the artists associated with the Murphy Company was E. Percy Moran, a cousin of Jean Leon Gerome Ferris. Son of the marine painter Edward Moran, Percy studied with his father and also in Paris. By 1883 he had opened his own studio in New York City; there he mainly created genre pictures of women and children that appeared as book and magazine illustrations. After 1900 he turned his attention to images of Washington and sold canvases to the Murphy Company. According to the People's Art Project, organized by a group of Iowans in the 1980s to photograph a century of Murphy calendars, Moran sold the company thirteen Washington images for reproduction. The first, for a 1919 calendar, was *Birth of Old Glory*, his portrayal of an imaginary event involving Betsy Ross and George Washington. His next, *The Stars and Stripes*, appeared in 1920 and pictured Washington describing the flag to Lafayette and other French and American officers. The 1924 offering, *Washington's Devotion to His Mother*, and the 1929 calendar, *In Days of Peace—Mount Vernon*, revealed a personal and private Washington. Moran's last sale to the firm occurred in 1935, the year he died. But his depictions of Washington continued to grace Murphy calendars, as the company recycled earlier reproductions. *Birth of Old Glory* was the most popular, reappearing as recently as 1990.[21]

Walter Beach Humphrey, a teacher of illustration and commercial art, produced fourteen Washington subjects for the Murphy Company; they appeared on calendars between 1950 and 1973. Almost all were Revolutionary War scenes, including the first, which showed Washington taking charge of the Continental Army in Cambridge, and the last, of Washington greeting French and American troops at Yorktown. Almost all pictured the flag. In fact, Humphrey indicated that the Murphy Company's desire for exciting scenes showing the American flag had seriously limited his choice of subjects. A calendar containing *Liberty's Delegation* appeared in 1956 (color plate 26). The company also published Humphrey's images of more private moments, such as *Thank

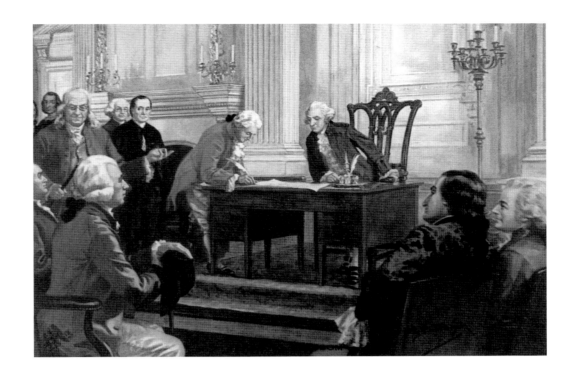

FIGURE 56

John Henry Hintermeister
(American, 1870–1945)

Signing of the Constitution, 1925

Calendar illustration, Osborne Company, Clifton, New Jersey (after a 1925 painting in the collection of Fraunces Tavern Museum, New York). Alternatively labeled Title to Freedom *and* The Foundation of American Government. *Private collection.*

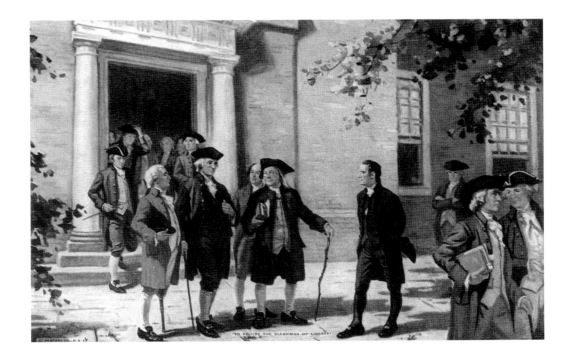

FIGURE 57

Henry Hintermeister
(American, 1897–1970)

Leaving Independence Hall after Signing the Constitution, 1950

Calendar illustration, Osborne Company, Clifton, New Jersey. Alternatively labeled To Secure the Blessings of Liberty *and* Forward from This Day. *Private collection.*

Almighty God (illustrating Washington at worship) and *The Washington Bible* (showing Nelly Custis receiving the family Bible from her grandmother). Humphrey maintained an abiding interest in obtaining commissions for more pictures of peacetime events. "If you ever hear of a Washington enthusiast with money," he inquired of this writer in 1965, "let me know." He died the next year, leaving ten preliminary color sketches of nonmilitary scenes of Washington's activity, including a sketch of the president and his grandchildren in the Mount Vernon library and another of Washington voting in Alexandria.[22]

Some former Osborne and Murphy employees started their own calendar firms. Henry Huse Bigelow, for example, was a salesman for Osborne and Murphy until 1896, when he joined with the St. Paul, Minnesota, businessman Hiram Brown to found Brown and Bigelow, with an investment of less than $5,000. Bigelow sold 250 copies of

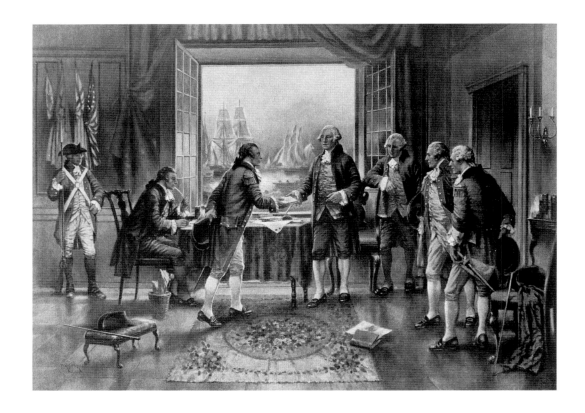

his first calendar, which featured a black-and-white illustration of Washington. In 1923 Bigelow was sent to prison for income-tax evasion; there, he met a fellow inmate, Charles Ward, who had been convicted of possession of narcotics. Ward joined the firm in 1925, the year he and Bigelow were released. After Bigelow died while vacationing in Canada in 1933—presumably by drowning—Ward became the active and enterprising president of what would become the most successful calendar company in America.[23]

In 1900 Ferris noted that the success of the three-color process "marked the birth of the calendar publishing trade as far as I was concerned." For the rest of his career, Ferris was a major contributor of images to Brown and Bigelow as well as to the Gerlach-Barklow Company of Joliet, Illinois, founded in 1907 by Theodore Gerlach and Edward Barklow, two former Murphy salesmen.[24]

Jennie Brownscombe, another painter of Washington imagery, also supplied pictures to Gerlach-Barklow. Brownscombe, who had studied art in New York and Paris, produced canvases noted for their realistic romantic figures and beautiful color. Eventually, she turned to historical subjects, painting works such as *The First Thanksgiving* (ca. 1914) and twenty Washington subjects, divided equally between public and private scenes. Gerlach-Barklow bought rights to *The First Meeting of Colonel Washington and Mrs. Custis* in 1919 (color plate 18) and a year later purchased permission to reproduce *The Marriage of George and Martha Washington,* which shows the newlyweds about to enter a carriage while wedding guests and family wish them well.[25]

Guido Kemper and D. Carol Thomas founded a business in 1883 in Cincinnati, called the Kemper-Thomas Company, which manufactured printed wrapping paper until E. B. Danson purchased it in 1906, when it began publishing art calendars.[26] During the next several years, E. Percy Moran sold Kemper-Thomas at least eleven Washington subjects. Moran's well of inspiration occasionally ran dry, causing him to borrow heavily and awkwardly from himself; sometimes, he simply produced an exterior version of a scene he had previously shown indoors—and put some of the same people in it. For instance, in *The Beginning of the American Navy* (ca. 1923, figure 58) Moran depicted Washington in civilian garb, handing a commission to Captain John Barry. A sentry stands at left, and a scribe is seated at a table. At right, three men look

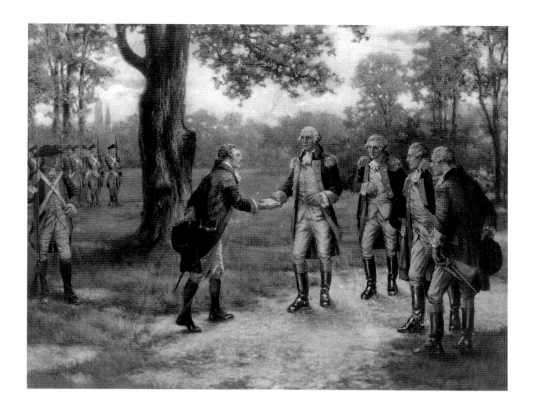

FIGURE 59

E. Percy Moran
(American, 1862–1935)

Washington Receiving His Commission as Commander-in-Chief of the American Army,
n.d.

Calendar illustration, Kemper-Thomas Company, Cincinnati. Private collection.

on; the one nearest Washington rests his right elbow and lower arm atop a chair. Oddly, the same sentry and trio of onlookers turn up in *Washington Receiving His Commission as Commander-in-Chief of the American Army* (n.d., figure 59), which pictures an event that took place in 1775, nineteen years before Barry was chosen to head the new nation's navy.[27]

Just as earlier generations of artists had painted numerous pictures of the private and public Washington, so, too, did a younger generation, who realized that a market still existed for their portrayals of this national icon.[28] But demand for their works was not as strong as it had been for those of the older generations—at least at the art-calendar companies, of which there were fewer by the mid–twentieth century. The Kemper-Thomas Company bought the Osborne Company in 1957, and the new firm became Osborne-Kemper-Thomas; two years later, Gerlach-Barklow joined the enterprise; today the company is no longer in business. The pioneering Thomas D. Murphy Company was sold in 1982 to Jordan Industries, which also purchased Shaw-Barton, founded in 1940. Brown and Bigelow, which has had several owners over time, remains a power in the calendar field.[29]

Perhaps a change in public taste is the primary reason for the decline of Washington imagery on calendars. In 1965 Brown and Bigelow's art director observed that the most significant shift in the trade was to "the use of contemporary design." For the first time, he declared, "we have found it acceptable, [and] we will see calendars done with an entirely different approach to pictorial representation."[30] Ten years later, as the nation celebrated the bicentennial of the Declaration of Independence, there was a temporary revival of interest in history subjects.[31] But most artists seeking to sell images to the trade had to paint pretty girls, cunning animals, or lovely scenery to attract the interest of company executives, and even those subjects faced competition from photographs, which calendar companies, advertising agencies, and book and magazine publishers were purchasing intact. Nevertheless, if the market for Washington images has declined, it has hardly disappeared. Today, two centuries after his death, visual representations of the nation's first president continue to appear frequently in the popular media.

NOTES

1. See John Hill Morgan and Mantle Fielding, *The Life Portraits of Washington and Their Replicas* (Philadelphia: Printed for the subscribers, 1931), and the essay by David Meschutt in this volume. Although the Washington image first appeared on the dollar bill in 1869, it was used as early as 1861 on a $500 U.S. government-issue, sixty-day interest-bearing note. See Albert Pick, *Standard Catalog of World Paper Money,* 7th ed. (Iola, Wis.: Krause Publications, 1994), 2:1190.

2. For sculpture, see Frances Davis Whittemore, *George Washington in Sculpture* (Boston: Marshall Jones Company, 1933), and the essay by H. Nichols B. Clark in this volume.

3. For a discussion of the literary image of George Washington, see the essay by Barbara J. Mitnick in this volume.

4. Prior to working for the Strobridge firm, Ogden had been a staff artist for *Frank Leslie's Illustrated Newspaper.* For biographical information, see *Who Was Who in America* (Chicago: A. N. Marquis, 1943), 1:912, and Peggy and Harold Samuels, eds., *The Illustrated Biographical Encyclopedia of Artists of the American West* (Garden City, N.Y: Doubleday, 1976), 351. The 1899 date comes from a birthday card, sent by the regent and vice-regents of the Mount Vernon Ladies' Association, on which the picture appears.

5. For Dunsmore, see *The National Cyclopedia of American Biography* (New York: James T. White and Company, 1909), 10:366–67; *Who Was Who in America* (Chicago: A. N. Marquis, 1950), 2:166; and Florence Seville Berryman, "Dunsmore's Epic of the American Revolution," *Daughters of the American Revolution Magazine* 60, no. 11 (November 1926): 644–54, and 61, no. 1 (January 1927): 25–33.

6. Born in California in 1886, Hinton later lived in Chicago, where he studied at the School of the Art Institute. For biographical information, see "Painter of Our National Heritage, Walter Haskell Hinton: Retrospective Exhibition," exh. brochure (Knoxville: Ewing Gallery of Art and Architecture, University of Tennessee, n.d.). See also note 17 of this essay.

7. Another potential market for these and other artists were firms that made color reproductions for customers who wanted pictures for framing. Examples are C. Klackner and the Knapp Company, both of New York City. Information about these and other firms is scarce, with references generally restricted to catalogues of works of art published by the U.S. Copyright Office, Library of Congress, Washington, D.C. Furthermore, their products usually are unclassified by the library and included among more than ten million prints and photographs stored off-site and essentially unavailable to researchers. This difficult situation may account for the dearth of scholarly work on color prints produced during the twentieth century. For information about the unclassified pictures, contact Harry Katz, Popular and Applied Graphic Arts Section, Prints and Photographs Division, Library of Congress. See also Neil Harris, "Iconography and Intellectual History: The Halftone Effect" and "Pictorial Perils: The Rise of American Illustration," in *Cultural Excursions: Marketing Appetites and Cultural Tastes in Modern America* (Chicago and London: University of Chicago Press, 1990).

8. For color-reproduction methods, see Steven Lubar, *Infoculture: The Smithsonian Book of Information Age Inventions* (Boston and New York: Houghton Mifflin, 1993), 51–64. For color separation, see Tom Cardamone, *Mechanical Color Separation Skills for the Commercial Artist* (New York: Van Nostrand Reinhold, 1980).

9. Samuels, eds., *Illustrated Biographical Encyclopedia of Artists of the American West,* 385. For Pyle, see *Dictionary of American Biography,* 8, pt. 1 (New York: Charles Scribner's Sons, 1935), 287–90, and *The National Cyclopedia of American Biography* (New York: James T. White and Company, 1941), 29:266–67. More extensive studies include Henry C. Pitz, *The Brandywine Tradition* (Boston: Houghton Mifflin, 1969), and idem, *Howard Pyle: Writer, Illustrator, Founder of the Brandywine School* (New York: Clarkson N. Potter, 1975). Willard S. Morse and Gertrude Brinckle, comps., *Howard Pyle: A Record of His Illustrations and Writings* (Wilmington, Del.: Wilmington Society of the Fine Arts, 1921), lists all his works and where they were reproduced.

10. The story of Pyle as illustrator of Wilson's *George Washington* can be followed in correspondence in Arthur Link, ed., *The Papers of Woodrow Wilson,* vol. 9 (Princeton, N.J.: Princeton University Press, 1970), especially Henry M. Alden to Woodrow Wilson, June 28, 1895, 311; Wilson to Alden, July 12, 1895, 314; Alden to Wilson, August 21, 1895, 316; Howard Pyle to Wilson, October 5, 1895, 323; Wilson to Pyle, October 7, 1895, 324; and Wilson to Pyle, December 23, 1895, 367–68. Pyle and Wilson exchanged more than twenty letters in 1896.

11. For details of the book contract, see Harper and Brothers to Wilson, May 5, 1896, Link, ed., *The Papers of Woodrow Wilson,* 9:500. Wilson's acceptance of the contract and his wish to include the Pyle illustrations are in Wilson to Harper and Brothers, May 16, 1896 (9:504–5).

12. William M. Sloane, *Book Buyer* (December 1896), as quoted in Link, ed. *The Papers of Woodrow Wilson* (1971), 10:67.

13. For a full biographical treatment of Ferris and discussion of his work, see Barbara J. Mitnick, "Jean Leon Gerome Ferris, 1863–1930: America's Painter Historian" (Ph.D. diss., Rutgers: State University of New Jersey, 1983), which also has nineteen appendices, including an autobiographical sketch by the artist (Appendix 3) and an edited version of his account book, which runs from 1888 to 1930 (Appendix 4). See also idem, *Jean Leon Gerome Ferris, 1863–1930: American Painter Historian,* exh. cat. (Laurel, Miss.: Lauren Rogers Museum of Art, 1985).

14. Information about Ferris's *Ladies' Home Journal* reproductions is in Mitnick (1983), Appendix 7, 278–79, and Appendix 4, 266–67. For the Congress Hall exhibition, see Mitnick (1983), 157–65.

15. See Mitnick (1983), Appendix 4, 269–70, and Appendix 8, 280–81. Ferris also sold rights to nearly thirty of his pictures for inclusion in Ralph Gabriel, ed., *The Pageant of America: A Pictorial History of the United States,* 15 vols. (New Haven, Conn.: Yale University Press, 1925–28). See Mitnick (1983), Appendix 4, 267, and Appendix 6, 276–77.

16. For DeLand, see *Who Was Who in America,* 2:151, and "Famous Firsts: The Paintings of Clyde O. DeLand," *American History Illustrated* 14, no. 1 (April 1979): 20–29. See also letters to the author from DeLand's cousin Harold DeLand, June 18, 1949, and from the artist's friend Maurice Bower, March 1, 1965.

17. See Roland Wade, "A Brush with History," an undated reprint of an article that appeared in a company publication. When asked how the incidents depicted in his paintings came to him, Hinton replied, "I have many books on Washington," adding that they provided ideas. Information about the Washington National Insurance Company and about Hinton comes from the following undated company pamphlets: *George Washington: Pictures of His Early Life; George Washington: Pictures of Little-Known Events;* and *George Washington and the American Revolution Bicentennial.* See also letters to the author from com-

pany employee Frank Elston, February 12, 1965, and July 21, 1965; from company employee F. E. White, October 6, 1975; and from Hinton, March 5, 1965, in which the artist wrote about his paintings. An interview with the artist is "*Coverage* Visits Walter Haskell Hinton," *Coverage* [Washington National Insurance Company periodical] (December 1961): 14–17.

18. For the development of art-calendar companies, see R. C. Rollings, *Specialty Advertising: A History* (Irving, Tex.: Specialty Advertising Association International, n.d.), and Jerilyn Barford and Paul A. Camp, *Those Grand Pioneers of Promotion: A History of Specialty Advertising* (Langhorne, Pa.: Advertising Specialty Institute, 1979). The latter publication is a special issue of *The Counselor* 25, no. 13 (January 1979). For information on Osborne and Murphy, see Rollings, *Specialty Advertising*, 5–8, and Barford and Camp, *Those Grand Pioneers*, 39–60.

19. For the Hintermeisters, see Peter H. Falk, ed., *Who Was Who in American Art* (Madison, Conn.: Sound View Press, 1985), 283. Henry Hintermeister provided the author with a list of his paintings and those of his father in a letter of May 30, 1965. Additional information, including copy sent to newspapers for obituaries, was supplied to the author by Hintermeister's brother Roland on November 24, 1975, and February 19, 1976. It is confusing, but interesting, that both artists signed their paintings "Hy. Hintermeister."

20. Rollings, *Specialty Advertising*, 13; Barford and Camp, *Those Grand Pioneers*, 39–60; *Where Murphy Calendars Are Made: A Pictorial Study* (Red Oak, Ia.: Murphy Press, 1913); and "Calendar's Cradle," *The Iowan Magazine* 1, no. 2 (December 1952–January 1953): 23–26, 41–42. Elizabeth McKenzie, of the People's Art Project, Red Oak, Ia., provided the author with a transcript of a May 16, 1990, interview with Richard Howlette, a former Murphy Company executive.

21. For Moran, see *The National Cyclopedia of American Biography*, 10: 367, and *Who Was Who in America*, 1:863. See also *The Moran Family*, exh. cat. (Huntington, N.Y.: Heckscher Museum, 1965), especially 18. Moran's sales to the Murphy Company can be followed in computer printouts of the People's Art Project, Red Oak, Ia. For the People's Art Project, see *The People's Art, 1889–1989*, exh. cat. (Red Oak, Ia.: privately printed, 1991); Elizabeth McKenzie, "The People's Art," *American Art Review* 6, no. 1 (February–March 1994): 116–23; and Jean C. Florman, "The People's Art: Murphy Calendars," *The Iowan Magazine* 40, no. 3 (spring 1992): 34–39.

22. Humphrey to the author, February 16, 1965. A brief biographical sketch of the artist appears in Falk, ed., *Who Was Who in American Art*, 299. The records of the People's Art Project provide data about Humphrey's dealings with the Murphy Company.

23. For Brown and Bigelow, see Rollings, *Specialty Advertising*, 11–13, and Barford and Camp, *Those Grand Pioneers*, 147–64.

24. Mitnick (1983), Appendix 4, 262–63, 268. For the Gerlach-Barklow Company, see Rollings, *Specialty Advertising*, 16, and Barford and Camp, *Those Grand Pioneers*, 62–63.

25. For Brownscombe, see *The National Cyclopedia of American Biography* (New York: James T. White and Company, 1918), 16:425; *Who Was Who in America*, 1:154; Edward T. James, ed., *Notable American Women* (Cambridge: Harvard University Press, 1971), 1:258–59; Jules Heller and Nancy G. Heller, *North American Women Artists of the Twentieth Century* (New York: Garland Publishing, 1995), 94; and Kent Ahrens, "Jennie Brownscombe: American History Painter," *Woman's Art Journal* 1, no. 2 (fall 1980–winter 1981): 25–29.

26. For Kemper-Thomas, see Rollings, *Specialty Advertising*, 9–11, and Barford and Camp, *Those Grand Pioneers*, 65.

27. Because Moran did not date these paintings, their sequence can only be established stylistically. The author received these Kemper-Thomas calendars from a client of the firm, the Russell Index Company, Pittsburgh, in January 1948. Because Moran sold paintings rather than reproduction rights, his canvases have scattered.

28. Mark Edward Thistlethwaite, *The Image of George Washington: Studies in Mid-Nineteenth-Century American History Painting* (New York and London: Garland Publishing, 1979), discusses artists born between 1810 and 1830 who produced scenes from Washington's life between 1840 and 1870; they include Alonzo Chappel, Felix Darley, John W. Ehninger, Daniel Huntington, T. H. Matteson, Thomas P. Rossiter, Christian Schussele, and J. B. Stearns. Walter M. Baumhofer, born in 1904, produced three Washington subjects for the Murphy Company in the 1960s. For details, see the People's Art Project computerized catalogue and a letter from Baumhofer to the author, March 9, 1975, in which he wrote, "I wish I had had the opportunity of doing more Washington paintings."

29. For changes in art-calendar company ownership, see *A Welcome to You* (Cincinnati: Osborne-Kemper-Thomas Company, 1961); Rollings, *Specialty Advertising*, 8, 10, 13, 16; Barford and Camp, *Those Grand Pioneers*, 160; and *Red Oak (Ia.) Express*, November 3, 1982, March 17, 1989, May 16, 1989, and February 23, 1990.

30. Clair V. Fry, art director, Brown and Bigelow, to the author, February 24, 1965.

31. Various calendars with a Bicentennial theme appeared in 1976.

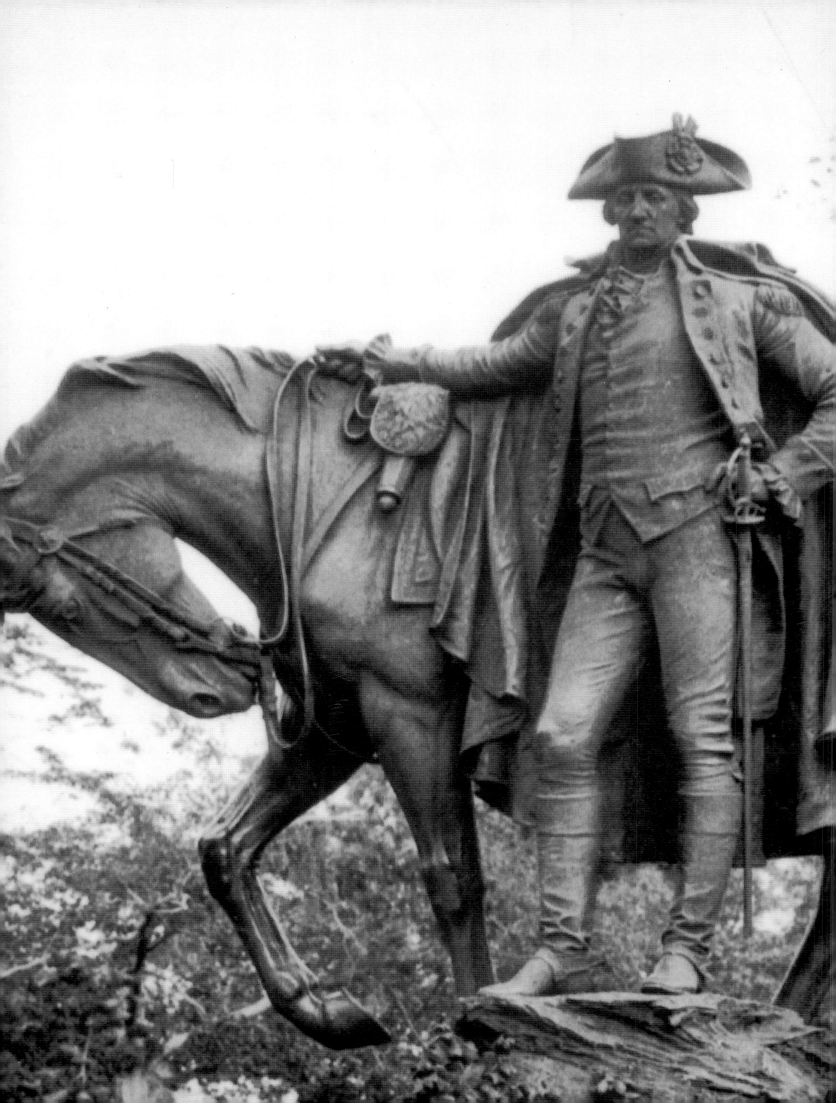

BARRY SCHWARTZ

GEORGE WASHINGTON: A NEW MAN FOR A NEW CENTURY

*George Washington never tolerated the notion, flaunted by some of his succes-
sors in the Presidential chair, that the voice of the people, whatever its tone or
its message, is the voice of God; nor was his political philosophy summed up
in "keeping his ear to the ground," in order to catch from afar the rumblings
of popular approval or dissent. . . . Will any one say that there is no need of
such men now, or that the common people would not hear them gladly if once
it were known that they dwelt among us?*

—*The Nation,* 1899[1]

"Every conception of the past is construed from the standpoint of the
concerns and needs of the present."[2] Could the sociologist George
Herbert Mead's statement be applied to George Washington at the 1899
centennial of his death? Was Washington the same man at the turn of
the twentieth century, when America was becoming an industrial democ-
racy, as he was at the turn of the nineteenth, when the nation was still a
rural republic? The title of the present essay suggests that the question has already been
answered, but the matter is more complex than that. Because any historical object
appears differently against a new background, Washington's character and achieve-
ments necessarily assumed new meaning from the Jacksonian era and Civil War
through the Industrial Revolution. Washington's changing image, however, is only
one part of this story. Focusing on the first two decades of the twentieth century, the
other part of the story—"Washington's unchanging image"—must also be considered.
During the Progressive Era, as it came to be called, America's newly industrialized soci-
ety was transformed by a host of political and economic reforms: Antitrust legisla-
tion, child-labor laws, a redistributive income tax, the direct election of United States
Senators, and woman suffrage were among scores of significant measures ushering the
United States into the twentieth century. What made Washington so serviceable to this
era, however, were the features of his image that endured as well as changed.

Portrait and history painters originally depicted Washington in the neoclassical
style. These images were credible to their intended viewers, but their continued rele-
vance depended on realist models, evident as early as the 1820s and maturing by mid–

century, showing Washington to be an ordinary man in whom ordinary people could see something of themselves. Although certain aspects of his image were reinterpreted as times changed, its fundamental character, deeply set in the reality of the late eighteenth century, could not be altered. The patrician image of Washington, originally captured in prints, paintings, and sculpture through a neoclassical paradigm, remained appealing through the nineteenth and early twentieth centuries. Thus, patrician and egalitarian traditions in the portrayal of George Washington coexisted, each articulating the concerns of a rapidly modernizing, imperfect society.

Projecting the Present into the Past: A Man of the People

The first generation of Washington biographers included Aaron Bancroft, John Marshall, James Kirk Paulding, David Ramsay, and, most prominently, Jared Sparks. Marshall's and Sparks's works were authorized by George Washington's nephew Bushrod. In the 1840s a new corps of biographers, including John Frost, Joel T. Headley, and Benson J. Lossing, presented an idealized version of the man, as had their predecessors; but they humanized their hero, showing him performing in normal as well as spectacular ways.[3] After the Civil War, Washington's admirers far outnumbered his critics, but his prestige had diminished, and sympathetic intellectuals were concerned to clarify further the record of his life. Their efforts succeeded, and by the turn of the century he seemed an ordinary man embodying the greatness of which all men are capable—in short, a man with whom the masses could identify. "Nearly every recent biographer," noted Wayne Whipple in his own book about the great leader's life, "has announced that he was now taking down the wooden image called 'Washington' from its high pedestal."[4] Although some observers, such as the writer Edward C. Towne, regarded this shift as "a method of detraction . . . upon the theory that we gain a man while we lose a hero," the general public, according to one *Chicago Daily Tribune* editor, found "the newer Washington a far more attracting personage than the older one."[5]

Washington was refashioned under the same paradigm that popularized the life of Lincoln. This "realist" model was a postwar development, well suited to the candid depiction of life in a new, industrially oriented society. Realism portrayed life "as it was" rather than idealizing it. By taking as its subject matter "the common, the average, the everyday," realism expressed the nation's increasingly egalitarian mood.[6] Realist writings not only supported contemporary reportage of business villains and their abuses but also brought forth heroes of the past and reinterpreted their virtues. Many writers, even the socially privileged, wanted particularly to know what George Washington was "really" like in his everyday life; their discoveries made him seem less distant and more approachable than he had seemed earlier.

Since many in the late nineteenth century regarded the frontier as the ultimate source of democracy, those wishing to perpetuate the first president's memory stressed his frontier experiences. Woodrow Wilson, the son of an upper-middle-class minister, asserted that Washington's exploits in the wilderness made him as much a man of the people as Lincoln. "Living tolerably on the frontier" was a litmus test for the "true American type," and Washington passed it. He was "a man fit either for the frontier or the council-room."[7] As the frontier disappeared, Washington's admirers continued to

FIGURE 60

William Ballantyne Brown
(American, fl. early 20th century)

Lincoln and Washington, 1909

*Cover from an unidentified journal. The
Lincoln Museum, Fort Wayne, Indiana
(Ref. no. 2431).*

identify him with it. President William Howard Taft, reared by an old and distinguished Ohio family, told one Washington's Birthday audience how much he resented the idea that Washington was unlike common Americans and cited his experience as an "Indian fighter" and "pioneer."[8] Washington was, to be sure, an aristocrat, but his emotions and actions resembled those of the average man. "When there was active work to be done," the *Chicago Daily Tribune* told its readers, "he did not hesitate to lay aside his coat and labor with his workmen, and there were few whose strength could vie with his." In his relations with all people, "Washington was stretching out a hand to Lincoln."[9] Washington's connection to Lincoln, the personification of American democracy, is made explicit in prints that circulated throughout the country during the early decades of the twentieth century. In one such image, a journal-cover illustration produced during the 1909 centennial of Lincoln's birth, the People's President reads from a stack of books and documents as Washington, pictured on the wall behind, figuratively guides him (figure 60).

Late-nineteenth-century accounts of Washington's romantic life also conveyed his humanity. The press and popular literature stressed this theme more than any other. "He indulged in romantic dreams of youthful love," a Savannah reporter informed his readers, while the biographer Paul Leicester Ford detailed for the first time Washington's hands-off but nonetheless passionate friendship with Sally Fairfax, the wife of his close friend George William Fairfax. Washington's infatuation with Sally began in adolescence and lasted, secretly, through his young adulthood. His affection, however, might not have been invested in Sally alone. In particular, who exactly was this "Mrs. Neil," who was expected to provide the twenty-one-year old Colonel Washington a "delight only heaven can afford"?[10] Ford left the matter unexplained.

Yet by all accounts, the love of Washington's life was Martha, and by the 1890s their wedding anniversary had become a day to be commemorated. Sponsored by the

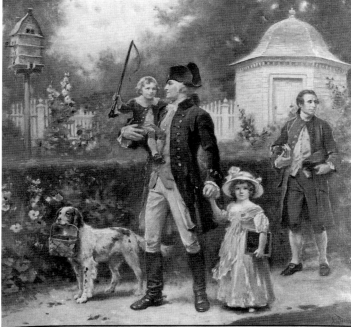

"THE MOUNT VERNON SCHOOL HOUSE, 1786"—By J. L. G. Ferris

FIGURE 61

Jean Leon Gerome Ferris
(American, 1863–1930)
The Mount Vernon School House, 1786,
ca. 1913
Cover illustration, The Literary Digest,
September 20, 1930. Private collection.

Daughters of the American Revolution, the celebration reawakened artistic as well as public interest. In 1849 Junius Brutus Stearns had painted *The Marriage of Washington to Martha Custis* (color plate 9), which was made into a popular print five years later by August Regnier. By the early twentieth century, depictions of the couple were considerably less formal. Jean Leon Gerome Ferris, the son of a middle-class Philadelphia portrait painter, was by far the most prolific producer of this historical genre.[11] His painting *The Courtship of Washington, 1758* (ca. 1917, color plate 21), to take one example, depicts George and Martha in a purely domestic situation. The ardent colonel holds the young widow's hand in his; he faces her and she, him. His gesture and her smile give the scene exceptional vitality. Disorder is also evident: Martha's cat, indifferent to the historic scene of which it is a part, grooms itself under the table; a doll and ball are on the ground at George's feet, bringing the two Custis children symbolically into the picture.

Love of children characterized the authentic George Washington. Woodrow Wilson discovered that Washington not only played with children whenever possible but also enjoyed just being around them. Needing refreshment after working for a long stretch, he "would often peep through the crack of a door and watch them play."[12] Painters and publishers recognized this as an endearing part of Washington's personality. Ferris, for example, shows him taking his two adopted grandchildren, George and Eleanor (Nelly) Custis, on a walk around the garden while their tutor, Tobias Lear, follows along, ready to begin lessons as soon as the indulgent grandfather can let them go (figure 61).

Ferris conceived his paintings of George, Martha, and their grandchildren during a period animated by a "moral movement in democracy," one in which the ruling elite was expected to resemble the people it represented and served.[13] John Ward

Dunsmore's *Marriage of Nellie* [sic] *Custis at Mount Vernon* (1909) depicts Washington in this light—one in which all viewers can see themselves. Nelly appears as a grown woman, greeted by her grandfather as she descends the steps on her wedding day (figure 51, p. 111). Resolved to marry on her grandfather's sixty-seventh birthday, she has asked him to attend the ceremony in his military uniform, and he has readily agreed. It is a touching scene: Grandfather and granddaughter attract every eye in the room as they look tenderly upon each other. Washington's back is to the viewer, but the warmth of Nelly's expression mirrors his. The scene becomes even more poignant as we realize that this was the great man's final birthday.

In Dunsmore and Ferris's generation, when the social distance between the people and their leaders was less than it had ever been before, the symbolic Father of His Country was portrayed as a real father and a real husband who loved and was amply loved in return. George Washington's prestige was not then as great as it had been before Abraham Lincoln became the nation's Prince of Martyrs in 1865, but he remained the only national hero on whose merits all Americans—Southerners as well as Northerners, Democrats as well as Republicans—could agree. This is why newspapers and popular magazines carried more articles about him than any other historical figure.[14] This is why he dominated late-nineteenth- and early-twentieth-century prints showing the nation's presidents, of which *Washington and His Successors* (1897, figure 62) is representative. And this is why he was the only American hero commemorated by a death centennial.

BRINGING THE PAST INTO THE PRESENT:
A MAN ABOVE THE PEOPLE

The idea for the December 14, 1899, observance of the anniversary of Washington's death originally emerged in the Colorado Grand Lodge of Freemasons, but it soon spread throughout the country and was adopted by many non-Masonic organizations.

In New York City, the Order of the Cincinnati and Sons of the Revolution jointly arranged commemorative services at St. Paul's Chapel, conducted by rectors of Trinity Church and of various universities in the area. The National Guard, the Society of the War of 1812, the Mayflower Society, the Daughters of the American Revolution, the Colonial Dames, the Aztec Society, and the Society of Colonial Wars, among other organizations, conducted their own ceremonies. New York City's schools flew flags at half mast and held extensive lessons and exercises, which included Grand Army of the Republic representatives explaining the significance of the day.[15]

Washington's death was commemorated in 1899 because the virtues his contemporaries admired remained relevant to his successors. His Federalist and Whig biographers, ambivalent about democracy, had emphasized Washington's gentlemanly qualities and set him apart from the people. But their influence was far from absolute. New political symbols, such as log cabins, cider, and axes, and new representative men, such as Andrew Jackson and William Henry Harrison, had modified the heroic vision of the early nineteenth century. These developments achieved their fullest expression when Lincoln entered the national scene. Before then, the neoclassical paradigm, although noticeably weakened by the 1840s, had powerfully influenced Washington's image. Emphasizing the man's restraint and temperance, his well-balanced abilities, his steady judgment, and his devotion to justice and order, the neoclassical model reflected an enduring patrician ideal. The late nineteenth century brought the 1876 celebration of the nation's centennial and the Colonial Revival, both of which promoted nostalgia for the time when the country was founded; in that atmosphere, few Americans had difficulty thinking of great men in neoclassical terms. Many, in fact, could not conceive of greatness in any other way.

While Ferris and Dunsmore democratized Washington's image on canvas and Howard Pyle and others did the same in book and magazine illustrations, sculptors were constructing a stately man, the only kind whom Washington's own contemporaries would have recognized. That such an elevated conception is not inherent in the medium of sculpture is evident in contemporaneous representations of Abraham Lincoln. Few images seemed more natural than Gutzon Borglum's 1911 statue of the seated Lincoln wearing a sad expression, hunched over on a bench at street level where passersby could sit beside him; Charles Mulligan's 1911 sculpture of the youthful Lincoln with an ax beside a felled tree; George Grey Barnard's 1917 portrayal of Lincoln as a frontier lawyer, with big feet and and shabby clothes; and Merrell Gage's 1918 depiction of Lincoln casually leaning forward, about to rise from a low-backed chair. No sculptural depiction of George Washington even remotely resembles these mundane images.[16]

There are many neoclassical forms, differing from one country, one generation, and one artistic medium to another. At the turn of the twentieth century, the neoclassical statue was identified by distinctive characteristics—formal or military attire and cloak; erect posture, with one leg slightly bent; one hand resting on a pillar or fasces or an ornate table or chair, or holding a scroll, public document, or sword, or pointing in some direction; if seated, the figure's back and arms are fully supported by a symbolic chair of state; if on horseback, the upright figure grasps a weapon or reins. Thus depicted, Washington appears larger than life, always majestic, always performing sublime feats.

Rudolph Siemering's bronze equestrian statue, dedicated in Philadelphia in 1897 before a multitude that included President William McKinley, epitomizes Washington's neoclassical form (figure 63). Conceived and wrought in Berlin after Christian

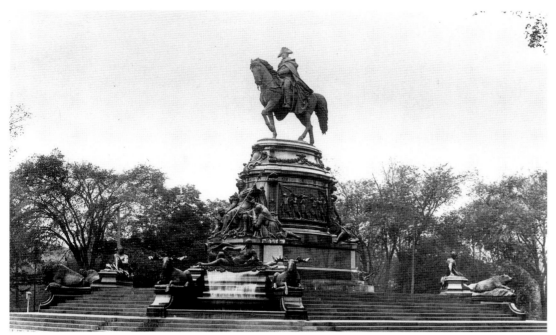

FIGURE 63
Rudolph Siemering
(German, 1835–1905)
The Washington Monument, 1897
*Bronze, h: 108 in. Benjamin Franklin
Parkway at Eakins Oval,
Philadelphia.*

Rauch's 1852 statue of Frederick the Great, the work captures Washington sitting majestically on his spirited horse, holding a field glass in one hand and reins in the other. Symbols abound in Siemering's statue. Indian men and nude Indian women, situated beside four cascading fountains, represent the Delaware, Hudson, Potomac, and Mississippi Rivers. Siemering has employed indigenous species of moose, deer, bear, and buffalo, along with the Indians, to distinguish the New World from the Old. Thirteen steps, representing the colonies, lead to the three-tiered pedestal. At the back of the monument, invisible to the viewer, a seated female figure symbolizing America rouses her slumbering sons to battle. At the front, America holds a horn of plenty in one hand, a trident in the other. Her victorious sons lay the chains they have cast off and their emblems of allegiance at her feet. On the sides of the pedestal are two bas-reliefs: In one, several soldiers marching to war represent American determination and character; on the other side, a west-bound immigrant train represents peace and progress.[17] Embodying the history, the very soil, of America, Washington looks toward Independence Hall, where he was appointed to lead the Continental Army.

Siemering had initially imagined his statue at the very time James Russell Lowell read his poem "Under the Old Elm" at the July 3, 1875, centennial of Washington's taking command of his troops in Cambridge. Washington, as Lowell described him, lived in a world of "statelier" movement, and he prevailed over forces that dwarf those minor issues over which we now "fret." Although Lowell's world was more open, vital, and freer in emotional expression than was Washington's, there was, nevertheless, something banally narrow about it. It was during America's "roomier days," a time of ampler leisures and stormier crises, that

> Virginia gave us this imperial man
> Cast in the massive mould
> Of those high-statured ages old
> Which into grander forms our mortal metal ran;
> She gave us this unblemished gentleman
>
> . . .
>
> Mother of States and undiminished men
> Thou gavest us a country, giving him.[18]

FIGURE 64

Lorado Taft (American, 1860–1946)

Apotheosis of Washington, 1901

Bronze, h: 168 in. Pemco Webster and Stevens Collection, Museum of History and Industry, Seattle, Washington.

Yet how is this "imperial man" to be regarded by a society of ordinary men, of men cast in the modest mold of a low-statured age whose mortal metal runs into diminished forms?

Thoughtful citizens everywhere asked themselves this question. They believed that without great men and great ideas there could be no civilization—only venality, mediocrity, and crassness. "Why was it," asks Mrs. Lightfoot Lee, the main character in Henry Adams's novel *Democracy* (1880), "that everything Washington touched, he purified, even down to the associations of his house? And why is it that everything we touch seems soiled? Why do I feel unclean when I look at Mount Vernon?"[19]

Lowell and Adams spoke not to their class alone. Most ordinary men and women recognized the moral decay of their Gilded Age generation and were ready to embrace the genteel Washington as an example to emulate. Throughout the Progressive Era, too, he embodied the ideals that America's business and political leaders seemed to betray. In a poem published in the *Chicago Daily Tribune* in 1910 to commemorate his birthday, Washington is asked:

> You, who were Freedom's chosen spear—
> Her organ—
> Would you have traded, had you known,
> The occupant of England's throne
> For Rockefeller or for Pier-Pont Morgan?"[20]

True, Washington also had been wealthy, but because he was a selfless aristocrat rather than a self-serving businessman, he had been suited for public responsibility. In the words of a contributor to the staunchly progressive *Outlook* magazine, "He was in no sense commercial, and no American hero has ever been commercial."[21] The aristocratic ideal was thus harnessed to the antibusiness inclinations of the common man.

For the sculptor Lorado Taft, the memory of Washington was a model for, rather than a model of, a diminished society. His 1901 bronze, *Apotheosis of Washington,* dedicated ceremoniously on the campus of the University of Washington in Seattle, stands fourteen feet tall on a twenty-foot-high pedestal (figure 64). Washington wears a long military cloak, his hands rest on an oversized symbolic sword, and his head is upright. Seeking to evoke the quality as well as the endurance of Washington's presence, Taft intended the statue to be nonrealistic: "I wish this . . . to have a touch of the ideal, to show 'The Father of His Country' rather than the General . . . in any particular situation." He added, "I dream of it as a kind of apotheosis of Washington, a "mighty, shadowy presence serenely surveying the uttermost territory of the nation which he founded. I give him a certain aloofness."[22]

J. Massey Rhind's *George Washington Bids Farewell* is, like Taft's *Apotheosis,* lofty and distant (figure 65). The general, receiving news of the British evacuation of New York City, takes leave of his troops at Rocky Hill, New Jersey. Dedicated in Newark on November 2, 1912, the bronze statue shows Washington, dismounted but with commanding mien, head and shoulders elevated above his impatient steed.[23]

The Siemering, Taft, and Rhind statues all reflect the pervasive idealism and excess of the American Renaissance, an artistic movement that bridged the Gilded Age and the Progressive Era. Since it was "a new sense of history that most directly formed

FIGURE 65

J. Massey Rhind
(American, 1860–1936)

George Washington Bids Farewell, 1912

Bronze, h: 120 in. Washington Park, Newark, New Jersey.

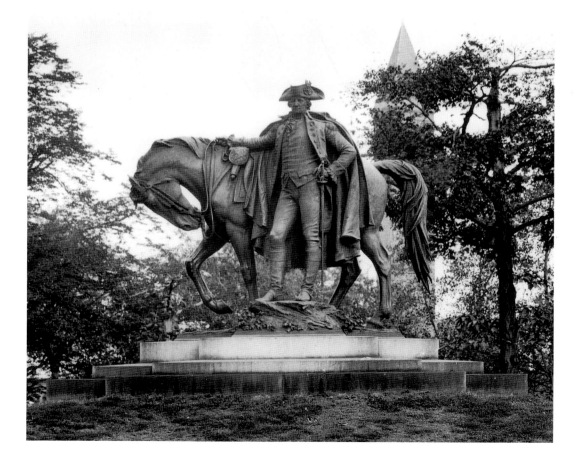

Figure 66

Hermon A. MacNeil
(American, 1866–1947)
George Washington as Military Commander, 1916 (left)
and

A. Stirling Calder
(American, 1870–1945)
George Washington as President, 1918 (right)

Marble, h. of each: 144 in. Washington Arch, Washington Square Park, New York.

the mental set of the American Renaissance,"[24] the past was idealized not only in oversize statues but also in the widespread construction of massive museums, libraries, and imposing architectural structures such as temples, domes, colonnades, and, above all, triumphal arches. The Dewey Triumphal Arch and Colonnade in New York City, the Arch of the Rising Sun in San Francisco, and the Sailors and Soldiers Memorial Arch in Brooklyn were conceived and erected amid urban growth, surging nationalism, and the City Beautiful movement.[25] It was within this context that Hermon A. MacNeil and A. Stirling Calder installed their interpretations of Washington as military commander and president, respectively, in New York City's Washington Arch in 1916 and 1918 (figure 66). MacNeil portrayed the general struggling to maintain his army through bitter winters. The great soldier appears in hat and cape, hands resting on his sword, standing upright in front of allegories of Courage and Fortitude. On the opposite pylon appears Calder's President Washington, also accompanied by allegorical images—Wisdom and Justice—dressed in the simplest style and exuding virile grace and dignity.[26]

In the spirit of the American Renaissance and its celebration of distinction, the sculptors of Washington, including Daniel Chester French, Edward C. Potter, Frederick G. R. Roth, and Henry Merwin Shrady, were determined to perpetuate America's genteel legacy. If popular illustrators made Washington's image safe for modern democracy, sculptors encouraged viewers to know the man as his contemporaries had—that is, as a demigod whose virtues and feats no mortal could match. The sculptor's chisel expressed something the collective memory had set aside but never lost.[27]

Ultimately, it was less important for twentieth-century Americans to know what policies and political measures Washington would have supported and opposed than to know what traits were revealed in that support and opposition. This attitude generated a seemingly inexhaustible number of articles on his character. Saturating the

February issues of popular magazines and the Washington's Birthday editions of newspapers, these commentaries affirmed the compatibility of the dignity of the state and its citizens. Washington's character and life, on the one hand, and Progressive Era reforms on the other were thus infused by the same principle, so that the invocation of one invariably evoked the other. Distinction and democracy were, in this sense, reconciled: In Washington, the American people, although living through a period of rapid change, found a stalwart emblem of their unchanging ideals.

GEORGE WASHINGTON AND THE GREAT WAR

The Great War, as it was called until World War II began, projected the ideals of the Progressive Era beyond national borders.[28] Just as Washington had been seen to stand for America's antiplutocratic reforms, he now came to symbolize the meaning behind its first involvement in an extended overseas war. During nineteen months of American fighting, from April 1917 through the November 1918 armistice, his image embodied American war goals, justified the suffering of American soldiers, the sorrow of their survivors and friends, the sacrifices of the society. Images of George Washington thus "framed" the Great War within the grand narrative of the nation.[29] "Every conscious perception," notes the anthropologist Clifford Geertz, "is an act of recognition, a pairing in which an object (or an event, an act, an emotion) is identified by placing it against a background of an appropriate symbol."[30] Works of art are "appropriate symbols" because people rely on them to encompass, and to help make sense of, their experiences. Emphasizing orators' citations of Washington's advice on preparedness in their 1917 Washington's Birthday messages, Daniel Fitzpatrick, a St. Louis newspaper cartoonist, pictured General Washington standing resolutely in the snow, his military cape waving in the cold wind, his sword protruding from below the cape (figure 67). Six weeks later, the United States entered the conflict.

FIGURE 67

Daniel Fitzpatrick
(American, 1891–1969)

Liberty and Justice at Any Price!,
February 22, 1917

Editorial cartoon, St. Louis
Post-Dispatch.

LIBERTY AND JUSTICE AT ANY PRICE!

New images of Washington were created to inspire patriotism; old ones, such as John Quincy Adams Ward's 1889 statue above the steps of Federal Hall National Memorial in New York City, were invoked to the same end (figure 17, p. 50). Ward's work had been created to commemorate Washington's first presidential inauguration. In 1918 the actor Douglas Fairbanks, Sr., stood on the Federal Hall steps, beneath the leader's outstretched hand, and used a megaphone to urge a great throng of listeners to buy war bonds in support of their country's crusade for democracy (figure 68). As Americans engaged their "relentless enemy in a life-and-death struggle," a syndicated writer noted, "what Washington did and said, and caused to be done, is taking on a new and solemn meaning."[31] The writer might have declared just as readily that the "life-and-death struggle" assumed its solemn meaning directly within the context of "what Washington did and said." In the twentieth century, as in the nineteenth, Washington was a lamp for, as well as a mirror of, the times.

Certainly he was for the sculptor Frederick MacMonnies. Before the war, when MacMonnies was living in France, he stalled on an agreement to produce a monument commemorating the Battle of Princeton. But in September 1914, when British and French forces stopped the German offensive at the first Battle of the Marne, uncomfortably close to the artist's home, MacMonnies changed his conception of the work. "I was groping for [the monument] in the past," he later wrote, "and suddenly the present was full of war. I had to admit that my attempt to imagine it was pale indeed to

FIGURE 68

Douglas Fairbanks Sr., George Washington, and Bonds for the Great War, 1918

Photograph. Library of Congress, Washington, D.C.

FIGURE 69

Frederick MacMonnies

(American, 1863–1937)

Princeton Battle Monument, 1922

*Limestone, h: 300 in. Princeton,
New Jersey.*

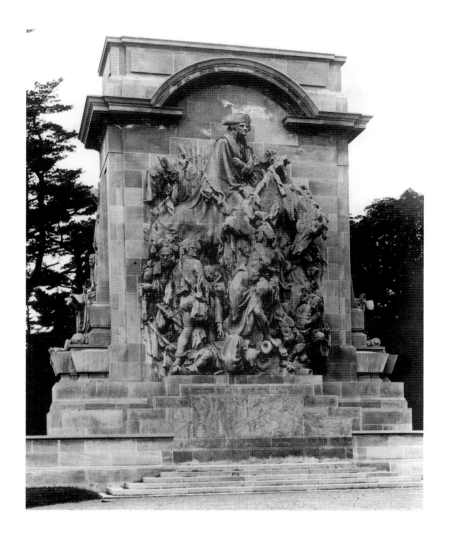

its reality." More than two years before Americans entered the Great War, MacMonnies had associated an Allied victory in Europe with Washington's rallying his troops at Princeton in January 1777 for the first substantial American victory of the Revolutionary War. Attached to a monumental arch and dedicated on June 9, 1922, his bas-relief captures the confusion, trauma, and discouragement of the battle (figure 69). Columbia seizes the reins of George Washington's horse and with her right hand takes the flag from a fallen soldier, whose comrade in death lies at her feet. These figures, along with the cold and exhausted drummer boy at the viewer's lower right, the elderly soldier on the far left binding his own wounds in order to fight further, and, beside him, the worn but sturdy soldier supporting the fallen General Hugh Mercer, are all subordinated to Washington. The commander's clenched left hand protrudes from his cloak while his right hand pulls the sword from its scabbard. Critics complained that the monument was too bombastic for the significance of the battle, but for MacMonnies, as for the public, the work was "a composite symbol of the immensity of Washington's achievement and lends a vivid force to the evocation of this tragic moment on which depended the fate of the Republic."[32]

As MacMonnies worked through the Great War on his relief, printmakers invoked Washington to situate the conflict historically. In a government poster, for example, Washington and Lincoln frame President Woodrow Wilson and the *Brave Boys of 1917* (figure 70), who extend the legacy of America's first great war leader and first president to the world. Propaganda posters portrayed Washington in both military and

FIGURE 70

Unknown

*The Brave Boys of 1917—America
We Love You,* 1917

*Halftone, 19¾ × 16 in.
Reproduced by permission of
The Huntington Library,
San Marino, California.*

civilian dress, visualizing his being "first in war, first in peace"—a symbolic bridge connecting the United States's military and political institutions.

The renewal of a traditional history-painting topic—Washington resigning his command at the end of the Revolutionary War—captured the vital principle of the subordination of military to civilian authority. Edwin Blashfield's triptych *Washington Surrendering His Commission at the Feet of Columbia* (1902, color plate 19), painted for the Baltimore courthouse, is symbolic rather than realistic. The central panel shows him, in a long military coat, accompanied by personifications of the Virtues in medieval and classic dress carrying emblems of War, Peace, Abundance, and Glory. The great general is voluntarily resigning his military power. The "larger implications of the story," observed the artist and critic Kenyon Cox, "are much more clearly expressed than they could be by a realistic representation of the scene that occurred at Annapolis in 1783."[33] Only symbolic devices persuasively capture the transcendent majesty of Washington, the most powerful and influential man in America, subordinating himself to Congress.

CONCLUSION

In the 1840s, humanized representations of George Washington began appearing along with images of Washington the demigod. Between 1865 and 1920, the two ver-

sions were depicted more vividly and frequently than ever, and each was admired in the context of contrasting ideals and interests. Washington the man reflected the dignity of the common people;[34] Washington the demigod reflected a genteel standard before which the entire citizenry, regardless of wealth or patriotism, fell short. Affirming the "use value" of memory, these two conceptions conform to the sociologist Michael Schudson's recognition that "the past is constantly being retold in order to legitimate present interests" and to elaborate present ideals and realities.[35] Throughout the nineteenth century, however, the changing portrayals of Washington possessed similar elements, confirming Schudson's complementary belief that "the past is in some respects, and under some conditions, highly resistant to efforts to make it over." Legacies, Schudson adds, offer the most potent resistance, for the ways people reconstruct the past are "confined to the experiences of their own traditions."[36] Thus, at the turn of the twentieth century, Americans seeking idealism amid political corruption and economic exploitation came to know and revere the same Washington known and revered in the early nineteenth century. Self-sacrifice instead of self-interest; indifference to power instead of political ambition; moderation instead of excess; resoluteness instead of brilliance; rationality instead of fervent religiosity; harmony instead of inconsistency between public and private life: These patrician ideals appeared in the paintings, prints, drawings, and statuary of the new industrial era.

Washington's virtues were the very traits that eventually enabled Abraham Lincoln to surpass him in popular esteem. Aristocratic men, however selfless and wise, are respected, not loved—at least not in a maturing industrial society, with its emphasis on equality, rights over obligations, a loosening of institutional restraints, deepening sentimentality, and an enhanced appreciation of spontaneity and the senses.[37] In the journalist Norman Hapgood's words:

> [M]en live little in their judgements, much in their sentiments. Lincoln was a great man; Washington was even greater; but Lincoln lived and expressed the sorrows, the longings, the humor of us all, and the abilities and character of Washington are not easy of approach.... The man around whose gigantic figure the American nation was formed is not romantic and he is not to a high degree articulate; there is in the actual Washington little to reach the sentimental soul.[38]

For Hapgood, as for other commentators, Washington's distinguishing trait was an undramatic devotion to duty. His "was a nature fit for bearing the greatest load ever carried by an American," but it was precisely that nature that reduced his personal attractiveness. He spent his life, from late adolescence to old age, in positions of responsibility. Sacrificing youth, he grew into a stately and aloof adult, a man to be emulated rather than embraced.[39]

Washington's image has resisted fundamental revision because of the force of his character, the clarity of his political purposes, and the intensity of his charisma. Charisma, as the sociologist Edward Shils defined it, reflects the possession of "ordering power"—the capacity to destroy and recreate institutions and states.[40] The contemporary relevance of Washington's ordering power in the late nineteenth century and the first decades of the twentieth century was enhanced, but not explained, by America's new industrial, political, and military strength. For this reason, democratized images of Washington could be superimposed upon the earlier epic images, but they could never replace them. George Washington was a "new man for a new century," then, not because people changed their conceptions of what he did but because they related what he did to their new problems and conditions, because they discovered him to be a paragon not only for his own age but for theirs as well.

NOTES

1. "Washington," *The Nation* 69 (December 21, 1899): 460.

2. George Herbert Mead, "The Nature of the Past," in *Essays in Honor of John Dewey*, ed. John Coss (New York: Henry Holt, 1929), 353.

3. John Marshall, *The Life of George Washington*, 5 vols. (Philadelphia: C. P. Wayne, 1804–7); David Ramsay, *The Life of George Washington* (New York: Hopkins and Seymour, 1807); Aaron Bancroft, *An Essay on the Life of George Washington, Commander in Chief of the American Army through the Revolutionary War; and the First President of the United States* (Worcester, Mass.: Thomas and Sturtevant, 1807); James Kirk Paulding, *A Life of Washington*, 2 vols. (New York: Harper and Brothers, 1835); Jared Sparks, *The Writings of George Washington: Being His Correspondence, Addresses, Messages, and Other Papers, Official and Private, Selected and Published from the Original Manuscripts; with a Life of the Author, Notes, and Illustrations*. Half-title: *Life of George Washington*, 12 vols. (Boston: F. Andrews, 1834–37). The "humanizing" biographies, shaped in part by the romantic paradigm that peaked between 1830 and 1865, include John Frost, *The Pictorial Life of George Washington* (Philadelphia: Thomas Cowperthwait, 1848); Benson J. Lossing, *Mount Vernon and Its Associations* (New York: W. A. Townsend, 1859); and Joel T. Headley, *The Illustrated Life of Washington: Together with an Interesting Account of Mount Vernon as It Is* (New York: G. and F. Bill, 1859). See also William F. Thrall, Addison Hibbard, and C. Hugh Holman, *A Handbook to Literature* (New York: Odyssey Press, 1960), 425–27, 429–32, and the essay by Barbara J. Mitnick in this volume.

4. Wayne Whipple, *The Story-Life of Washington* (Philadelphia: John C. Winston Company, 1911), 1:xiii.

5. Edward C. Towne, preface to J. F. Schroeder and Benson J. Lossing, *Life and Times of Washington* (Albany, N.Y.: M. M. Belcher, 1903), 1:iv; *Chicago Daily Tribune*, February 22, 1910.

6. See Cleanth Brooks, R. W. B. Lewis, and Robert Penn Warren, *American Literature: The Makers and the Making, 1861–1914* (New York: St. Martin's Press, 1974); and Thrall, Hibbard, and Holman, *Handbook to Literature*, 397.

7. Woodrow Wilson, *The Papers of Woodrow Wilson*, ed. Arthur S. Link (Princeton: Princeton University Press, 1966–90), 11:105.

8. Quoted in the *New York Times*, February 23, 1910.

9. *Chicago Daily Tribune*, February 12, 1909.

10. *Savannah (Ga.) Republic*, February 22, 1873; Paul Leicester Ford, *The True George Washington* (Philadelphia: J. B. Lippincott, 1905), 84.

11. For a discussion of grand-style portrayals of Washington, see Mark Edward Thistlethwaite, *The Image of George Washington: Studies in Mid-Nineteenth-Century American History Painting* (New York and London: Garland Publishing, 1979). See also Thistlethwaite's general discussion in "The Most Important Themes: History Painting and Its Place in American Art," in William H. Gerdts and Mark Thistlethwaite, *Grand Illusions: History Painting in America* (Fort Worth: Amon Carter Museum, 1988), 7–58. Despite the prodigious quantity and popularity of Ferris's work, there is only one scholarly account of him: Barbara J. Mitnick, *Jean Leon Gerome Ferris, 1863–1930: American Painter Historian*, exh. cat. (Laurel, Miss.: Lauren Rogers Museum of Art, 1985).

12. Wilson, *Papers of Woodrow Wilson*, 55:482.

13. Richard Hofstadter, *The Progressive Movement* (Englewood Cliffs, N.J.: Prentice-Hall, 1963), 36.

14. Washington's overshadowing of Lincoln during this period is also evidenced by citation counts in the popular literature. Between 1875 and 1899, the *Congressional Record* accumulated 174 entries for Washington (relating mainly to speeches and legislation pertaining to monuments), compared to 64 entries for Lincoln. The *New York Times* shows an even greater disparity: 842 Washington-related articles and 293 related to Lincoln. *Poole's Index* for 1882–92 contains 181 Washington entries and 54 Lincoln entries. Late-nineteenth-century prints depicting American presidents articulated Washington's place in the nation's memory by foregrounding his image or placing it at the center, by rendering his image larger, or by placing it above those of his successors. *Our Presidents* (1876), one of many centennial-year prints, makes Washington the central figure and places Lincoln at his remote left. *Our Twenty-two Presidents* (1884) highlights both men, aligning them vertically (Washington placed above) with images of Columbia and the United States Capitol (see also figure 62). Political-campaign prints of the day conformed to the same pattern.

15. *New York Times*, December 10–15, 1899.

16. Borglum's seated figure of Lincoln is at the Essex County Courthouse, Newark, N.J.; Mulligan's sculpture of the young Lincoln is in Garfield Park, Chicago; Barnard's frontier-lawyer Lincoln is in Lytle Park, Cincinnati; and Gage's seated Lincoln is on the grounds of the Kansas Statehouse, Topeka.

17. For further discussion of the statue and the dedication, see John Tancock, "The Washington Monument," in *Sculpture of a City: Philadelphia's Treasures in Bronze and Stone* (New York: Walker Publishing Company for Fairmount Park Art Association, 1974), 132–41. For illustration of the convention of using indigenous animals and native people to distinguish the New World from the Old World, see Wendy C. Wick, *George Washington, An American Icon: The Eighteenth-Century Graphic Portraits*, exh. cat. (Washington, D.C.: Smithsonian Institution Traveling Exhibition Service and the National Portrait Gallery, 1982), 8–9. See also Frances Davis Whittemore, *George Washington in Sculpture* (Boston: Marshall Jones Company, 1933), 114–16.

18. James Russell Lowell, *The Poetical Works of James Russell Lowell* (reprint, Boston: Houghton Mifflin, 1978), 369.

19. Henry Adams, *Democracy: An American Novel* (1880; reprint, New York: Henry Holt, 1925), 135.

20. *Chicago Daily Tribune*, February 22, 1910.

21. "Washington the Man," *Outlook* 8 (February 1908), 388.

22. Quoted in Whittemore, *Washington in Sculpture*, 148–49.

23. For a discussion of Rhind's statue and the dedication, see Whittemore, *Washington in Sculpture*, 153–58; and *Newark Evening News*, November 2, 1912.

24. Richard Guy Wilson, "Presence of the Past," in Richard Guy Wilson, Dianne H. Pilgrim, and Richard N. Murray, *The American Renaissance, 1876–1917*, exh. cat. (Brooklyn: Brooklyn Museum, 1979), 30.

25. Hirschl and Adler Galleries, *The Arts of the American Renaissance*, exh. cat. (New York: Hirschl and Adler Galleries, 1985), 7–15. See also Richard Guy Wilson, "The American Renaissance and New Jersey," in *Public Art in New Jersey during the American Renaissance* (Wayne, N.J.: Museums Council of New Jersey, 1990), 5–17.

26. The Washington Arch and MacNeil and Calder statues are discussed in Whittemore, *Washington in Sculpture*, 159–66, and Donald Martin Reynolds, *Masters of American Sculpture: The Figurative Tradition from the American Renaissance to the*

Millennium (New York: Abbeville Press, 1993), 72–74. For more on the subject of Washington sculpture, see the essay by H. Nichols B. Clark in this volume.

27. Of the 1,066 articles about Washington cited in the *New York Times Index* between 1875 and 1920, about 13 percent commented on the traditional military and political aspects of his life; 28 percent dealt with the erection of memorials and monuments to him; 14 percent were about Washington statues or paintings; 18 percent reported on the discovery and trade of relics—things Washington wore, touched, or used; and 23 percent described observances related to the anniversaries of his birth or military and political achievements. Thus, almost all articles depicted Washington as anything but a common man, despite the efforts of many late-nineteenth-century scholars and publicists.

28. Arthur S. Link and Richard L. McCormick, *Progressivism* (Arlington Heights, Ill.: Harlan Davidson, 1983), 105–11. See also J. F. Decker, "The Progressive Era and the World War I Draft," *Magazine of History* (winter–spring 1986): 15–18.

29. Barry Schwartz, "Frame Images: Toward a Semiotics of Collective Memory," *Semiotica* 121 (July 1998), 1–40.

30. Clifford Geertz, *The Interpretation of Cultures: Selected Essays* (New York: Basic Books, 1973), 215.

31. *Los Angeles Times,* February 22, 1918.

32. Robert Judson Clark, "Frederick MacMonnies and the Princeton Battle Monument," *Record of the Art Museum: Princeton University* 43, no. 2 (1984): 45. See also Whittemore, *Washington in Sculpture,* 169.

33. Kenyon Cox, *The Classic Point of View* (New York: Charles Scribner's Sons, 1911), 76.

34. Since the democratized image of Washington affirmed nationalistic sentiment, it was invoked often in the context of ethnic strife. Nativists' use of him was manifest in many ways, from pamphlets describing "General Washington's Vision"—a prophecy of America's struggle against European influence (reprinted from Wesley Bradshaw, *National Tribune* 4 [December 1880])—to inflammatory anti-immigrant orations by clergymen and politicians. For the latter, see Karal Ann Marling, *George Washington Slept Here: Colonial Revivals and American Culture* (Cambridge: Harvard University Press, 1988), 128–31, 191, 235–36. The existence of a large immigrant population, unschooled in Americanism, prompted a group of prominent citizens to ask a Congressional committee in 1924 to support their proposal for a federally organized observance of the bicentennial of Washington's birth. The pedagogical intent, expense, and scope of this observance, detailed in *History of the George Washington Bicentennial Celebration,* 4 vols. (Washington, D.C.: United States George Washington Bicentennial Commission, 1932), must have satisfied the original planners. For documentation of nativist motives attending the conception of the bicentennial, see *Activities of the Commission and Complete Final Report of the U.S. George Washington Bicentennial Commission* (Washington, D.C.: United States George Washington Bicentennial Commission, 1932), 5:600.

35. Michael Schudson, "The Present in the Past versus the Past in the Present," *Communication* 11, no. 2 (1989): 105.

36. Ibid., 108, 109.

37. Barry Schwartz, "The Reconstruction of Abraham Lincoln, 1900–1920," in David Middleton and Derek Edwards, eds., *Collective Remembering* (London: Sage, 1990), 81–107.

38. Norman Hapgood, "Washington and Lincoln," *Dial* 67 (July–November 1919): 93.

39. Ibid.

40. Edward A. Shils, "Charisma, Order, and Status," in *Center and Periphery: Essays in Macrosociology* (Chicago: University of Chicago Press, 1975), 256–75.

MARK THISTLETHWAITE

HERO, CELEBRITY, AND CLICHÉ:
THE MODERN AND POSTMODERN IMAGE OF GEORGE WASHINGTON

This century's visual culture has included a profusion of images of George Washington. Artists have shown him being baptized, standing next to the Sphinx, sinking into the dollar bill, crossing a rainbowed Delaware River, mounted on the racehorse Man o' War, and in drag.[1] In art galleries, newspapers, magazines (one even named *George*!), and movies, as well as on television and the Internet, Washington appears as hero, celebrity, and cliché (figure 71).

In 1988 the cultural historian Karal Ann Marling presented a full range of Washington imagery in her book *George Washington Slept Here,* with particular emphasis on the first half of the twentieth century.[2] This brief essay focuses on a sampling of images produced since 1950 to point up how the indelible paradigms of Gilbert Stuart's "Athenaeum" portrait (1796, figure 5, p. 33) and Emanuel Leutze's *Washington Crossing the Delaware* (1851, color plate 10) have been appropriated and recast by modernist and postmodernist artists. A look at two remarkable paintings from the 1930s sets the stage for this discussion.

The first president's likeness inundated American culture during the 1930s as a consequence of the enormous interest and publicity generated by the celebration of the bicentennial of his birth. This Washington-intensive decade is bracketed by two fascinating images: N. C. Wyeth's *In a Dream I Meet General Washington* (1930, color plate 23) and Grant Wood's *Parson Weems' Fable* (1939, figure 72). Although neither artist is considered a modernist, each created a work that resonates with modernism and, in the case of Wood, with postmodernism as well.

FIGURE 71

DixieFoam Beds advertisement,
New York Times, February 15, 1990.

FIGURE 72

Grant Wood
(American, 1892–1942)

Parson Weems' Fable, 1939

Oil on canvas, 38³⁄8 × 50¹⁄8 in. Amon Carter Museum, Fort Worth, Texas.

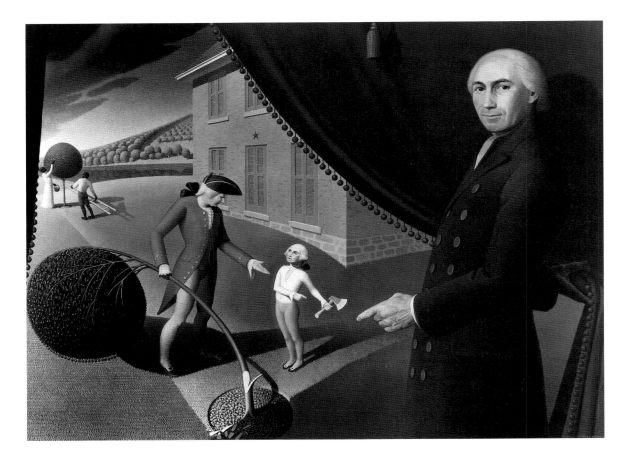

Wyeth's large picture features the artist himself, standing on a scaffold and listening to General Washington describe the Battle of Brandywine. Fought near the artist's Chadds Ford home, this 1777 engagement had long fascinated Wyeth, and he had been profoundly impressed by a 1927 reenactment of the battle. The painter appears to have been interrupted while working on a huge mural. As in the classical myth of Pygmalion and Galatea, the artist's creation has come alive. The talkative hero sits casually on his huge horse. By contrast, Wyeth's attentive stance and shieldlike palette render him more warriorlike than his uncharacteristically relaxed subject. The general gestures over his shoulder to the military action: an artillery wagon speeding off, a column of British troops on the march, Lafayette waving his hat, and Continental soldiers moving at double-time across the hilly, brightly rendered landscape. Two fallen Redcoats at lower left lead the eye to a boy, the artist's son Andrew, perched sketching on a rock that seems to be part of, not apart from, the historical landscape. The artist's scaffold, painted in Cézannesque hinges of color, merges with the battle scene, blurring the distinction between the painter and his mural. The composition's spatial confusion generates shifting perspectives entirely appropriate to a picture that derives from a dream.

As Wyeth described it, after almost tumbling off a thirty-foot-high scaffold while painting a mural of Washington's 1789 pre–inauguration reception in Trenton, he had an "amazingly vivid dream" in which the leader spoke to him about the Battle of Brandywine.[3] As a result, the famous illustrator produced a dreamscape that, intriguingly and incongruously, put him in league with the contemporary movement of surrealism, whose adherents were preoccupied with dream imagery. Wyeth was by no stretch of the imagination a surrealist, but in style and content, *In a Dream I Meet General Washington* reflects a modernist sensibility.

Grant Wood's *Parson Weems' Fable* also possesses an air of unreality, if not surreality. Like Wyeth, Wood includes himself in the painting, but through the compositional element of his own Iowa City house. Appropriating Charles Willson Peale's *The Artist in His Museum* (1822), wherein Peale lifts a curtain to reveal his creation, Wood shows the great mythmaker Mason Locke Weems drawing back a tasseled curtain to reveal his famous fabrication: the story of Washington and the cherry tree.[4]

Subject and style come together, as blatantly patterned and immaculately delineated forms reinforce the artifice of Weems's narrative. Further, faced with the dilemma of presenting the six-year-old George as immediately identifiable and authentic, Wood audaciously, but logically, transplants Stuart's ubiquitous "Athenaeum" portrait onto the child's body. In essence, Wood constructs Washington through collage, a most modern technique. Another modernist element, irony, is inherent in this portrayal of a man who falsified a story about telling the truth. At once humorous and serious, *Parson Weems' Fable* manifests the artist's concern that "a valuable and colorful part of our national heritage is being lost as a result of the work of analytical historians and debunking biographers."[5] Wood made it clear that the painting aimed not only to reassert America's mythic heritage but also to reaffirm the nation's uniqueness at the very moment when Europe was entering a second world war: "[I]n our present unsettled times, when democracy is threatened on all sides, the preservation of our folklore is more important than generally realized."[6]

Besides borrowing from the Peale picture, the composition of *Parson Weems' Fable* parallels a widely used type of advertising layout of the 1930s in which an individual is shown close up, facing the reader while gesturing toward a scene/product in the background. This popular format, used to promote an immense range of goods and com-

FIGURE 73

Association of American Railroads advertisement, *Saturday Evening Post,* March 25, 1939.

panies, appeared in such widely read periodicals as the *American Magazine, Time,* and the *Saturday Evening Post* (figure 73). Given Weems's true calling as a huckster, the composition's similarity to advertising is telling.

Parson Weems' Fable was completed the same year that saw the publication of one of the most influential pieces of writing on modern art, Clement Greenberg's "Avant-Garde and Kitsch." In this essay, the critic opposes the avant-garde, an elitist enterprise by which culture progresses, to the rearguard phenomenon of kitsch. His description of kitsch—"popular, commercial art and literature with their chromeotypes, magazine covers, illustrations, ads, slick and pulp fiction, comics"—corresponds to the spirit of Wood's painting, and the modernist Greenberg would certainly have dismissed *Parson Weems' Fable* as such.[7] However, from today's postmodernist perspective, the picture appears in a more favorable light. Its use of appropriation and parody, as well as its recognition of the importance of the narrator to any historical account, accord well with the postmodern attitude and prefigure images of George Washington that would be created during the second half of this century.

Precisely when the "postmodern" era began is a matter of debate, and, given the slippery nature of the term itself (no two critics can quite agree on its definition), that will remain so. Postmodernism's origins certainly lie in the 1960s, specifically in pop art and in Robert Venturi's "gentle manifesto," *Complexity and Contradiction in Architecture.*[8] The art movement and the book alike embraced the ambiguity of contemporary experience and promoted an aesthetic that expressed "richness of meaning rather than clarity of meaning."[9] By the early 1970s "postmodernism" had gained currency as a label to describe art that had both broken with and extended modernism. Postmodernism signaled a change in which many of the elements associated with modernism—an antihistorical and antinarrative bias, an emphasis on originality and authenticity, and

an idealist sensibility—were questioned or rejected outright. But even as early as the 1930s, as we have seen in *Parson Weems' Fable*, there were certain works imbued with postmodern qualities. This was the case with another pre-postmodern work, Larry Rivers's *Washington Crossing the Delaware* (1953, color plate 28).

Painted during the heyday of abstract expressionism, *Washington Crossing the Delaware* represented the conscious effort of its creator to make a name for himself by defying the tenets of modernism.

> I was energetic and egomaniacal and what is even more: important, cocky and angry enough to want to do something no one in the New York art world could doubt was *disgusting, dead,* and *absurd.* So, what could be dopier than a painting dedicated to a national cliché—Washington Crossing the Delaware.[10]

Rivers challenged the basic precepts of abstract expressionism by drawing upon a mythic moment from American history. That he chose to throw down the gauntlet by portraying a scene best known through Leutze's huge 1851 composition is both a mark of that nineteenth-century painting's celebrity and an indication of the low opinion modernists held of history painting, particularly if it involved George Washington.[11] The image of the hero had lapsed into cliché, and modernism detested cliché.

Rivers has asserted that Leutze's painting was not the direct source of inspiration for his work. More important were his reading of Tolstoy's *War and Peace,* his admiration for the grand history paintings he had studied in the Louvre, and the patriotic plays he remembered from grade school.[12] Nevertheless, he could not have avoided Leutze's image, as it was (and is) a picture as familiarly linked to the historical event as Stuart's likeness is to Washington. This was especially true in the early cold war years, when, for example, an illustration of schoolchildren viewing Leutze's "nationally beloved work of art" served as the cover of a 1951 issue of the *Saturday Evening Post.*[13] In 1952 a special exhibition of the picture was held at the site where Washington was thought to have crossed the Delaware. And in fact, Rivers did acknowledge, backhand-edly, the image's significance for him:

> The last painting that dealt with George and the rebels is hanging in the Met and was painted by a coarse German nineteenth-century academician who really loved Napoleon more than anyone and thought crossing a river on a late December after-noon was just another excuse for a general to assume a heroic, slightly tragic pose.... What *I* saw in the crossing was quite different. I saw the moment as nerve–wracking and uncomfortable. I couldn't picture anyone getting into a chilly river around Christmas time with anything resembling hand-on-chest heroics.[14]

Rivers's work obviously differs compositionally from Leutze's. Where photographic clarity informs Leutze's depiction, vague space and indistinct forms characterize Rivers's work.[15] Confusion prevails, as sketchy figures float like apparitions around the centralized Washington, who stands in a boat and peers tentatively at us. He is not the exemplary hero willing Americans to victory but an ill-defined figure set in the midst of chaos. The obvious narrative and theatricality of the Leutze give way here to a com-position that absorbs the viewer into its thin washes of color by provoking the specta-tor to piece together the disjointed narrative. Looking at the work today in terms of its daring treatment of a historical event trivialized by the outmoded heroics of the Leutze painting, one is struck by its anticipation of postmodernism.

Although his work utilized the large compositional format characteristic of abstract expressionist paintings, Rivers eschewed not only the modernist tradition of the new in his choice of subject matter but also in his appropriation of high art and popular culture. The general's outfit is taken from Jacques-Louis David's 1812 work

Napoleon in His Study (which is ironic, considering Rivers's negative comment about Leutze's love of Napoleon). For the head of Washington, Rivers drew upon a grimacing face from Leonardo's 1505 cartoon for the *Battle of Anghiari*.[16] He also consulted images in children's books whose more schematic illustrations offered alternatives to the heroic Leutze composition.[17]

Not surprisingly, given the climate of opinion in which it was produced and the painter's avowed intention to create a confrontational work, *Washington Crossing the Delaware* was "cordially detested" by critics.[18] Yet the Museum of Modern Art acquired the picture in 1955, provoking the question, Rivers recalled, "What was George doing next to Franz [Kline] and Philip [Guston]?" while also inspiring Frank O'Hara's poem "On Seeing Larry Rivers' *Washington Crossing the Delaware* at the Museum of Modern Art."[19] In 1956 Kenneth Koch wrote a one-act play derived from the painting; when it was performed six years later at the Maidman Theatre in New York City, it featured a set created in 1961 by Alex Katz (figure 74).[20]

Katz's assembly shows the general sharing the boat with four soldiers and a standing horse. Katz reverses the direction of the crossing from that in Leutze's canonical image to represent movement from Pennsylvania to New Jersey more accurately.[21] The cutout figures evoke the childlike character of the grade-school patriotic plays Rivers recollected when working on his painting. The set includes a sign inscribed, "The Dream of Washington." In the play, Washington bids America "Goodnight" and dreams of cutting down his father's cherry tree. Nineteenth-century images had depicted Washington dreaming of the Spirit of America; now his own legend was the stuff of dreams.[22]

The appearance of Katz's *Washington Crossing the Delaware* in 1962 coincided with the emergence of pop art. Indeed, the set exhibits the clarity of form and sense of parody associated with that movement. Like numerous pop works, Katz's tableau places real objects—a china teapot and two cups and saucers—alongside the painted forms. The work differs from most pop art, however, by treating a historical subject.[23]

Not until the middle of the next decade, during the celebration of the United States Bicentennial, were significant images of the Delaware crossing produced again, when, for example, Leutze's iconic work provided the springboard for Peter Saul's and Robert Colescott's highly expressive paintings of 1975. Saul's immense canvas represents the crossing as a visual overload of Day-Glo colors and distorted, distended

FIGURE 74

Alex Katz (American, b. 1927)

Washington Crossing the Delaware, 1961

Various media, various dimensions. National Museum of American Art, Smithsonian Institution, Washington, D.C. Gift of Mr. and Mrs. David K. Anderson, Martha Jackson Memorial Collection (American Revolutionary Soldiers), Gift of Aaron Kozak (Union Jack), Gift of Jean Goodman.

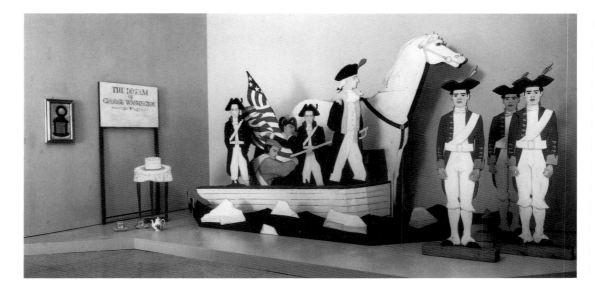

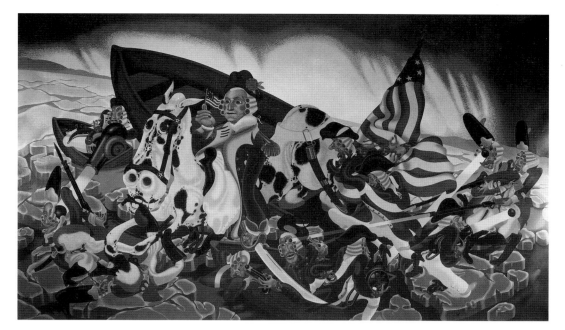

FIGURE 75

Peter Saul
(American, b. 1934)

George Washington Crossing the Delaware, 1975

Acrylic on canvas, 89 × 151 in. Collection of Allan and Jean Frumkin, New York. Courtesy George Adams Gallery, New York.

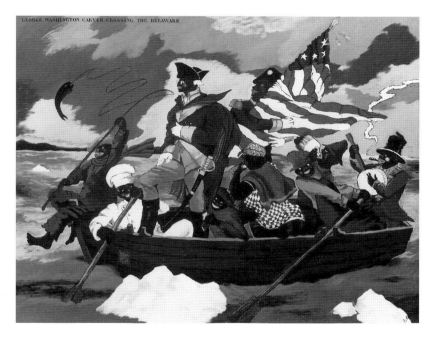

FIGURE 76

Robert Colescott
(American, b. 1925)

George Washington Carver Crossing the Delaware: Page from an American History Textbook. 1975

Acrylic on canvas, 84 × 108 in. Collection of Robert Orchard, St. Louis.

rubbery figures (figure 75). A dazed-looking Washington holds up a comically small flag in one hand and wields a huge sword with the other. The hero sits on a horse, which, like the soldiers, spills out of the precariously pitching boat. Typical of Saul's art, violence reigns as British and American troops blast away at each other on the ice floes. Here the Leutze painting is transformed into a grotesque, cartoonish image of mayhem.

Colescott more directly appropriates the Leutze image, but he, too, gives it a highly personal spin (figure 76). Entitled *George Washington Carver Crossing the Delaware: Page from an American History Textbook,* the work portrays a benign, bespectacled Carver standing in his namesake's place. The grim, focused determination of Leutze's soldiers (who include one black figure, Prince Whipple) is replaced by a boatload of grinning, raucous African Americans. Colescott's figures exaggeratedly enact stereotypical roles, such as the mammy, cook, and banjo player. "In re-exposing those images, I wanted to show the grand-scale stupidity of stereotyping," Colescott explained.[24] One figure shines Carver's boot; another hooks a catfish from the prow of

FIGURE 77

Alfred Quiroz
(American, b. 1944)
George Washington Inspects the
Hemp Crop, 1994

Acrylic on mahogany,
Astroturf, and plastic plant,
90 × 86 × 18 in. Private collection.

the boat; a man chugs moonshine; and the woman fellates the officer caressing the American flag. The painting is satirical and, at the same time, unsettling.

> I just thought, this is ridiculous; this is funny. There is a layer about tokenism and another about education, and everybody will get it. It never occurred to me that there would be those who wouldn't get it and who might even take offense at it. I just did it with the assumption that this was going to be my historical painting, my bicentennial statement about American history.[25]

Despite Colescott's stated intentions, the widely reproduced work has sparked controversy.[26] Is Colescott, an African-American artist who studied with the French modernist Fernand Léger, lessening or promoting stereotypes? No easy answer exists, for, as a parody, the work ridicules by imitation. The painting does not allow for an "either-or" response; rather, it embraces the "both-and" character of postmodernism.[27]

Irreverence also defines the work of Alfred Quiroz. His *George Washington Inspects the Hemp Crop* (1994, figure 77) sets a happy Washington between a guffawing gentleman with a clay pipe and a grinning, corncob-pipe-puffing slave. It is apparent that all three have indulged in the fruits of the hemp/marijuana plant. This expressionistic, comic-book-like painting, which includes Astroturf and an actual plastic plant, parodies nineteenth-century images exalting Washington the farmer. Quiroz's scene also provides an antidote to the priggishness of the cherry-tree incident. The subject does have a historical basis: Washington raised hemp as a crop to be sold, usually to make cordage and fabric. However, such products seem far from the minds of Quiroz's figures. By spoofing Washington's interest in hemp, the artist de-heroizes the *pater patriae,* makes him contemporary, and allows him a smile, a feature rare in Washington imagery (except in advertisements).

A smiling George Washington is perhaps only possible when the hero is "under the influence." A birthday card produced a few years ago featured Gilbert Stuart's Washington bearing a big grin. Below the image is written: "George on Prozac." In

Robert Arneson's ceramic sculpture *George and Mona in the Baths of Coloma* (1976, Stedelijk Museum, Amsterdam) the apparently naked Father of His Country casts a lecherous smile upon a fetching Mona Lisa—two icons in hot water! Washington's green countenance, scored with lines, purposely suggests the form in which Stuart's portrait is seen daily: the 1796 "Athenaeum" image on the dollar bill.

The "Athenaeum" portrait achieved iconic status almost as soon as it was painted; it *became* Washington even as it idolized him. As a character in an 1823 novel declared: "If George Washington should appear on earth . . . I am sure that he would be treated as an imposter, when compared with Stuart's likeness of him, unless he produced his credentials."[28] One hundred fifty years later, a Gahan Wilson newspaper cartoon depicted a cashier asking a Stuartesque Washington, "Any identification?" Grant Wood's little boy would not truly be Washington without Stuart's head. Larry Rivers considered copying Stuart's painting for inclusion in his *Washington Crossing the Delaware*.[29] Just as Rivers made reference to Leutze's painting in order to provoke the adherents of abstract expressionism, George Deem used a Stuart portrait to poke fun at that movement in his 1989 picture *The New York School*. Jackson Pollock, Mark Rothko, and company are presented as conservatively dressed men seated in an archetypal American classroom, where Washington's portrait hangs prominently above the blackboard. The well-known anti-establishment spirit of these abstract painters collides humorously with the benign traditionalism of the Washington image, which, as the writer Cynthia Ozick recalled from her school days in the 1930s, "represented . . . above all, a sense of stability, or call it security—the notion that the world was constituted exactly as it ought to be."[30]

Stuart's Washington decorates walls in Tom Wesselmann's pop interior scenes, such as *Little Great American Nude #6* (1961) and *Still Life #31* (1963, color plate 29). The latter updates nineteenth-century domestic views that include an image of Washington, usually above the fireplace, blessing the American home. Wesselmann collages a photographic reproduction of the "Athenaeum" portrait into a composition that includes a working television as the contemporary "hearth." Washington's visage both anchors and asserts the Americanness of the brightly colored, clean, modern environment.

An exemplary pop art melding of high and low culture occurred when the late Roy Lichtenstein translated a reproduction of a woodcut version of Stuart's portrait, which he discovered in a Hungarian newspaper, into his painting *George Washington* (1962, figure 78).[31] Lichtenstein's signature inclusion of Benday dots (indicators of the printing process) reminds us of the "Athenaeum" portrait's wide dissemination through reproductions. That he has selected Stuart's Washington as a subject, when most of his works deal with mundane objects, affirms how deeply the image is embedded in American visual culture. While Lichtenstein treats the portrait as a cliché, he also plays up Washington's status as a hero and celebrity by depicting him as younger and firmer, and by increasing the image to poster size. The artist's modifications perhaps reflect the powerful aura of the youthful then-president John F. Kennedy.

Stuart's Washington receives an even more monumental treatment in Ed Paschke's painting *Prima Vere* (1986). Like Lichtenstein and many others, Paschke has long been fascinated by the impact reproductions have on how we know (or think we know) what we know. *Prima Vere* reads like an electronic- or print-media image whose jarring colors are out of whack. By distorting color and form, Paschke reminds us that our perceptions and conceptions of Washington, like those of so many other figures and events, are shaped by reproductions—and how easily and willingly we credit a reproduction with being the real thing.

A striking recent portrayal of the hero is Vitaly Komar and Alexander Melamid's *Washington Lives II* (1994, color plate 30). The two Russian-born émigrés, working in a social realist style, combined Stuart's "Athenaeum" and full-length "Lansdowne" portraits to show Washington emphatically raising his arm, Lenin-like. Emblems of America, including an aggressive eagle, fill the lower-right corner of the composition, while "purple mountains' majesty" appear at the lower left. The heroics of the dramatically lit scene are belied by the humorous incongruity of the wigged Washington wearing a button-down collar, three-piece business suit, and the passive expression of the "Athenaeum" image. The painting is a dead-on parody of the traditional "state portrait," an official image in which leader and nation are identified as one.

Komar and Melamid's painting appeared in the January 1995 issue of *Artforum,* illustrating their manifesto promoting a five-year plan for a new American social realism. Deeming Washington "America's greatest revolutionary hero" and declaring "revolutionaries never die!," the artists called on "cultural workers" and "everyone who believes that the revolutionary legacy of the Founding Fathers is threatened with extinction to create a work devoted to this patriotic theme."[32] The mock seriousness of the manifesto and the image perfectly complement one another.

Since publishing their manifesto, the artists have created several works related to *Washington Lives II* that form a series entitled American Dreams. Based on the notion that what Russian émigrés to the United States dream about is George Washington, American Dreams includes collages, paintings, and even an opera centering on the hero.[33] Komar and Melamid's admiration for and fascination with Washington were also manifested in *America's Most Wanted* (1994). This picture, a sort of paint-by–

numbers composition, resulted from a poll conducted to determine the types of painting Americans liked best and liked least. Recognizing that so much in this country depends on and is determined by polls, the pair engaged a market-research firm to conduct and evaluate interviews with 1,001 participants, who responded to 102 questions. Originally, Komar and Melamid intended to create a painting for each of the six economic groups surveyed. They found, however, such a consistent set of responses that they were able to produce a single, all-American work.

The interviewees' most favored ideal image was a realistically rendered, dishwasher-sized, nonreligious outdoor composition that included animals, clothed people, historical figures, the color blue, a body of water, and an autumnal setting.[34] Hence Komar and Melamid's painting shows George Washington standing near a lake in the fall season, with other people and deer nearby.

Despite the scientific aspect of the poll, the choice of objects in the painting itself is arbitrary and much the artists' own invention. The inclusion of Washington was not specifically dictated by the survey, which asked, "If you prefer famous people, do you prefer figures from a long time ago, like Lincoln or Jesus, or more recent figures, like John F. Kennedy or Elvis Presley?"[35] Because the majority leaned toward famous people farther back in time, the two artists chose Washington's image in recognition of its fundamental symbolic importance to the United States.

In 1995 Komar and Melamid placed their project on the World Wide Web and expanded it to poll fifteen countries, including China, Denmark, France, and Turkey, to determine other national preferences. The artists' move to the Web reinforces the increasing significance and impact of this electronic medium. The Web offers an extraordinarily rich means of accessing and disseminating Washington images old and new. For instance, Colonial Williamsburg's Presidents' Day launch of its new Web site in 1996 was celebrated by showing a young George seated at a computer, "surfing the Net." Among the more intriguing and ambitious sites is the one designed by the artist Michael Friedman; his home page proclaims:

> If you accept at face value the myths concerning George Washington, you might as well turn back now. These pages are intended to change your understanding of this hero president king false-teeth wearing Delaware crossing childless father of our country. rethink resee George didn't chop the cherry tree [*sic*].[36]

After clicking on "See George!," one may view seven Friedman paintings of Washington. The site also provides an enlarged, outlined Washington from the dollar bill, which can be printed out and colored by children as "a George suitable for the refrigerator."[37] Visitors to the site are encouraged to post comments; one such message was especially telling:

> I'm trying to find a good print of GW that I've recently seen on T.V. It's probably very famous but since I'm a new fan of the Pres. I'm not sure where to get it and hope you might. It is a portrait of GW as an older guy; it is pretty dark and looks Rembrandtesque (in reality it probably doesn't but it's my only way of describing it).[38]

These words wonderfully evoke the image of Washington as hero ("older guy," "Rembrandtesque"), celebrity ("I'm a new fan of the Pres"), and cliché ("very famous" print "recently seen on T.V.").

This anonymous message from cyberspace, along with the multitude of representations of George Washington populating our culture at the end of the twentieth century, makes it clear that even two hundred years after his death, Washington's image—in whatever medium and however used—still powerfully affects us.

NOTES

I am grateful for the research assistance provided by Caitlin Thistlethwaite as I prepared this essay.

1. The works referred to are: Anonymous, *Baptism of George Washington* (1908, Gano Chapel, William Jewell College, Liberty, Mo.); Michael Clark, *George Washington by Sphinx* (1981, location unknown); Phillip Hefferton, *Sinking George* (1962, private collection); Sante Graziani, *Crossing with Multi Rainbows* (1972, private collection); Francisco Sainz, *General Washington on Man o' War* (ca. 1959, location unknown); and Ed Kienholz, *George Washington in Drag* (1957, private collection). Few women artists have been drawn to Washington imagery; Florine Stettheimer and Audrey Flack are notable exceptions.

2. Karal Ann Marling, *George Washington Slept Here: Colonial Revivals and American Culture, 1876–1986* (Cambridge: Harvard University Press, 1988).

3. Christine B. Podmaniczky, *N. C. Wyeth: Experiment and Invention, 1925–1935*, exh. cat. (Chadds Ford, Pa.: Brandywine River Museum, 1995), 36.

4. Peale's picture (Museum of American Art, Pennsylvania Academy of the Fine Arts, Philadelphia) was well known at the time. It appeared in the exhibition *Life in America*, organized by the Metropolitan Museum of Art, New York, for display at the 1939 New York World's Fair, and *Life* magazine reproduced it on page 26 of its June 19, 1939, issue.

5. Grant Wood, "A Statement from Grant Wood Concerning His Painting 'Parson Weems' Fable,'" January 2, 1940, unpaginated typescript, curatorial files, Amon Carter Museum, Fort Worth.

6. Ibid. For a discussion of this painting as a response to the threat of fascism, see Cecile Whiting, *Antifascism in American Art* (New Haven, Conn., and London: Yale University Press, 1989), 98–106.

7. Clement Greenberg, "Avant-Garde and Kitsch," *Partisan Review* 6, no. 5 (fall 1939): 39.

8. Robert Venturi, *Complexity and Contradiction in Architecture* (New York: Museum of Modern Art, 1966), 22.

9. Ibid., 23.

10. Frank O'Hara, *Art Chronicles, 1954–1966* (New York: George Braziller, 1975), 111–12.

11. Roy Lichtenstein also painted two versions of *Washington Crossing the Delaware* around 1951, but these were much less ambitious in size and intention than Rivers's work.

12. Helen A. Harrison, *Larry Rivers* (New York: Harper and Row, 1984), 34; Larry Rivers with Arnold Weinstein, *What Did I Do?: The Unauthorized Autobiography* (New York: HarperCollins, 1992), 312.

13. "This Week's Cover," *Saturday Evening Post* 223, no. 35 (February 24, 1951): 3. Steven Dohanos was the illustrator.

14. Quoted in O'Hara, *Art Chronicles*, 112.

15. In Rivers's *Golden Oldies* (1978, private collection), which includes images from some of his earlier paintings, several of the figures are more clearly visible.

16. Suzanne Ferguson, "Crossing the Delaware with Larry Rivers and Frank O'Hara: The Post-modern Hero at the Battle of Signifiers," *Word and Image* 2, no. 1 (January–March 1986): 27.

17. See, for example, Edward A. Wilson's illustrations in Enid LaMonte Meadowcroft, *The Story of George Washington* (New York: Grosset and Dunlap, 1952), 154.

18. Sam Hunter, *Larry Rivers* (New York: Rizzoli, 1989), 45.

19. Rivers, *What Did I Do?*, 313.

20. Koch wrote the play in the absurdist style of Alfred Jarry. It was to have had its debut at Rivers's son Steven's school on February 22, [1956?], but the school canceled the performance (Rivers, *What Did I Do?*, 313).

21. Oscar De Mejo's *The Crossing of the Delaware* (1982, Aberbach Fine Art, New York) takes the same orientation, as did Thomas Eakins's relief sculpture for the Trenton Battle Monument (1893).

22. For a nineteenth-century example, see Louis Maurer's lithograph for Currier and Ives, *Washington's Dream* (1857), reproduced in Barbara J. Mitnick, *The Changing Image of George Washington*, exh. cat. (New York: Fraunces Tavern Museum, 1989), 49.

23. For a discussion of pop artists' renderings of contemporary history, see Mark Thistlethwaite, "Revival, Reflection, and Parody: History Painting in the Postmodern Era," in Patricia M. Burnham and Lucretia Hoover Giese, eds., *Redefining American History Painting* (Cambridge: Cambridge University Press, 1995), 210–13.

24. Quoted in Jim Waltzer, "In Profile: Robert Colescott," *Art and Antiques* 20, no. 6 (June 1997): 104.

25. Quoted in Sharon Fitzgerald, "Robert Colescott Rocks the Boat," *American Visions* 12, no. 3 (June 1, 1997): 14–16.

26. See Robert L. Douglas, "Robert Colescott's Searing Stereotypes," *New Art Examiner* 16, no. 10 (June 1989): 34–37, and Mitchell Kahan, "Robert Colescott: Pride and Prejudice," *Art Papers* 9, no. 3 (May–June 1985): 22–23.

27. My use of these two terms derives from Venturi, *Complexity and Contradiction*, 23.

28. From *Randolph* by John Neal, quoted in Harold Edward Dickson, ed., *Observations on American Art: Selections from the Writings of John Neal (1793–1876)* (State College, Pa.: Pennsylvania State College, 1943), 3.

29. Rivers, *What Did I Do?*, 54.

30. Michael Pollack, "A Gallery of Memories," *New York Times*, January 7, 1996, sec. 4A, p. 28.

31. Diane Waldman, *Roy Lichtenstein*, exh. cat. (New York: Solomon R. Guggenheim Museum, 1993), 31.

32. Andrew Ross, "Poll Stars: Komar and Melamid's 'The People's Choice,'" *Artforum* 33, no. 5 (January 1995): 74–75.

33. In 1995 the artists collaborated with a Toledo Zoo elephant on a piece entitled *Renee Paints Bust of George Washington*. Apparently, this work was not formally included in the American Dreams series.

34. "Least wanted" was a paperback-sized abstract painting.

35. Fifty-six percent of respondents favored historical figures; fourteen percent preferred more recent ones. Twenty-two percent said, "It depends," and eight percent were not sure. For the questions and responses, see "The Search for a People's Art: Painting by Numbers," *The Nation* 258, no. 10 (March 14, 1994): 334–48. The Nation Institute sponsored the poll, which was conducted by the firm Marttila and Kiley Inc.

36. Http://www.columbia.edu/~gmr3/GeorgeFlag.html. August 8, 1997.

37. Http://www.columbia.edu/~gmr3/ColoringBook.html. August 12, 1997.

38. Http://www.columbia.edu/~gmr3/CommentForm.html #comments. August 8, 1997.

Selected Bibliography

Abbot, W. W., and Dorothy Twohig, eds. *The Papers of George Washington,* Colonial, Confederation, and Presidential Series. Charlottesville: University Press of Virginia, 1983–94.

Ahrens, Kent. "Jennie Brownscombe: American History Painter." *Woman's Art Journal* 1, no. 2 (fall 1980–winter 1981): 25–29.

Anderson, Patricia A. *Promoted to Glory: The Apotheosis of George Washington.* exh. cat. Northampton, Mass.: Smith College Museum of Art, 1980.

Arnason, H. H. *The Sculptures of Houdon.* New York: Oxford University Press, 1975.

Atterbury, Paul, ed. *The Parian Phenomenon: A Survey of Victorian Parian Porcelain Statuary and Busts.* Shepton Beauchamp, England: Richard Dennis, 1989.

Ayres, William, Barbara J. Mitnick, et al. *Picturing History: American Painting, 1770–1930.* New York: Rizzoli, 1993.

Baker, W. S. *The Engraved Portraits of Washington, with Notices of the Originals and Brief Biographical Sketches of the Painters.* Philadelphia: Lindsay and Baker, 1880.

———. *Bibliotheca Washingtoniana: A Descriptive List of the Biographies and Biographical Sketches of George Washington.* 1889. Reprint, Detroit: Gale Research Company, 1967.

Bancroft, Aaron. *An Essay on the Life of George Washington, Commander in Chief of the American Army through the Revolutionary War; and the First President of the United States.* Worcester, Mass.: Thomas and Sturtevant, 1807.

Bantel, Linda et al. *William Rush, American Sculptor.* exh. cat. Philadelphia: Pennsylvania Academy of the Fine Arts, 1982.

Barford, Jerilyn, and Paul A. Camp. *Those Grand Pioneers of Promotion: A History of Specialty Advertising.* Langhorne, Pa.: Advertising Specialty Institute, 1979.

Bell, John. "A Sketch of Mr. Washington's Life and Character, Appended to a Political Epistle to His Excellency, George Washington, Esq." (Annapolis, 1779), as reprinted in *The Westminster Magazine, or the Pantheon of Taste: Containing a View of the History, Politics, Literature, Manners, Gallantry, and Fashions of the Year 1780* 8 (August 1780): 413–16.

Benezra, Neal. *Robert Arneson: A Retrospective.* exh. cat. Des Moines, Iowa: Des Moines Art Center, 1985.

Benezra, Neal et al. *Ed Paschke.* exh. cat. New York: Hudson Hills Press, 1990.

Berryman, Florence Seville. "Dunsmore's Epic of the American Revolution." *Daughters of the American Revolution Magazine* 60, no. 11 (November 1926): 644–54, and 61, no. 1 (January 1927): 25–33.

Boorstin, Daniel J. *The Americans: The National Experience.* New York: Random House, 1965.

———. "The Mythologizing of George Washington." In *George Washington: A Profile,* edited by James Morton Smith, 262–85. New York: Hill and Wang, 1969.

Brockett, F. L. *The Lodge of Washington: A History of the Alexandria Washington Lodge, No. 22, A. F. and A. M., of Alexandria, Va., 1783–1876.* Alexandria, Va.: G. H. Ramey and Son, 1899.

Brookhiser, Richard. *Rediscovering George Washington, Founding Father.* New York: Simon and Schuster, 1996.

Brown, William Moseley. *George Washington, Freemason.* Richmond, Va.: Garrett and Massie, 1952.

Caldwell, John, and Oswaldo Rodriguez. *American Paintings in the Metropolitan Museum of Art.* vol. 1. Princeton, N.J.: Princeton University Press, 1994.

Callahan, Charles H. *Washington: The Man and the Mason.* 6th ed. Alexandria, Va.: Memorial Temple Committee of the George Washington Masonic National Memorial Association, 1913.

Carson, Cary. "The Consumer Revolution in Colonial British America: Why Demand?" In *Of Consuming Interests: The Style of Life in the Eighteenth Century,* edited by Cary Carson, Ronald Hoffman, and Peter J. Albert. Charlottesville: University Press of Virginia, 1994, 483–697.

Clark, H. Nichols B. *A Marble Quarry: The James H. Ricau Collection of Sculpture at the Chrysler Museum of Art.* New York: Hudson Hills Press, 1997.

Clark, Robert Judson. "Frederick MacMonnies and the Princeton Battle Monument." *Record of the Art Museum: Princeton University* 43, no. 2 (1984). Special issue, devoted to MacMonnies' Princeton monument.

Cooper, Helen A. *John Trumbull: The Hand and Spirit of a Painter.* New Haven, Conn.: Yale University Press, 1982.

Craven, Wayne. *Sculpture in America.* New York: Thomas Y. Crowell Company, 1968.

Cunliffe, Marcus. *George Washington, Man and Monument.* Boston: Little, Brown, 1958.

Custis, George Washington Parke. *Recollections and Private Memoirs of Washington.* Washington, D.C.: William H. Moore, 1859.

Desportes, Ulysse. "Giuseppe Ceracchi in America and His Busts of George Washington." *Art Quarterly* 26, no. 2 (summer 1963): 140–79.

Deutsch, Davida Tenenbaum. "Washington Memorial Prints." *The Magazine Antiques* 111, no. 2 (February 1977): 324–31.

Dimmick, Lauretta. "'An Altar Erected to Heroic Virtue Itself': Thomas Crawford and His Virginia Washington Monument." *American Art Journal* 23, no. 2 (1991): 4–73.

Douglas, Robert L. "Robert Colescott's Searing Stereotypes." *New Art Examiner* 16, no. 10 (June 1989): 34–37.

Duncan, Malcolm C. *Duncan's Masonic Ritual and Monitor.* 3d ed., with additions and corrections. Philadelphia: Washington Publishing Company, ca. 1866.

Dunlap, William. *The History of the Rise and Progress of the Arts of Design in the United States.* 2 vols. New York: George P. Scott, 1834.

Egbert, Donald Drew. *Princeton Portraits.* Princeton, N.J.: Princeton University Press, 1947.

Eisen, Gustavus A. *Portraits of George Washington.* 3 vols. New York: Robert Hamilton and Associates, 1932.

Eulogies and Orations on the Death of General George Washington, First President of the United States of America. Boston: Manning and Loring, 1800.

Evans, Dorinda. "Gilbert Stuart: Two Recent Discoveries." *American Art Journal* 16, no. 3 (summer 1984): 84–89.

Fabian, Monroe H. *Joseph Wright: American Artist, 1756–1793.* Washington, D.C.: Smithsonian Institution Press, 1985.

Ferguson, Suzanne. "Crossing the Delaware with Larry Rivers and Frank O'Hara: The Post-modern Hero at the Battle of Signifiers." *Word and Image* 2, no. 1 (January–March 1986): 27–32.

Fitzgerald, Sharon. "Robert Colescott Rocks the Boat." *American Visions* 12, no. 3 (June 1, 1997): 14–16.

Ford, Paul Leicester. *The True George Washington.* Philadelphia: J. B. Lippincott, 1905.

Ford, Worthington. *George Washington.* New York: Charles Scribner's Sons, 1900.

Fowble, E. McSherry. *Two Centuries of Prints in America, 1680–1880: A Selective Catalogue of the Winterthur Museum Collection.* Charlottesville: University Press of Virginia, 1987.

Franco, Barbara. "Masonic Imagery." In *Aspects of American Printmaking, 1800–1950,* edited by James F. O'Gorman, 1–29. Syracuse, N.Y.: Syracuse University Press, 1988.

Frelinghuysen, Alice Cooney. *American Porcelain, 1770–1920.* New York: Metropolitan Museum of Art, 1989.

Frost, John. *The Pictorial Life of General Washington.* Philadelphia: Thomas Cowperthwait, 1848.

Gabriel, Ralph. *The Pageant of America: A Pictorial History of the United States.* 15 vols. New Haven, Conn.: Yale University Press, 1925–28.

Gale Research Company, with an introduction by Bernard F. Reilly. *Currier & Ives: A Catalogue Raisonné.* 2 vols. Detroit: Gale Research Company, 1983.

Gould, Robert Freke. *Military Lodges: The Apron and the Sword, or Freemasonry under Arms.* London: Gale and Polden, 1899.

Hallam, John S. "Houdon's *Washington* in Richmond: Some New Observations." *American Art Journal* 10, no. 2 (November 1978): 72–80.

Harris, Neil. *Cultural Excursions: Marketing Appetites and Cultural Tastes in Modern America.* Chicago and London: University of Chicago Press, 1990.

Hay, Robert P. "George Washington: American Moses." *American Quarterly* 21, no. 4 (winter 1969): 780–91.

Hayden, Sidney. *Washington and His Masonic Compeers.* 3d ed. New York: Masonic Publishing and Manufacturing Company, 1866.

Headley, Joel T. *The Illustrated Life of Washington: Together with an Interesting Account of Mount Vernon as It Is.* New York: G. and F. Bill, 1858.

Heaton, Ronald E. *The Image of Washington: The History of the Houdon Statue.* Norristown, Pa.: Privately published, 1971.

Heller, Jules, and Nancy G. Heller. *North American Women Artists of the Twentieth Century.* New York: Garland Publishing, 1995.

Hevner, Carol Eaton. *Rembrandt Peale, 1778–1860: A Life in the Arts.* exh. cat. Philadelphia: Historical Society of Pennsylvania, 1985.

Hindes, Ruthanna. "A Wooden Statue of George Washington." *The Magazine Antiques* 62, no. 1 (July 1952): 46.

History of the George Washington Bicentennial Celebration. 5 vols. Washington, D.C.: United States George Washington Bicentennial Commission, 1932.

Holt, T. W. *The Model Man: An Oration on Washington, in Which He Is Compared with the Sages and Heroes of Antiquity, Together with an Analysis of His Character, and the Annunciation of Him as the Model Man.* St. Louis: T. W. Ustick, 1866.

Holzer, Harold. *Washington and Lincoln Portrayed: National Icons in Popular Prints.* Jefferson, N.C., and London: McFarland and Company, 1993.

Howlett, D. Roger. *The Sculpture of Donald De Lue: Gods, Prophets, and Heroes.* Boston: David R. Godine, 1990.

Hunter, Sam. *Larry Rivers.* New York: Rizzoli, 1989.

Irving, Washington. *Life of George Washington.* 5 vols. New York: G. P. Putnam, 1856–59.

Jackson, Donald, ed. *The Diaries of George Washington.* 6 vols. Charlottesville: University Press of Virginia, 1976–79.

Johnston, Elizabeth Bryant. *Original Portraits of Washington, Including Statues, Monuments, and Medals.* Boston: James R. Osgood, 1882.

Kahan, Mitchell. "Robert Colescott: Pride and Prejudice." *Art Papers* 9, no. 3 (May–June 1985): 22–23.

Klapthor, Margaret Brown, and Howard Alexander Morrison. *G. Washington: A Figure upon the Stage.* Washington, D.C.: National Museum of American History, Smithsonian Institution, 1982.

Knox, Katharine McCook. *The Sharples.* New Haven, Conn.: Yale University Press, 1930.

Krakel, Dean. *End of the Trail: The Odyssey of a Statue.* Norman: University of Oklahoma Press, 1973.

Lanier, John J. *Washington: The Great American Mason.* New York: Macoy Publishing and Masonic Supply Company, 1922.

Lindquist, David P., and Caroline C. Warren. *Colonial Revival Furniture.* Radnor, Pa.: Wallace Homestead Book Company, 1993.

Longacre, James B., and James Herring, eds. *The National Portrait Gallery of Distinguished Americans.* 4 vols. New York: Monson Bancroft, 1834.

Longmore, Paul K. *The Invention of George Washington.* Berkeley: University of California Press, 1988.

Lossing, Benson J. *Mount Vernon and Its Associations.* New York: W. A. Townsend, 1859.

Marling, Karal Ann. *George Washington Slept Here: Colonial Revivals and American Culture, 1876–1986.* Cambridge: Harvard University Press, 1988.

Marshall, John. *The Life of George Washington.* 5 vols. Philadelphia: C. P. Wayne, 1804–7.

McCabe, James D. *The Illustrated History of the Centennial Exhibition.* Cincinnati: Jones Brothers, 1876.

Miles, Ellen G. *Saint-Memin and the Neoclassical Profile Portrait in America.* Washington, D.C.: Smithsonian Institution Press, 1994.

———. *American Paintings of the Eighteenth Century.* Washington, D.C.: National Gallery of Art, 1995.

Miller, Lillian B. "Engines, Marbles and Canvases: The Centennial Exposition of 1876," *Indiana Historical Society: Lectures, 1972–1973,* 2–29. Indianapolis: Indiana Historical Society, 1973.

———, ed. *The Peale Family: Creation of a Legacy, 1770–1870.* New York: Abbeville Press, 1996.

Miller, Lillian B., Sidney Hart, and Toby A. Appel, eds. *The Selected Papers of Charles Willson Peale and His Family.* 3 vols. New Haven, Conn.: Yale University Press, 1983–91.

Mitnick, Barbara J. *Jean Leon Gerome Ferris, 1863–1930: America's Painter Historian.* Ph.D. diss., State University of New Jersey, 1983.

——. *Jean Leon Gerome Ferris, 1863–1930: American Painter Historian.* Laurel, Miss.: Lauren Rogers Museum of Art, 1985.

——. *The Changing Image of George Washington.* exh. cat. New York: Fraunces Tavern Museum, 1989.

Montgomery, Florence M. *Printed Textiles: English and American Cottons and Linens, 1700–1850.* New York: Viking Press, 1970.

Morgan, John Hill, and Mantle Fielding. *The Life Portraits of Washington and Their Replicas.* Philadelphia: Printed for the subscribers, 1931.

Morse, Jedidiah. "Sketch of the Life of General Washington," *The American Geography; or, a View of the Present Situation of the United States of America.* Elizabethtown, N.J.: Printed by Shepard Kollock for the author, 1789.

O'Hara, Frank. *Art Chronicles, 1954–1966.* New York: George Braziller, 1975.

Palmer, Arlene. "American Heroes in Glass: The Bakewell Sulphide Portraits." *American Art Journal* 11, no. 1 (January 1979): 4–26.

Paulding, James Kirk. *A Life of Washington.* 2 vols. New York: Harper and Brothers, 1835.

Perkins, Robert F., Jr., and William J. Gavin III. *The Boston Athenaeum Art Exhibition Index, 1827–1874.* Boston: Library of the Boston Athenaeum, 1980.

Pitz, Henry C. *The Brandywine Tradition.* Boston: Houghton Mifflin, 1969.

——. *Howard Pyle: Writer, Illustrator, Founder of the Brandywine School.* New York: Clarkson N. Potter, 1975.

Podmaniczky, Christine B. *N. C. Wyeth: Experiment and Invention, 1925–1935.* exh. cat. Chadds Ford, Pa.: Brandywine River Museum, 1995.

Quick, Michael, Marvin Sadik, and William H. Gerdts. *American Portraiture in the Grand Manner, 1720–1920.* exh. cat. Los Angeles County Museum of Art, 1981.

Ramsay, David, *The Life of George Washington.* New York: Hopkins and Seymour, 1807.

Reynolds, Donald Martin. *Masters of American Sculpture: The Figurative Tradition from the American Renaissance to the Millennium.* New York: Abbeville Press, 1993.

Rivers, Larry, with Arnold Weinstein. *What Did I Do?: The Unauthorized Autobiography.* New York: HarperCollins, 1992.

Roberts, Allen E. *G. Washington: Master Mason.* Richmond, Va.: Macoy Publishing and Masonic Supply Company, 1976.

Rollings, R. C. *Specialty Advertising: A History.* Irving, Tex.: Specialty Advertising Association International, n.d.

Ross, Andrew. "Poll Stars: Komar and Melamid's 'The People's Choice.'" *Artforum* 33, no. 5 (January 1995): 72–77.

Rush, Richard. *Washington in Domestic Life from Original Letters and Manuscripts.* Philadelphia: J. B. Lippincott, 1857.

Sadik, Marvin. *Christian Gullager: Portrait Painter to Federal America.* Washington, D.C.: Smithsonian Institution Press, 1976.

Safford, Carleton L., and Robert Bishop. *America's Quilts and Coverlets.* New York: E. P. Dutton, 1972.

St. George, Judith. *The Mount Rushmore Story.* New York: G. P. Putnam's Sons, 1985.

Schroeder, J. F., and Benson J. Lossing. *Life and Times of Washington.* 4 vols. Albany, N.Y.: M. M. Belcher, 1903.

Schwartz, Barry. *George Washington: The Making of an American Symbol.* New York: Free Press, 1987.

Schwartz, Marvin D., Edward J. Stanek, and Douglas K. True. *The Furniture of John Henry Belter and the Rococo Revival.* New York: E. P. Dutton, 1981.

Sellers, Charles Coleman. *Portraits and Miniatures by Charles Willson Peale.* Philadelphia: American Philosophical Society, 1952.

——. *Charles Willson Peale with Patron and Populace: A Supplement to Portraits and Miniatures by Charles Willson Peale.* Philadelphia: American Philosophical Society, 1969.

——. *Patience Wright: American Artist and Spy in George III's London.* Middletown, Conn.: Wesleyan University Press, 1976.

Sharp, Lewis I. *New York City Public Sculpture by Nineteenth-Century American Artists.* exh. cat. New York: Metropolitan Museum of Art, 1974.

——. *John Quincy Adams Ward: Dean of American Sculpture.* Newark: University of Delaware Press; and London and Toronto: Associated University Presses, 1985.

Simmons, Linda Crocker. *Charles Peale Polk, 1776–1822: A Limner and His Likenesses.* exh. cat. Washington, D.C.: Corcoran Gallery of Art, 1981.

Sizer, Theodore, ed. *The Autobiography of Col. John Trumbull.* New Haven, Conn.: Yale University Press, 1953.

Smith, Alan. *The Illustrated Guide to Liverpool Herculaneum Pottery.* London: Barrie and Jenkins, 1970.

Sparks, Jared. *The Writings of George Washington: Being His Correspondence, Addresses, Messages, and Other Papers, Official and Private, Selected and Published from the Original Manuscripts; with a Life of the Author, Notes, and Illustrations.* Half-title: *Life of George Washington.* 12 vols. Boston: F. Andrews, 1834–37.

Steinway, Kate. "The Kelloggs of Hartford: Connecticut's Currier and Ives." *Imprint: Journal of the American Historical Print Collectors Society* 13, no. 1 (spring 1988): 2–12.

Stewart, Robert G. *Robert Edge Pine: A British Portrait Painter in America, 1784–1788.* Washington, D.C.: Smithsonian Institution Press, 1979.

Thistlethwaite, Mark. "The Artist as Interpreter of American History." *In This Academy: The Pennsylvania Academy of the Fine Arts, 1805–1976.* exh. cat. Philadelphia: Pennsylvania Academy of the Fine Arts, 1976, 99–121.

——. *The Image of George Washington: Studies in Mid-Nineteenth–Century American History Painting.* New York and London: Garland Publishing, 1979.

——. "The Most Important Themes: History Painting and Its Place in American Art." In *Grand Illusions: History Painting in America,* by William H. Gerdts and Mark Thistlethwaite, 7–58. Fort Worth: Amon Carter Museum, 1988.

——. "Revival, Reflection, and Parody: History Painting in the Postmodern Era." In *Redefining American History Painting,* edited by Patricia M. Burnham and Lucretia Hoover Giese, 208–25. Cambridge: Cambridge University Press, 1995.

Tuckerman, Henry T. "Crawford and Sculpture." *Atlantic Monthly* 2, no. 8 (June 1858): 64–78.

——. *The Character and Portraits of Washington.* New York: G. P. Putnam, 1859.

Waldman, Diane. *Roy Lichtenstein.* exh. cat. New York: Solomon R. Guggenheim Museum, 1993.

Wall, Charles C., Christine Meadows, et al. *Mount Vernon: A Handbook.* Mount Vernon, Va.: Mount Vernon Ladies' Association, 1985.

Wallace, David H. *John Rogers: The People's Sculptor.* Middletown, Conn.: Wesleyan University Press, 1967.

Waltzer, Jim. "In Profile: Robert Colescott." *Art and Antiques* 20, no. 6 (June 1997): 104.

Ward, Meredith E. *William Stanley Haseltine, 1835–1900/Herbert Hazeltine, 1877–1962.* New York: Hirschl and Adler Galleries, 1992.

Weems, Mason Locke. *The Life of George Washington,* with an introduction by Marcus Cunliffe. 1800. Reprint, Cambridge: Harvard University Press, 1962.

Whipple, Wayne. *The Story-Life of Washington.* Philadelphia: John C. Winston Company, 1911.

Whiting, Cecile. *Antifascism in American Art.* New Haven, Conn.: Yale University Press, 1989.

Whittemore, Frances Davis. *George Washington in Sculpture.* Boston: Marshall Jones Company, 1933.

Wick, Wendy C. *George Washington, An American Icon: The Eighteenth-Century Graphic Portraits.* Washington, D.C.: Smithsonian Institution Traveling Exhibition Service and the National Portrait Gallery, 1982.

Williams, John F., Jr. *William J. Williams: Portrait Painter and His Descendants.* Buffalo, N.Y.: C. C. Brock, 1933.

Wills, Garry. *Cincinnatus: George Washington and the Enlightenment.* Garden City, N.Y.: Doubleday, 1984

Wilson, Richard Guy. "Presence of the Past." In *The American Renaissance, 1876–1917,* by Richard Guy Wilson, Dianne H. Pilgrim, and Richard N. Murray, 27–55. exh. cat. Brooklyn: Brooklyn Museum, 1979.

Withington, Ann Fairfax. "Manufacturing and Selling the American Revolution." In *Everyday Life in the Early Republic,* edited by Catherine E. Hutchins, 285–315. Winterthur, Del.: Henry Francis du Pont Winterthur Museum, 1994.

Wunder, Richard P. *Hiram Powers: Vermont Sculptor, 1805–1873.* 2 vols. Newark: University of Delaware Press; and London and Toronto: Associated University Presses, 1991.

INDEX

Page numbers in *italics* refer to illustrations.

PHOTOGRAPH CREDITS